TIM BURTON

Quarto is the authority on a wide range of topics.

Quarto educates, entertains and enriches the lives of
our readers—enthusiasts and lovers of hands-on living.

www.QuartoKnows.com

First published in Great Britain 2016 by Aurum Press Ltd
74—77 White Lion Street
Islington
London N1 9PF

A catalogue record for this book is available from the British Library.

Designed by Sue Pressley and Paul Turner, Stonecastle Graphics Ltd

ISBN 978 1 78131 595 8
ebook ISBN 978 1 78131 662 7

2016 2018 2020 2019 2017

1 3 5 7 9 10 8 6 4 2

Printed in China

TIM BURTON

The iconic filmmaker and his work

Ian Nathan

Aurum
Press

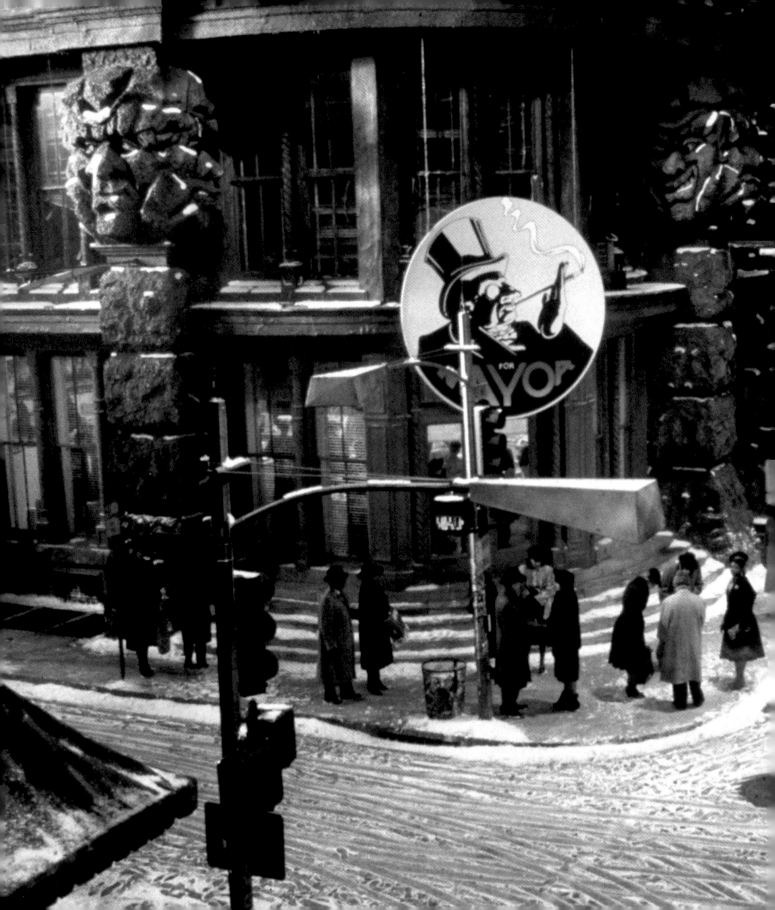

CONTENTS

Above: Gotham city in all its wintery glory. This second version of the city, built for the sequel, *Batman Returns,* was much more what Tim Burton had in mind. Its mix of comic-book, fairy-tale and dream-like imagery are unique to the director.

INTRODUCTION
Films as therapy

Once upon a time in Burbank, Tim Burton gathered together a rabble of local kids in a park and instructed them to make piles of debris and dig weird footprints in the ground. There they waited for some other kids to show up, and convinced them that an alien ship had crash-landed.

The callow Burton also once convinced the boy next door that a killer on the run had tripped and fallen into a neighbour's pool that had only recently been doused with acid and chlorine. 'I threw some clothes in there,' he remembered, 'and told this kid the guy had dissolved.'[1]

Long before he realized it, Burton was a director. Here is the preoccupation with death, the talent for thinking up extraordinary scenes, and an imagination rife with invaders from space ready to rain destruction upon suburbia.

The look, feel and subject matter of Burton's films are so distinctive they have become an adjective – *Burtonesque*. Describing what that word means is, I suppose, partly the endeavour of this book. Although, I'm not sure Burton himself entirely knows. Much of the time he isn't even clear why he does things – it just felt right, he often says. Thus logic can be of secondary importance. Where do those

horses come from in *Planet of the Apes*? And yet if you use the word *Burtonesque*, any film fan will know exactly what you are saying.

You're talking about the imagery. Such imagery! You could take any frame from any of his films and know that it came from his singular mind: gothic, whimsical, eerie, strange, haunting, and bursting with detail. Like animated films, only real – or real films, only animated.

Criticizing Burton for a lack of versatility is like criticizing Charles Dickens for being Dickensian. Burton and his films are extensions of one another – he could no more direct a generic high school comedy than take up the shot put.

There are so many images impossible to forget. Winona Ryder dancing in the snow in *Edward Scissorhands*; the woebegone expression on the shrunken face of the hunter in *Beetlejuice*'s waiting room to the afterlife; just about anything in *The Nightmare Before Christmas*. And in *Mars*

Attacks!, that Martian habit of rolling their eyeballs heavenward at Earthling idiocy is distinctively human. However outlandish his worlds, they harbour something real.

But *Burtonesque* is far more than just a matter of a unifying style; it is as much about character. Not for nothing do so many of his films use the name of the lead character as the title: *Batman*, *Ed Wood*, *Alice in Wonderland* … His films, it was once said, are full of 'wacko individualists'[2]. Which is another way of saying they are full of life – even if they happen to be dead.

Opposite: The director Tim Burton has arguably the most autobiographical canon in Hollywood history. In fact, his style is so distinctive it is has become an adjective – *Burtonesque*.

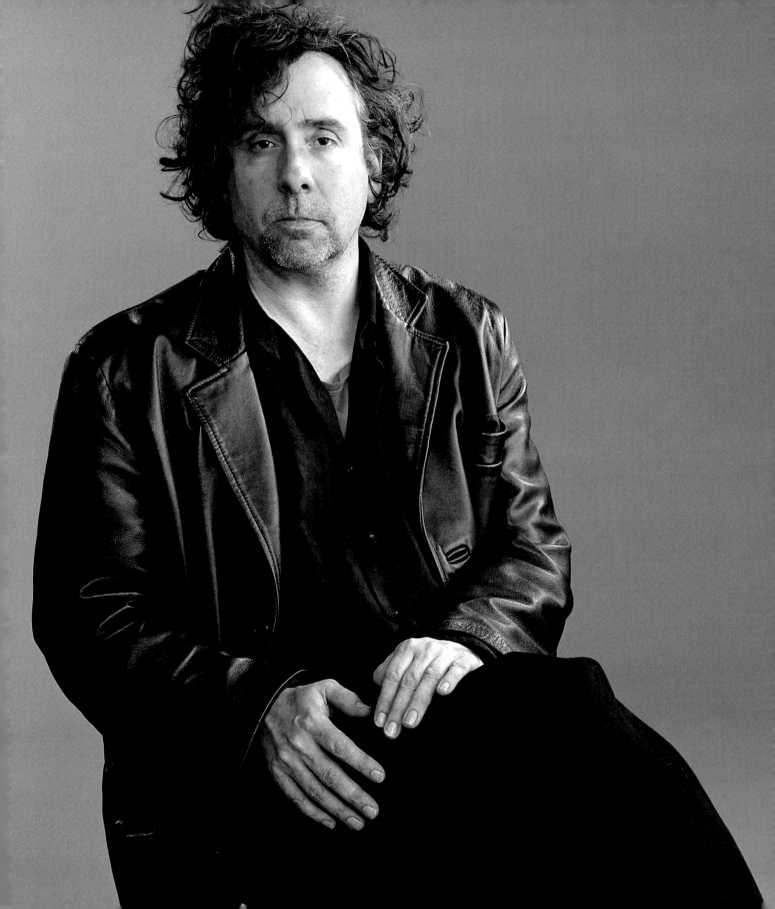

To get psychoanalytical for a moment, your classic Burton wacko cleaves into two types. Duality is the word Burton often uses. There are those wackos who reflect the man he is – the outsiders like Edward Scissorhands, concealing great talent and feeling misunderstood. And there are those with the personality he desires – extroverted and fearless like the Joker. In Johnny Depp, his great alter ego, both sides are explored.

Burtonesque also speaks of a tone. Burton's films might be distinctive, but they are almost impossible to categorize. *Batman* might appear to be a superhero movie, *Sleepy Hollow* a horror film. But they slip the bounds of their elected genre to become something else entirely. His films are often very funny without quite being comedies, sad without quite being tragic.

What's surprised me most in taking a magnifying glass to Burton's work is how much he has to say. Age, family, art, death, and even Hollywood figure as themes. Satire is one of many traits. *Burtonesque* can be very political, revealing a director infuriated by authority and class distinctions. American small-mindedness, as embodied by suburbia, is never far away.

This is arguably the most autobiographical canon in modern cinema, certainly in today's Hollywood. Tim Burton makes films about Tim Burton to please the Tim Burton trapped inside. In the man you will discover the inspiration for the films. Despite an aversion to interviews, he readily speaks about how films are like therapy, a way of working through the issues of his youth.

'Everyone seems grateful to him, particularly young people,' Helena Bonham Carter has said. 'He understands everyone's separateness and isolation, that feeling that you don't fit in or that you're different.'[3]

In other words, he speaks to all of us.

8

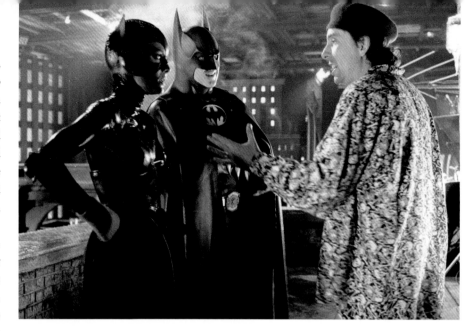

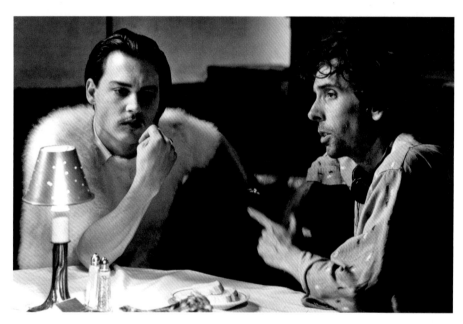

Above: Partners in sublime – Burton (right) confers with an angora-clad Johnny Depp during the making of *Ed Wood*. Depp would, of course, become the director's great alter ego.

Top: Tim Burton (right) discusses the finer points of superhero etiquette with Catwoman (Michelle Pfieffer) and Batman (Michael Keaton) on the steamy set of *Batman Returns*. While not easy to make, the sequel remains one of his finest films.

Opposite: Helena Bonham Carter (centre) during the shooting of *Sweeney Todd* with Depp (left) and Burton, who might as well be in costume. The film satisfied the director's long held desire to make a full musical.

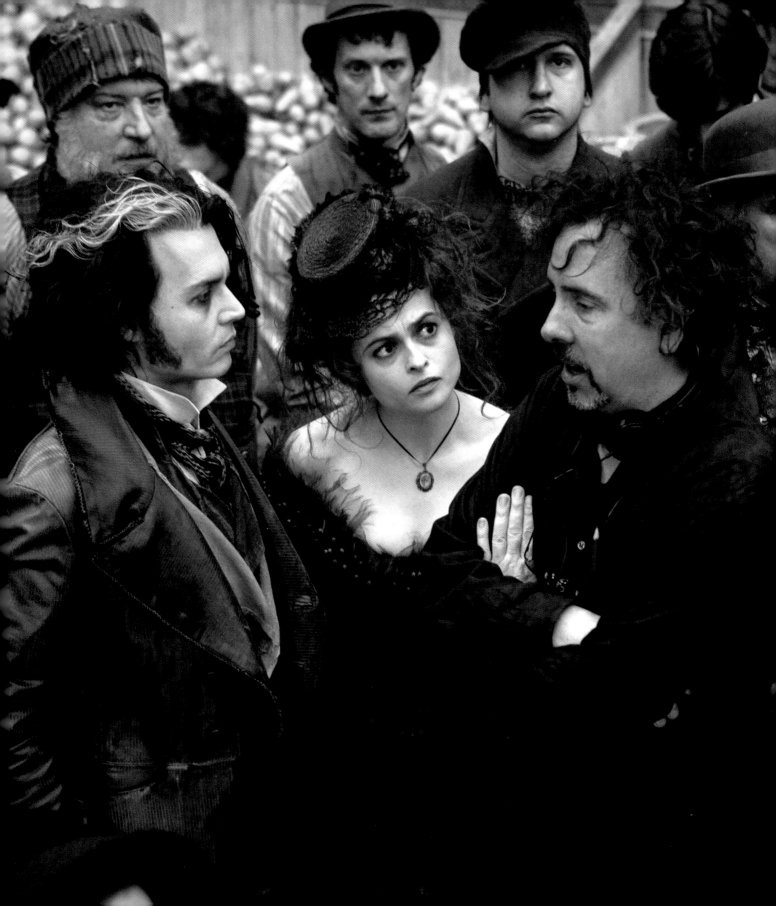

THE BOY WHO LIVED IN THE DARK
Escaping from suburbia

'I've always loved monsters and monster movies,' says Tim Burton, as if beginning the voice-over to his own biopic (*OddFella*?). 'I was never terrified of them, I just loved them from as early as I can remember.'[1]

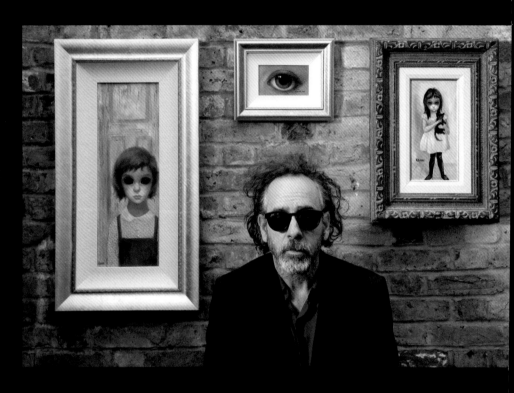

Above: An older, wiser, sunglasses-clad Tim Burton on the set of *Big Eyes*, framed by Margaret Keane paintings. He very much related to Keane's sense of being an outsider.

Monsters, he has always thought, are misunderstood. They have more heart than any of the humans you're supposed to root for; they're way more interesting. He can see himself in *King Kong* (1933), and *Dracula* (1931), and *Creature from the Black Lagoon* (1953), and the alien with the huge brain in *This Island Earth* (1955), and the skeletons that rise out of the ground to fight the Hollywood hunks in *Jason and the Argonauts* (1963). Burton once considered the perfect job was being

'the guy inside the Godzilla costume'[2]: he could spend all day fighting other monsters and wiping out cities.

He remembers how deeply he felt for Frankenstein in the classic James Whale version of 1931. Here was a monster who tried so hard to fit in, nevertheless the regular folk turned on him with pitchforks and flaming brands and chased him to a windmill and set it alight. '*Frankenstein* is one of the first movies I remember seeing,' Burton sighs, knowing he was never the same again[3]. ✪

CARL LAEMMLE presents

DRACULA

featuring
BELA LUGOSI, DAVID MANNERS
HELEN CHANDLER, DWIGHT FRYE
EDWARD VAN SLOAN
A TOD BROWNING Production
from the famous novel and play by BRAM STOKER · Produced by CARL LAEMMLE JR.
A UNIVERSAL PICTURE

THE SUPREME EXCITEMENT
OF OUR TIME!

IN COLOR BY
TECHNICOLOR

THIS ISLAND EARTH

2½ YEARS IN THE MAKING

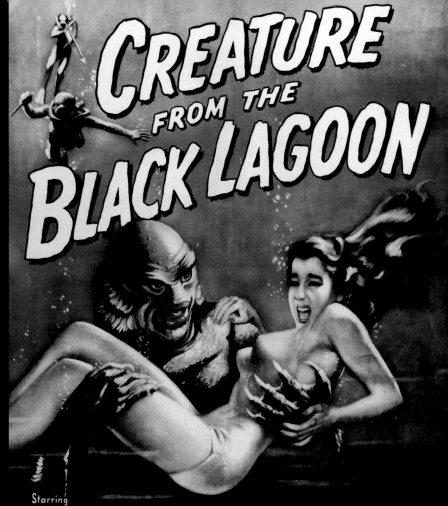

CREATURE FROM THE BLACK LAGOON

Starring
RICHARD CARLSON · JULIA ADAMS

with RICHARD DENNING · ANTONIO MORENO · NESTOR PAIVA · WHIT BISSELL

DIRECTED BY JACK ARNOLD · SCREENPLAY BY HARRY ESSEX AND ARTHUR ROSS · PRODUCED BY WILLIAM ALLAND · A UNIVERSAL-INTERNATIONAL PICTURE

Above: Growing up, Burton discovered the world of B-movies. Such films as Bela
Lugosi's *Dracula* (1931), monster flick *Creature from the Black Lagoon*, and the
mutant sci-fi of *This Island Earth* would have a major influence on his career.

11

Timothy Walter Burton first emerged from the dark at St Joseph's, Burbank, Los Angeles on 25 August 1958. Bill and Jean Burton made for an averagely American, upwardly mobile couple – a 1950s dream of normality housed in an identikit unit like the rows of pastel bungalows in *Edward Scissorhands*. Bill came from a baseball background: he played the minor leagues for the likes of the Fresno Cardinals, before injury forced him to retreat to the Burbank Parks and Recreation Department. Jean ran a gift shop, Cats Plus, which specialized in feline-themed merchandise. Burton has a younger brother, Daniel, now an artist, and of the few stories which include him, most significant is the time he smothered him in ersatz gore and pretended to hack him up with a knife. A terrified neighbour called the police.

Suburban Burbank, where Burton grew up, is on the northern flank of Los Angeles, over the hill that bears the Hollywood sign. He calls it the 'the pit of hell'[4]. The irony is that this is where three major studios – Warner Brothers, Disney and Universal – as well as the NBC television network create their magic, behind factory gates as impenetrable as those in *Charlie and the Chocolate Factory*. 'Movie capital of the world'[5], says Burton ruefully, but only streets away it's 'Anywhere USA'[6]. Amid the bland succession of houses, this introverted kid felt like he didn't belong.

'I was always a loner and spent a lot of time by myself, making up stories and that kind of thing,' he says, conveying a well-rehearsed picture of the childhood doldrums. 'We lived near a cemetery, so I'd like to go there and wonder about the scary guy who dug graves. I never really hung out with other kids and always found it difficult to really connect with people – in particular, girls. Looking back, it's kinda scary how solitary I was.'[7]

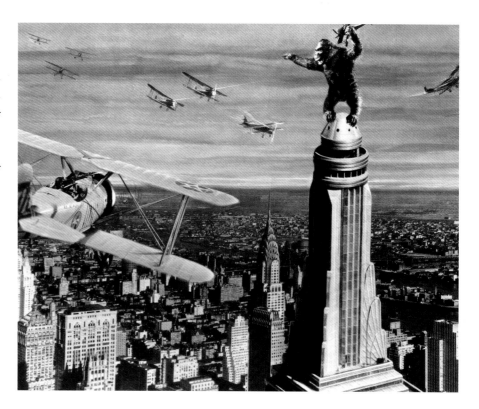

If you are searching for the key to Burton's psyche, how about the time his parents bricked up his bedroom windows? Growing up, his room had two perfectly good windows looking out on to the lawn. For some reason, his parents walled them up, leaving only a slit. He had to climb on a desk to see anything. 'I never did ask them why,' he admitted once. 'I guess they just didn't want me to escape.'[8]

Asked about this seminal event on another occasion, though, and Burton was a little less Grimm in his recollection. 'Yeah, they covered them up for insulation, supposedly. It was a suburban thing of keeping the heat in or something – they said the windows were letting in too much air. That's probably why I have always related to Edgar Allan Poe, who wrote several stories revolving around the theme of being buried alive.'[9]

Above: Burton always felt that monsters were misunderstood. Indeed, in films like *King Kong* (1933), he found the monster to be so much more interesting than the humans.

Opposite: The animator made good on the set of *Ed Wood*. Burton claims, when growing up it had never crossed his mind to try to become a director.

TIM BURTON

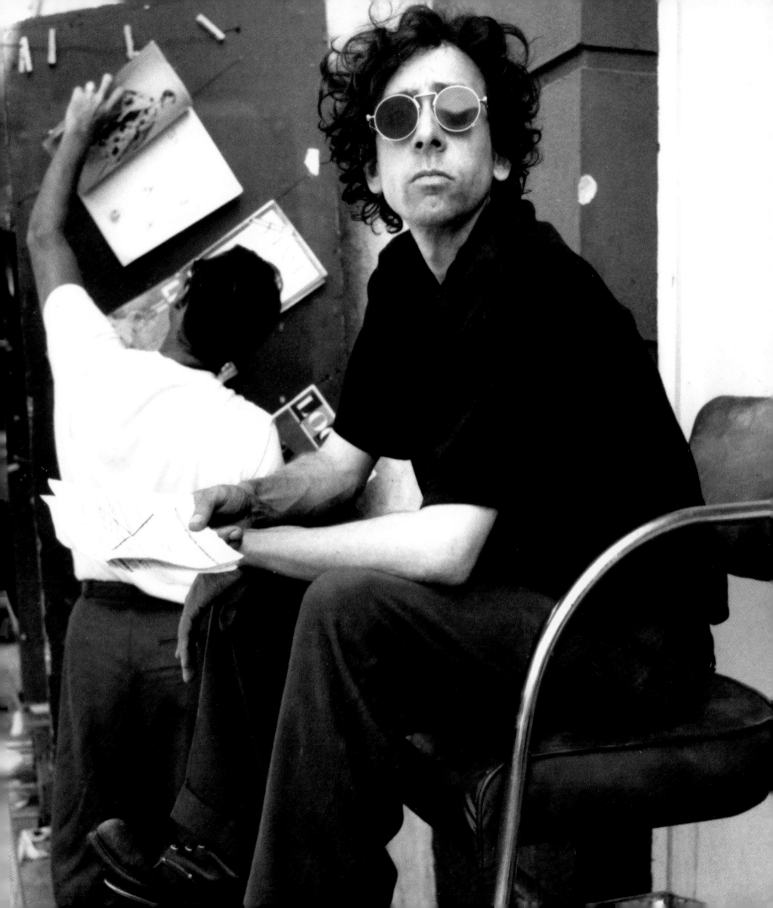

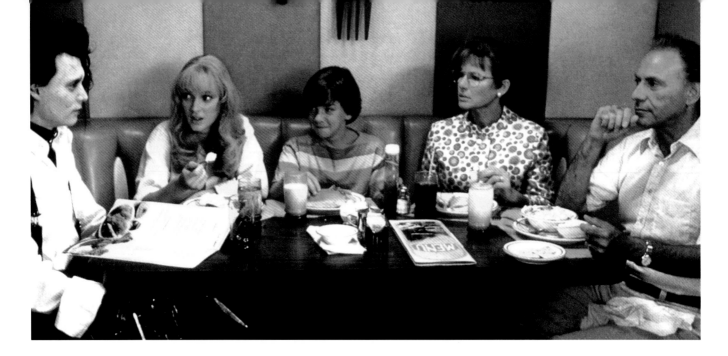

Poe has long inspired him. Through a host of poems and stories, the nineteenth-century writer (and son of actors) conjured macabre worlds where strange horrors lurked behind a thin veneer of normality. 'For me, reality is bizarre,'[10] insists Burton, whose films are suffused with Poe's dark romanticism, and his own collection of tales in verse, *The Melancholy Death of Oyster Boy & Other Stories*, is a direct homage.

Burton likes to enshroud his childhood in a gothic mist, like the beginning of a Poe short story or indeed one of his own films. The boy in the castle with scissors for hands, the bat in the mansion, the girl who tumbles down a rabbit hole – the suburban kid who ran away to become a director. Such self-mythologizing has made him so distinctive an artist.

His mother might have been quick to temper, and his father determined to run the household along puritanical lines, but these were all just and of a mild kind – as gently echoed in Alan Arkin's dinner table lectures in *Edward Scissorhands* (Bill Boggs was based on his father). His parents were good people,

Burton insists. He never really suffered any fairy-tale tyranny, confined to the attic like the undead Maitlands in *Beetlejuice*. There was simply this lack of connection with their eldest son.

'I know he feels there were painful conflicts between us,' Jean Burton told the New York Times in 1992. 'I think they were all from within. Tim was awfully tough on himself in many ways.'[11]

'Looking back on it now, it's pretty clear to me that my parents were depressed,' reflects Burton, 'and I always felt a deep, dark unhappiness permeating the air in their house.'[12] This was the quiet, floaty, semi-oppressive, blank palette which he filled with his imagination, inventing nightmares out of the everyday, the way Vincent Malloy, his stop motion alter ego in *Vincent*, dreams he has been 'possessed by the house and can never leave it again.'[13]

Between the ages of 14 and 16, Burton managed to escape, going to live with his grandmother not far away in Burbank. He maintains his grandmother saved him. At 16, he moved into his own apartment above

a garage she owned. He paid his way by bussing tables in a local restaurant. However tough movie-making would become, it would never be *that* bad.

Before his evening shift he would often hang out on Hollywood or Sunset Boulevard, gazing upon all the lost souls. 'Over there you would find tremendous sadness, pathetic people who had dreams but whose dreams had come to nothing,' he says. 'That melancholy touched me deeply, and stirred my imagination. It was the hidden face of Hollywood, the other side of the tinsel.'[14] ✪

Above: The Boggs take their peculiar new family member out to dinner in *Edward Scissorhands*. Alan Arkin's Bill Boggs (far right) was based on Burton's own father.

Opposite: The unfortunately undead Maitlands in *Beetlejuice*. The mild-mannered ghosts are outsiders in their own home, something to which the director (left) could relate.

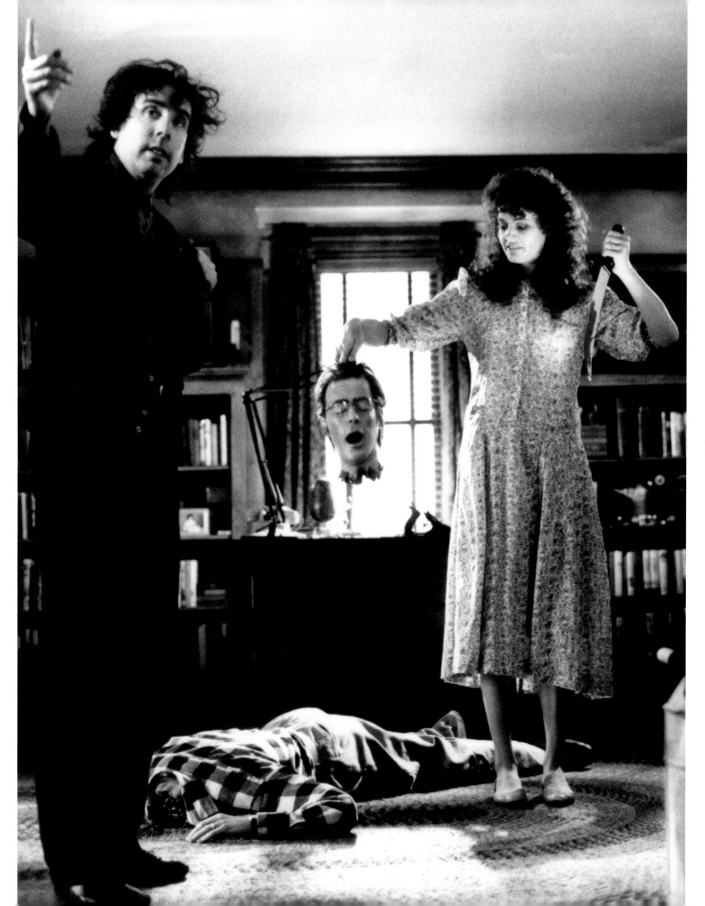

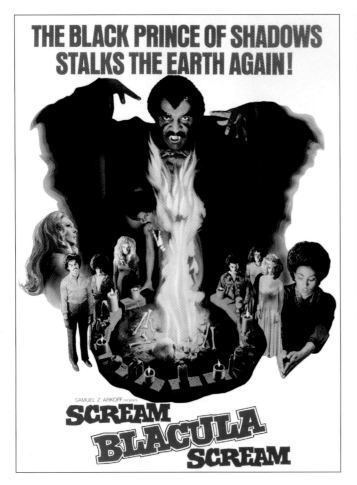

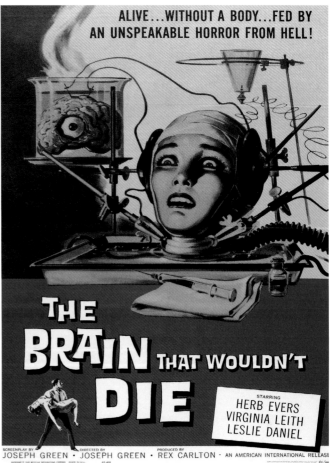

Above left: A classic poster for crazy blaxploitation horror flick *Scream Blacula Scream*, one of the many late night triple-bills Burton caught in local Burbank cinemas.

Above right: Even at a tender age, the gore in shockers like *The Brain That Wouldn't Die* never bothered Burton. When it was not rooted in reality, he found it strangely cathartic.

Looking back on his early years Burton says, 'I've always felt the same. I've never felt young, like I was a kid. I've never felt like I was a teenager. I've never felt like I was an adult.'[15]

Dressing in a brown leisure suit and bell bottoms, and listening to punk rock, he began an unsteady diet of Z-grade triple bills at the glut of Burbank cinemas: *Destroy All Monsters* (1968) plus *Scream Blacula Scream* (1973) and *Dr. Jekyll and Sister Hyde* (1971), with a tub of salted popcorn on the side.

Here lies the Burton foundation stone. All the disaster movies, samurai pictures, Japanese Kaijus, Italian giallos, desert epics, swashbucklers, blaxploitation, animations, noirs, alien invasions, biker flicks and

every last creature feature that fell into his gravitational pull – quality never a priority. 'There's enough weird movies out there so you can go a long time without friends,'[16] he laughs, to this day preferring a midnight movie to fancy studio screenings.

The gore never bothered him. In fact, he welcomed it: 'I grew up watching things like *The Brain That Wouldn't Die* [1962] on Saturday afternoon television. There's a guy with his arm ripped off and blood smeared all over the wall … I never saw it as negative. I find that stuff, when it's not rooted in reality, to be cathartic.'[17]

Above all there was Vincent Price. Born in 1911, Price was an art lover who began his

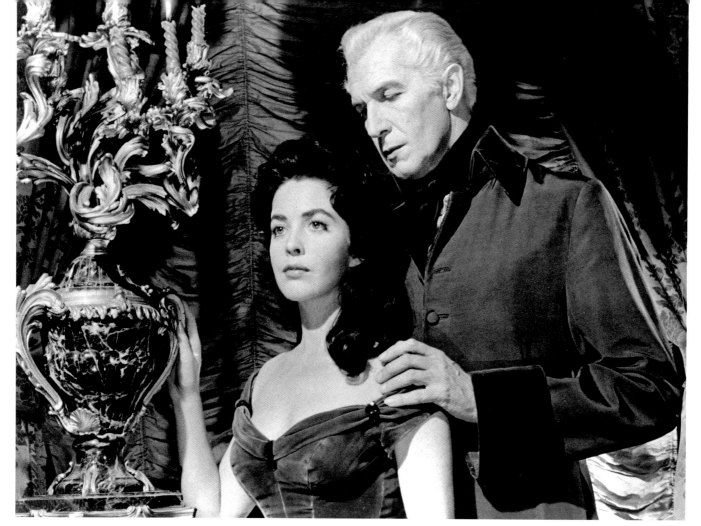

acting career with Orson Welles' Mercury Theatre Company, but nevertheless found his metier in horrors like *House of Wax* (1953) and *The Fly* (1958). His hangdog features, madly roving eyeballs, and withering cello-smooth voice made him ideal as the haunted protagonist. 'I saw all of his horror movies on TV,'[18] boasts Burton. Many were based on Edgar Allan Poe short stories, and there was something about those Poe melodramas he found cathartic: unseen demons, dying alone, going insane, being trapped and tormented in a rear room …

'I responded to Vincent's sincerity,' Burton says. 'I grew up feeling everything was odd and strange, and those films deal with that. They were like a symbolic version of life.'[19] The cobwebbed vault of the Corman-directed era of Poe adaptations starring Price – including *House of Usher* (1960), *The Pit and the Pendulum* (1961) and *The Masque of the Red Death* (1964) – stands as a testament to the rich depths to which B-movies could run. Such was Burton's devotion that he instigated a friendship with the ageing star, which bloomed into mutual appreciation. In 1991, he even began a documentary, *Conversations with Vincent*, which was sadly cut short by the actor's death in 1993. ✪

Above: Vincent Price, pictured here in *House of Usher,* was one of Burton's chief inspirations. He especially found the Edgar Allan Poe films symbolic versions of life.

THE BOY WHO LIVED IN THE DARK

Alongside his excursions to the cinema, the young Burton would sequester in his bedroom and draw huge schematics for epics and sci-fi movies featuring Martian invasions. If his parents complained, he drew all the more.

Burton is modest about his artistic talents (he considers them unconventional), but he has an evocative, creepy-crawly style in keeping with Edward Gorey and Charles Addams. And there were early signs he would prosper through his gifts. In ninth grade, he was awarded first prize in a local competition to design an anti-littering poster. It is amusingly apposite that his first public artistic gesture adorned the garbage trucks of Burbank.

At 18, he wrote *The Giant Zlig*, telling the story of approachable, Maurice Sendak-style monsters in well-sprung verse accompanied by colourful illustrations. Burton went as far as submitting *The Giant Zlig* to Disney for publication, a potential adaptation surely not far from his thoughts, and he kept the typed letter of rejection dated 19 February 1976. Giving her brief impressions, the kindly Jeanette Kroger, editor at Walt Disney Productions, was full of praise for his 'charming and imaginative characters.' She did, however, add that it 'may be too derivative of the Seuss works to be marketable—I just don't know.'[20]

Theodore Seuss Geisel, it's no great surprise, was a big influence on the developing Burton – not only in his affection for eccentrics, but also in his sublime marriage of illustration and narrative. Reading his books as a child, Burton would continue the drawings at the bottom of the page.

If there is a moment in his childhood that marked a glorious awakening to the possibilities of film-making, then it came simply as a way of dodging homework. Not much of an academic, instead of handing in a 20-page book report on Houdini, he made a Super 8 film in black and white, featuring himself repeatedly escaping railroad tracks. The resulting A grade is still among his best reviews. He would repeat the trick with other assignments.

In 1971, aged only 13, he made his first genuine film – *The Island of Doctor Agar*. Shot on Super 8, it is an unofficial adaptation of H.G. Wells' monster-experiment thriller *The Island of Doctor Moreau* (just as *Mars Attacks!* unofficially made sport of *The War of the Worlds*). There followed a wolfman movie, and a 'little stop motion film using model cavemen'[21] inspired by his almost visceral reaction to Harryhausen's technique Dynamation. Yet Burton maintains it never crossed his mind to try to become a director.

When he graduated Burbank High School in 1976, he won a scholarship to the prestigious California Institute of the Arts – known to everyone as CalArts. This is the school Walt Disney established in 1961 to train future generations of animators, although it offers a full programme of filmmaking studies. Burton specifically enrolled on the Disney animation programme, in the hope that it might eventually offer him gainful employment. There he felt himself to be among 'a collection of outcasts.'[22] ✪

Above: Burton directing *Beetlejuice*. This is the first time that critics and producers had paid attention to who was directing the film.

18

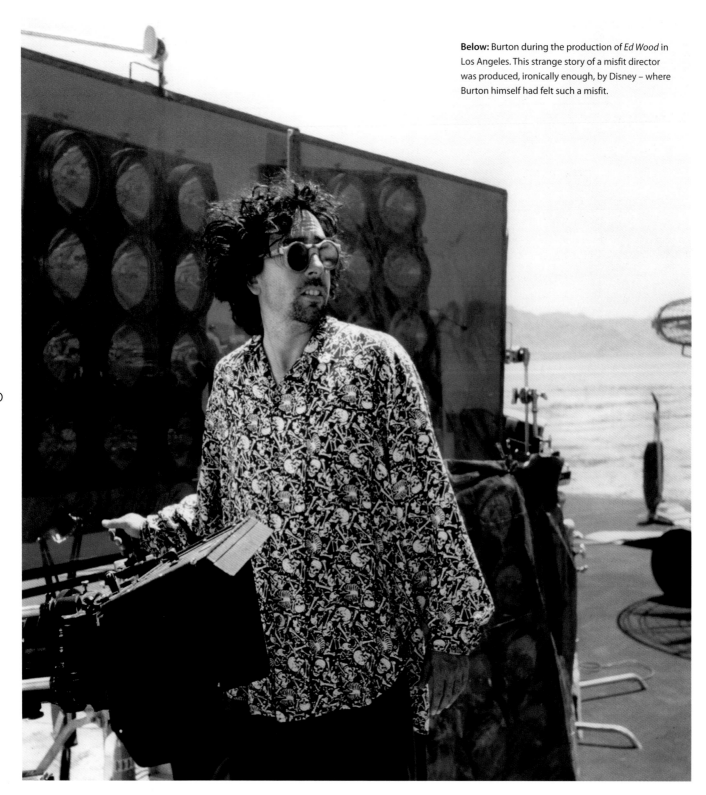

Below: Burton during the production of *Ed Wood* in Los Angeles. This strange story of a misfit director was produced, ironically enough, by Disney – where Burton himself had felt such a misfit.

TIM BURTON

CalArts in the late 1970s boasted a stellar crop of students. Huddled in the refectory, were such future giants of animation as Brad Bird, John Lasseter and Henry Selick. This is also where Burton met Rick Heinrichs, who has regularly served as his production designer and amanuensis to this day.

In their final year, animation students were asked to make a short film to demonstrate what they had learned. While most used the opportunity to show off a particular skill set, Burton caused a stir by entertaining everyone. A delightful animation in the style of mid-era Disney, *Stalk of the Celery Monster* tells the story of a creepy scientist, who is conducting experiments on a terrified woman. The twist at the end is that he is, in fact, her dentist, and these were manifestations of her neurotic mind. With something of the mischievous tone of *Mars Attacks!*, this is a rare dalliance in hand-drawn animation.

Also while at CalArts, he co-directed the 10 minute short *Doctor of Doom* with his friend Jerry Rees, who would go on to work on *Tron* (1982) and *Space Jam* (1996). This slight, black and white riff on *Frankenstein* is notable for featuring a rare onscreen performance from Burton as a hammy hypnotist (with his voice dubbed by Bird). Burton also supposedly did some uncredited work while still a student for Ralph Bakshi's uneven adaptation of *The Lord of the Rings* (1978).

Impressed by *Stalk of the Celery Monster*, Disney hired Burton as an animator, and he couldn't believe his good fortune. Wasn't this the dream scenario, to slip inside those gates and draw all day? Caught between regimes, Disney was in something of a creative lull, however, and Burton was put to work on the twee feature *The Fox And The Hound* (1981). It soon became clear how dreams could reveal themselves as nightmares. 'I couldn't draw all those four-legged foxes,'[23]

he winces. It felt as if he had joined the ranks of a factory production line. 'I would look out the window,' recalls Burton, 'and see the hospital where I was born, and the cemetery where my grandfather is buried.'[24]

He did manage to unbottle some of his latent creativity by completing sci-fi surfer film *Luau*, a spotty short that attempts to assemble Ed Wood-level dialogue, Russ Meyer-style exploitation, and anything Elvis did in Hawaii. Production had begun while still at CalArts, but Burton was ensconced at Disney when they eventually finished. Perhaps it's possible to catch an early glimpse of *Beetlejuice*'s genre-blending anarchy in its carnivalesque atmosphere and wacky make-up effects. Heinrichs, who worked on *Luau*, describes it as 'a pressure release valve for a lot of talented people.'[25]

You can't help but feel that Disney is perhaps portrayed too severely in the Burton life story – it's easy to picture a succession of faceless, authoritarian shop stewards thrusting a pencil into his grip. But Burton was just not Disney material, and his employers tried to help, offering him the plum chance to be a conceptual artist on a mythical fantasy called *The Black Cauldron* (1985), with the instruction to 'Go wild.'

He spent months dreaming up an extraordinary menagerie of creatures, stoking the flames of future phantasmagoria. There were birds, he remembers, 'and their heads would be like hands with eyes; instead of beaks there'd be hands grabbing you.'[26] None of his designs made it into the finished film.

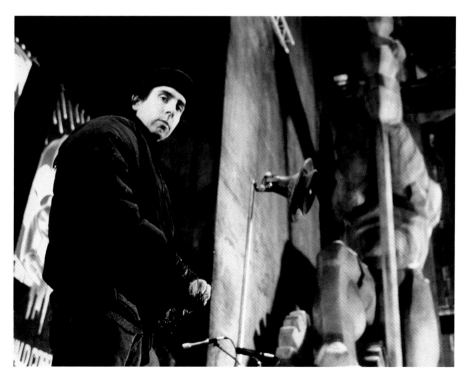

Left: Pictured during the difficult *Batman* shoot. As a struggling animator, Burton could never have envisaged that by only his third film he would be one of the biggest directors in the world.

THE BOY WHO LIVED IN THE DARK

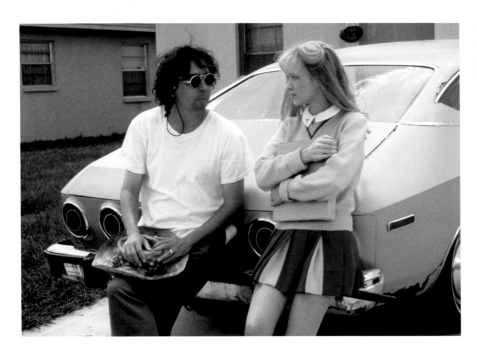

At this time, Burton produced a series of sketches for potential animated features. *Pirates* had weird exaggerated humans; *Alien* went with surreal outer-space life forms; *Little Dead Riding Hood* had a skeletal heroine; and he reimagined *Romeo and Juliet* as a romance between a land mass and an ocean. Most interesting is *Dream Factory*, a Hollywood satire featuring an abused stunt dummy, a dinosaur scriptwriter, and an imprisoned animator.

More signficantly, he drew up designs for *Trick or Treat*. Based on a screenplay by Delia Ephron, the project followed a pair of siblings on Halloween who encounter an actual haunted house. Not exactly Disney's thing, it was subsequently aborted. Still, it was on *Trick or Treat* that he met Julie Hickson from Disney's story department. Taken with Burton's unusual pictures, Hickson helped get the support for his first studio-backed ventures into directing – a series of formative shorts not quite what Disney had in mind.

Made in 1982, for $60,000, the wonderful, witty, visually inspired stop motion *Vincent* tells of the wild-haired seven-year-old Vincent Malloy, who bears a striking resemblance to Burton and lives in the suburbs. Emulating his idol Vincent Price, Vincent imagines himself isolated, beset by bats, wandering tormented through dark corridors and wiring electrodes to his dog.

Burton had hoped to show Disney that a stop motion feature was 'commercially feasible'.[27] But *Vincent* couldn't be less Disney, recalling the German Expressionist nightmares of *The Cabinet of Dr. Caligari* (1920), with weird tilted walls that we would see again in *Pee-wee's Big Adventure* (1985) and *Beetlejuice*. Marvellously, *Vincent* is narrated, in verse, by Price himself. Burton had simply written to his hero, enclosing a booklet of the script, and Price had accepted.

'I was so struck by Tim's amateur charm,' said Price, remembering the tyro-director with affection. 'I mean "amateur" in the French sense of the word, in love with something. Tim was in love with the medium, and dedicated to it.'[28]

Disney was very confused by the outcome. Did it have to be so very dark? After two weeks in a single cinema, and one showing on the Disney Channel, *Vincent* was buried alive in their vault, never to be spoken of again. Ironically, it won film festival awards at Chicago and in Annecy, France and is now considered one of the blueprints for *Burtonesque*.

Undaunted, Disney handed Burton $116,000 to make a live-action television special of Hansel and Gretel. Burton took an unconventional approach to the Black Forest fairy tale. His reimagining relocates to what can only be somewhere in Burton's mind, and is stocked with Japanese amateurs doing kung-fu (in tribute to his love of chopsocky). The innovation with special effects is what counts: the walls of the witch's house ooze bloody jam like a doughnut. The dumbfounded studio showed it only once, at 10.30 p.m. on Halloween 1982.

22

And still Disney gave him another shot. *Frankenweenie*, would set forth the 25-year-old Burton's manifesto: gothic atmosphere, suburban setting, misunderstood monster, horror and comedy blended like a smoothie. Here are motifs that would occur again and again: cute dogs, ugly trees, model work, and a burning windmill. Shot over 15 days in Pasadena, the 30-minute film centres on the young Victor (Barret Oliver), who figures out how to resurrect his recently run-over dog in science class, with Shelley Duvall and Daniel Stern as Victor's befuddled parents.

'I started thinking about how incredible the whole idea of Frankenstein really is, of bringing something dead back to life,'[29] says Burton by way of explanation.

Disney, again confronted with a kids' movie about death, were defeated. The scheduled release alongside *Pinocchio* (1940) was cancelled and, apart from a small run at some art-house cinemas, *Frankenweenie* was shelved – only to be remade as a more satisfying stop motion feature film in 2012.

'I have this reputation for being dark, which I don't think I really am,'[30] bemoans the misunderstood Burton. But he and Disney went their separate ways.

Almost back to square one, he was rescued by Duvall, who asked him to direct a television special of Aladdin and his Wonderful Lamp for her 'Faerie Tale Theatre'. It reconfigures the Arabian tale in Burtonland, but is otherwise quite impersonal.

Nevertheless, the idea of being a director was now firmly planted in his brain.

Below left: A promotional shot of reanimated mutt Sparky from *Frankenweenie*, Burton's darkly humorous take on *Frankenstein*. This short film, in effect, laid out a blueprint for his later career.

Below right: The fully formed director, complete with artistic beret, during the troubled shoot for *Planet of the Apes*. The conflict between art and commerce would be ever present.

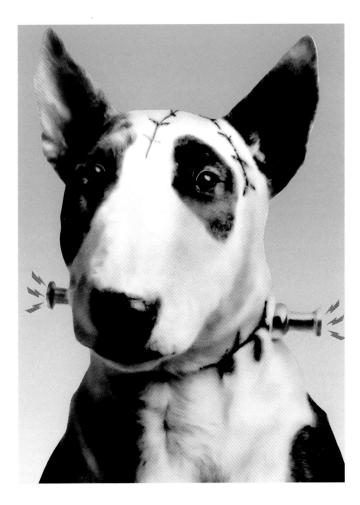

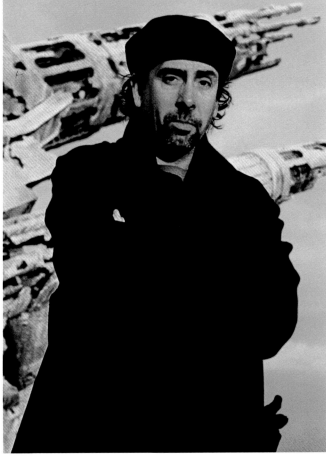

THE BOY WHO LIVED IN THE DARK

HAPPY HORRORS
Geeks and freaks

At the height of his popularity, Paul Reubens never stepped out of character. On talk shows, during interviews and at public appearances, he remained Pee-wee Herman, quirky to the point of derangement, clad in an undersized grey suit, red bow tie, 'déclassé' 1950s haircut, and what looked like lipstick – the MC of a Weimar-era nightclub spliced with Howdy Doody.

Pee-wee was an oddball right enough, and by the mid-1980s his Children's Presenter From Hell routine had enough of a groundswell to encourage Warner Brothers to commission a movie.

Born in New York, and raised in Sarasota, Florida, Reubens had attended CalArts in Los Angeles around the same time as Tim Burton, although neither can recall ever meeting. An extrovert, Reubens pursued comedy rather than filmmaking, creating an alter ego called Pee-wee. Inspired partly by Andy Kaufman's edgy antics and partly by the nasal twang he assumed performing juvenile roles in Sarasota rep, Reubens began to experiment with turning up to auditions as if he and this elfin crank were one and the same. (The name itself married a brand of harmonica with the surname of a 'weird kid' he once knew.) 'I always felt like Pee-wee Herman was performance art a little bit,' he says. 'I went to great lengths to make people believe he was a real person.'[1]

By 1981, Pee-wee had made walk-on cameos in 'Mork & Mindy' and *Cheech and Chong's Next Big Movie* (1980), and a series of guest appearances on 'Late Night with David Letterman' launched a nationwide tour. Then Warner called, and Reubens and co-creator Phil Hartman sat down to write a script that could somehow contain Pee-wee's outlandish persona in a plot.

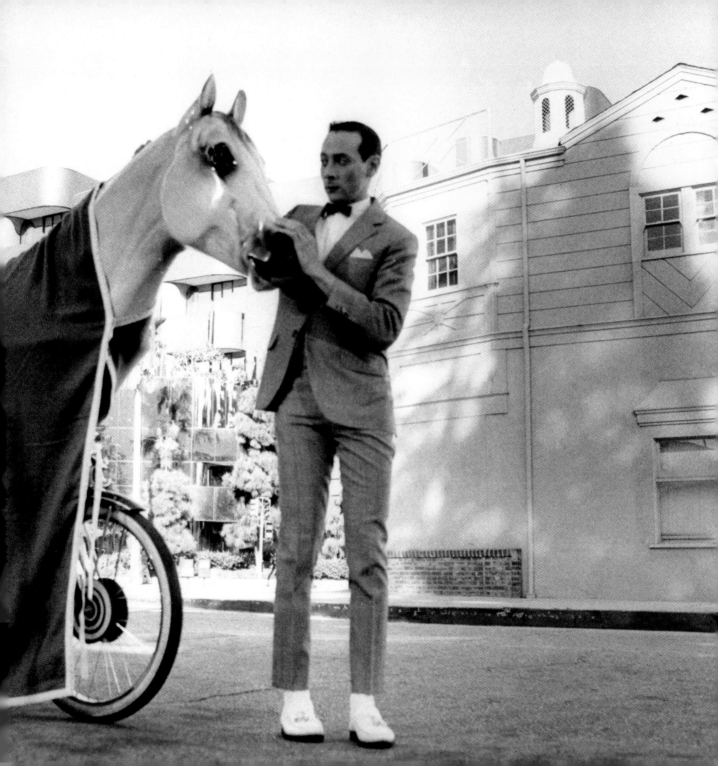

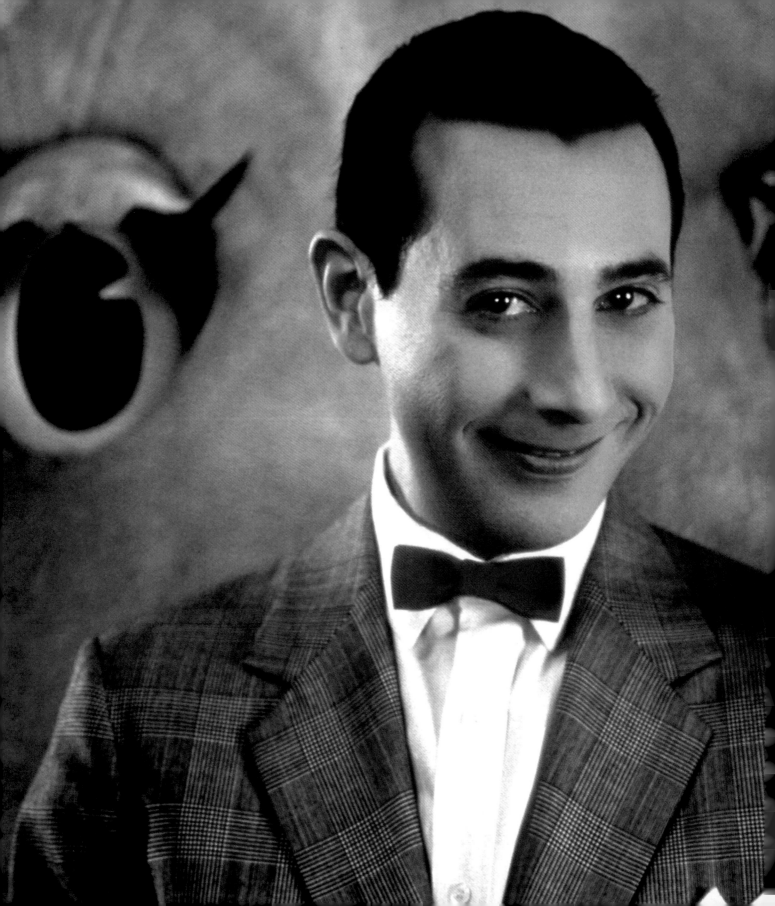

Pee-wee's Big Adventure

There are three versions of how Pee-wee and Burton came to make the perfect marriage. Certainly, a completed script was ready to go long before Burton was in the frame. Meanwhile, *Frankenweenie* producer Julie Hickson had transferred to Warner, and was once again lending her backing to the rise of Burton as feature film director by circulating a tape of the horror short among those that mattered. But the precise order of events has gained a pleasing layer of rose-tinted mythology.

First, there is the story Reubens likes to tell, with the full knowledge that Burton flourished into an A-list filmmaker. So: when it came to which director might possess the gumption to capture Pee-wee's peculiar comic tone, Reubens had drawn up a list of over 200 names and proudly handed it to the studio. In turn, the studio handed him their list, which contained only the one name. Reubens swears their choice was 'not right for it' (the director remains nameless) and, running the risk of Warner giving him up as a lost cause, begged for another week to track down the elusive magician. Overruling even his own manager, Reubens was emphatic: '… I spent fifteen years getting to this point. I gotta have the right director. Someone who can put their own stamp on it.'[2]

When a fellow party guest mentioned Burton's *Frankenweenie*, and that it starred his friend Shelley Duvall, Reubens got straight on the phone. 'Oh my god, Paul,' Duvall burst out, 'you and he are so perfect together.'[3]

'When I screened the short film the next day,' concludes Reubens, 'I knew in the first six shots that I wanted him to do it.'[4]

The second version of the story posits Mark Canton, president of production at Warner, as the driving force. 'As soon as I saw Tim's movie,' he recalls, 'I said I'd better meet with Tim.'[5] Impressed, he suggested Burton for this 'children's feature'. But Reubens resisted. Collaring the comedian at a party, Canton demanded he at least watch *Frankenweenie*. The rest is history. Or not …

The most fanciful yet resonant version of the story finds horror author Stephen King playing catalyst. A fan of *Frankenweenie*, he also knew Reubens. Well aware that the right director was needed – and fast – King passed his friend a VHS of the short film, convincing him that the untried director was perfect for his *Big Adventure*.

Whatever the case, Burton was genuinely a Pee-wee fan, having seen him perform live at the Roxy on Sunset Boulevard. He also loved the script – how it attempted every genre going, and never entirely made its mind up what was funny and what was plain weird. Still, he had his concerns. 'I didn't see what I could add of my own.'[6] ✪

27

Left: Tim Burton was already a Pee-wee fan before he directed the character's first movie. He really wanted to emphasize the fact that he hadn't known what was supposed to be funny and what was plain weird.

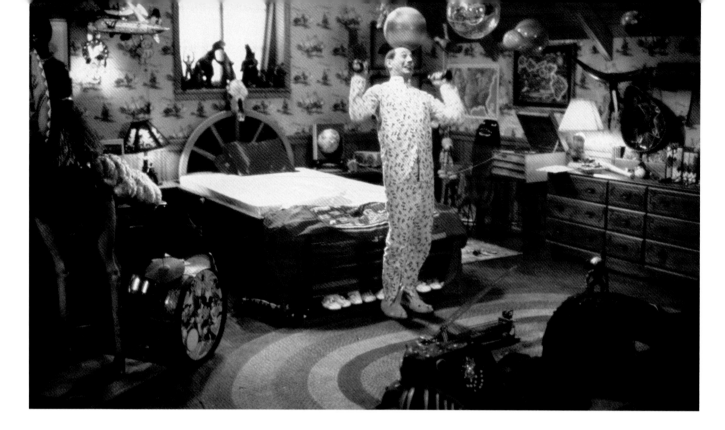

Shooting hurriedly in and around Los Angeles in the summer of 1984, they made do with a microscopic budget compared to the money Burton would wield only a few years later. And, while rudimentary in many respects, the resulting film displays Burton at his most ingeniously pennywise. He transformed pre-existing shops on Santa Monica Third Street into Pee-wee's regular haunts, and raided every thrift joint in the vicinity to decorate his quirky house. The crowd of extras for the Tour de France dream sequence ran to 35, including a local onlooker roped in to bolster the ranks.

'If it ain't bright, it ain't right,'[7] became the motto for the film's sunny style, reflecting Pee-wee's jaunty disposition. Which is ironic, given the underworld vibe for which the director became famous. Although, anyone who has seen *Mars Attacks!* and *Big Eyes*, will know that Burton's worlds come in shades of both light and dark.

Nevertheless, it is not exactly clear where Pee-wee ends and Burton begins. Which, perhaps, is the point. Outwardly, it would seem as if the director's wacky footprints are obvious: roadside dinosaurs, ghostly truck drivers, a biker-bar musical number. A magic shop proprietor's latest gizmos would be put to use in later films: the shrunken head in *Beetlejuice*; the squirting flower that is worn by *Batman*'s Joker.

And yet, the picaresque plot, parodying Vittorio De Sica's *The Bicycle Thieves* (1948) in Pee-wee's wild adventure across America to retrieve his stolen bicycle, had been completed before his arrival. 'Tim shot the 95-page script with only one change,'[8] says Michael Varhol, producer and co-screenwriter. That one change took place during the madcap chase across the Warner backlot that supplies the film's haphazard crescendo. Originally, Pee-wee blinds his pursuers in the studio's lighting department.

Instead, true to himself, Burton had Pee-wee cycle across the miniature set of a monster movie, where Godzilla battles Ghidora – a reference to Ishiro Honda's *Invasion of Astro Monster* (1965).

'I got to take the stuff that was there and embellish it,'[9] explains Burton. He followed the script as given, but began to layer in his own visual motifs, genetically unable to do otherwise, even for his first project. 'I walked into Pee-wee's Big Adventure and I felt one hundred percent connected to it. I understood it as mine, even though here was a character that was already created.'[10] ✪

Above: Reubens as Pee-wee commencing his morning routine amid the childlike paraphernalia of his bedroom. Elaborate set decoration would become a major feature of Burton's films.

TIM BURTON

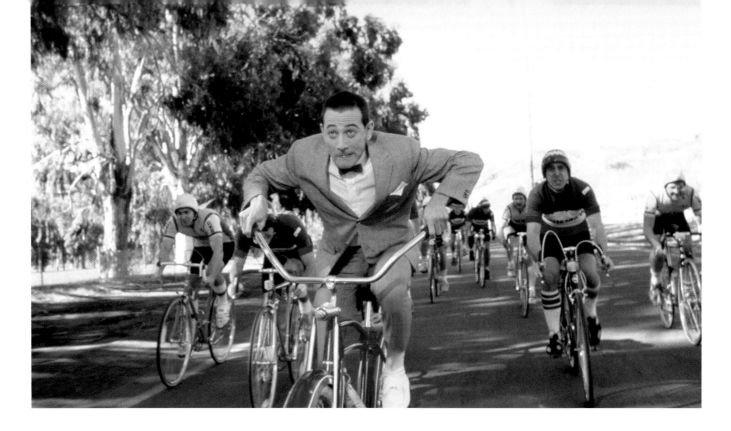

Above: Pee-wee triumphs in the *Tour de France* upon his beloved cherry-red Schwinn bicycle … in his dreams. Following its appearance in the film, the retro bikes are now highly sought-after.

Left: In its tale of the quest to retrieve a stolen bicycle, the madcap film parodies the plot of Vittorio de Sica's Italian neorealist classic *The Bicycle Thieves*. Any other resemblances stop there.

HAPPY HORRORS

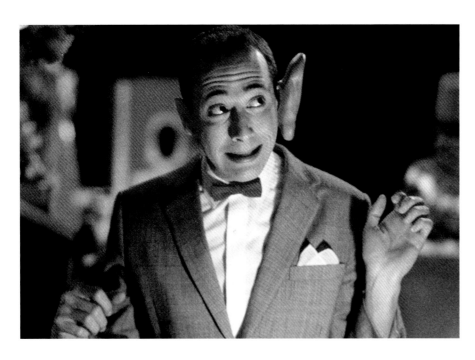

Left: While *Pee-wee's Big Adventure* was written supposedly to be a comedy, like many of the Burton films that follow, it is also a film that is entirely unclassifiable.

Opposite left: Critics likened Reubens' performance as the antic Pee-wee to the goofball charms of the American Jerry Lewis in films like *The Nutty Professor* …

Opposite right: … as well as the French actor Jacques Tati and his famous bumbling, monosyllabic, pipe smoking alter ego Monsieur Hulot. Both were marked by a strange aura of innocence.

30

Pee-wee's Big Adventure attempts as many styles as it has locations, although none more than 48 kilometers (30 miles) from the studio – The Alamo was recreated at the architecturally similar San Fernando Mission. Which, to Warner's dumbfounded delight, also led to a big hit. The critics may have been mixed – he was likened to David Lynch by some, while others found its crackpot juvenilia unbearable – but the film cost a miniature $7 million and made more than $40 million. However, diagnosed in hindsight, the film serves as a set of preliminary sketches of the ingredients that would flavour *Burtonesque*:

Dream Sequences

Even though all of it could be described as surreal, the film actively swaps reality for Pee-wee's dreams at several points. Events open with his fantasy of triumphing in the Tour de France on his beloved bike. While suffering concussion, he has a very *Burtonesque* nightmare about satanic clowns dismantling his bike, amid sets resembling those Dali created for Hitchcock's *Spellbound* (1945). Burton also plays on Hitchcock's *Vertigo* (1958), with swirling animated bicycle wheels to stress Pee-wee's stricken state of mind. Dreams and their ilk (thoughts, visions and flashbacks) will occur throughout Burton's work from *Ed Wood* to *Sleepy Hollow*, while *Alice in Wonderland* can be read entirely as a nightmare.

Stop motion Animation

The truck driver Large Marge (in person an unblinking Alice Nunn) is often cited as the key moment of proto-Burton. Picking up a hitchhiking Pee-wee, the film switches into a quasi-horror mode as this undead trucker's haggard face mutates momentarily into a stop motion corpse with bulging eyeballs straight out of Burton's sketchbook. She then resumes talking as if nothing is amiss – literally deadpan. The effect sends audiences reeling. If they had had the budget, Burton would have loved to have done much more than the tiny 36-frame sequence created by *Vincent* veteran Stephen Chiodo using clay moulds of Nunn's face.

The cobbled-together nature of the special effects would become a Burton tradition. *Beetlejuice* revelled in them, *Batman* was criticized for them, and *Mars Attacks!* went as far as replicating herky-jerky key-frame animation in glossy CGI.

Rock Stars as Themselves

That's Twisted Sister whose video is rudely interrupted by Pee-wee. Elsewhere, Alice Cooper will take a bow in *Dark Shadows* and Tom Jones be blown off his stage in *Mars Attacks!*.

An Unpredictable Tone

While identifiable as a comedy, *Pee-wee's Big Adventure* wanders off this chosen path into the hinterlands of horror, musical and something entirely unclassifiable. Like many so-called comedic characters in the Burton universe, Pee-wee veers between funny ha ha and funny peculiar with alarming abruptness (think of the spasmodic moods of both Beetlejuice and the Joker).

Likewise, here is the inception of Burton's habit of situating his films out of sync with their times. The central cherry-red Schwinn bicycle, like much about Pee-wee himself, cling to the 1950s, a sense of temporal dislocation that haunts everything from *Batman* to *Dark Shadows*.

A Childlike Perspective

Such is the mixture of kitsch decoration, borderline creepiness and real-world satire that Pee-wee almost serves as a prototype for Edward Scissorhands. Tittering like a schoolgirl, he's hardly a sad sack, but he possesses a similarly childlike temperament, and so exaggerated and repetitive are his mannerisms that they seem unreal. Pee-wee's collection of Rube Goldberg-style contraptions predict those assembled by Edward Scissorhands' Inventor.

New York Times critic Vincent Canby witheringly noted Pee-wee's likeness to bumbling French man-child Jacques Tati and that all-American goofball Jerry Lewis: 'like them all, he desperately wants to be funny but, unlike them, he isn't.' That said, Canby rather misses the point that Pee-wee's forced humour is a deliberate part of his make-up – his lack of self-awareness is quite terrifying.

The Personal Connection

'I have to connect,' avows Burton again and again when asked what draws him to material. He has to relate to the characters. More than that, he has to recognize himself within them. Although Pee-wee is as wild and free as the director is shy, Burton still understood him. Pee-wee is his first great outsider, a figure that would reoccur in many shapes and guises: Edward Scissorhands, Jack Skellington, Ed Wood, Alice, Barnabas Collins, et al.

'He operated in his own world,' confirms Burton, 'and there is something I find very admirable about that. He's a character who is on his own, who is able to operate in society, and yet is also a sort of outcast … In some ways there's a freedom to that, because you are free to live in your own world.'[11]

Beetlejuice

'I've made a burlesque version of *The Exorcist*,'[12] giggled Tim Burton, interviewed in Paris in 1988. He was attempting to capture the essential nature of his second film. It is a decent enough description, and certainly better than the director's previous claim that his new film was a 'flat-out nothing'[13].

Beetlejuice was the first time that critics began to pay attention to Burton as a distinctive creative force. The reviews ranged from the archly snooty to the boundlessly enthusiastic, but they were all tripping over each other to coin catchy slogans for the film's cocktail of madcap humour and matters of life and death.

Writer David Breskin called it 'pie in your face existentialism'[14]. Biographer Ken Hanke preferred 'backyard gothic'[15]. *Chicago Sun Times'* less than enthusiastic Roger Ebert offered 'Cartoon surrealistic'.

As the film became another unexpected hit making $73 million (soon enough, studios learned not to *expect* anything with Burton), he enjoyed the surreal sight of newscasters having to get their perfect teeth around the word 'Beetlejuice': 'It was like the feeling I got when I saw Andy Warhol on "The Love Boat".'[16]

Characteristically back to front, *Beetlejuice* is a ghost story turned inside out:

a normal, if recently deceased, New England couple (the Maitlands) must rid themselves of the ghoulish clan of the living (the Deetzes) who move into their old house in the town of Winter River. The Maitlands' attempts at haunting them proved ineffectual (and they are required to put in a 125-year-long shift – it's all in the *Handbook for the Recently Deceased*). Frustrated, they unwisely call upon the services of the titular 'bio-exorcist' to rid them of these turbulent pests. Then all hell really breaks loose. All of which adds up to a hilarious film about death.

'I can't figure out why it is I constantly respond to things on an intellectual level that are basically so stupid,' shrugs Burton. 'When I get material like *Beetlejuice*, I'm hooked.'[17] ✪

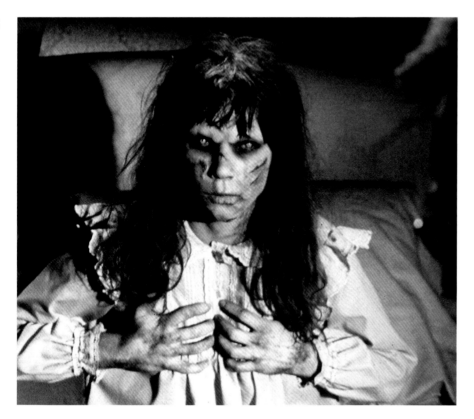

Left: Linda Blair as long suffering Regan in William Friedkin's classic tale of demonic possession *The Exorcist*. Tim Burton liked to laugh that he had made the 'burlesque' version with *Beetlejuice*.

Opposite: Michael Keaton as the literally immortal Betelgeuse. The character was completely transformed by Keaton from the more straightforwardly villainous figure in the script.

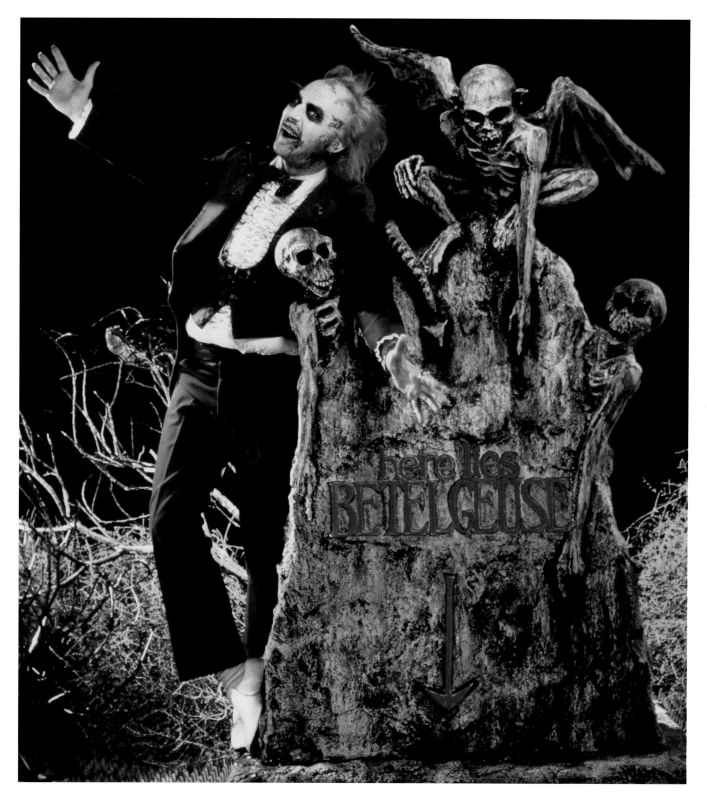

HAPPY HORRORS

It had taken a surprisingly long time for Burton to direct his second movie. Scripts had come and gone, but he had been unable to find that necessary connection. Everything had seemed some prima bland concoction with the word 'adventure' in the title. There was even a talking horse project called *Hot to Trot*. 'I was freaking out until the script for *Beetlejuice* came along,'[18] he admits.

Burton had filled some of his hiatus with a brief sojourn back to television, working on a pilot for the Steven Spielberg-produced animated series 'Family Dog' and directing *The Jar*, an episode of the 1985 NBC revival of 'Alfred Hitchcock Presents'. Based on a short story by Ray Bradbury, this story of a cursed amphora, set in the snotty art world, is almost a straight-laced precursor to *Beetlejuice*. They do share the same writer, horror author Michael McDowell.

David Geffen, the record label mogul who had a film production company at Warner, came to Burton with McDowell's *Beetlejuice* script, the story co-conceived with producer Larry Wilson. He was immediately struck by its perverse nature: 'I'm for anything that subverts what the studio thinks you have to do,' he says.[19]

Not that it was weirdness for its own sake. In Burton's hands, and through a rewrite by Warren Skaaren, the film offers a satire on Reaganite America: the Maitlands' small business ideal vs. the Deetzes' galumphing moneybags real estate speculation and phony avant-garde art. Betelgeuse himself represents private enterprise in the face of the corporatized afterlife. And this is a film that wants to laugh in the face of death.

'What I'm reacting against is people expect to be taken care of when they die,' says Burton, who would later make a cameo in Danny DeVito's *Hoffa* (1992) as a corpse in an open coffin. 'Which I find like giving up on life.'[20] His work rarely engages with any conventional notion of religion. Then, apart from forcing him to attend Sunday school for a few years, his parents had never been religious.

Once again, he felt in sync with 'all the strange images and characters and the way they float in and out'[21]. He liked that it didn't seem to be one genre or the other. And to contrast with the quaint New England backdrop of Winter River, where the Maitlands' clapboard home bears an uncanny resemblance to the house in Hitchcock's *Psycho* (1960), he could dream up an entire world of the dead. ✪

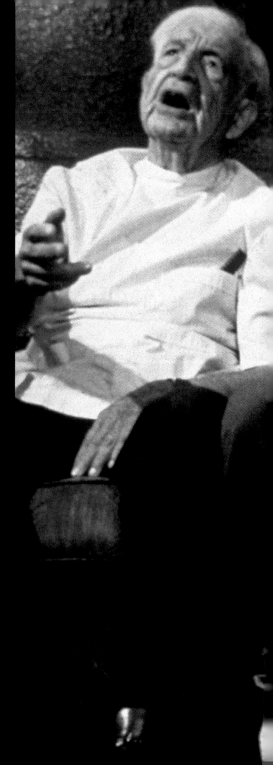

Left: Burton's passion for wacko individualists such as Betelgeuse is one of the reasons he was drawn to making the film. He was attracted by how different these characters were from his own personality.

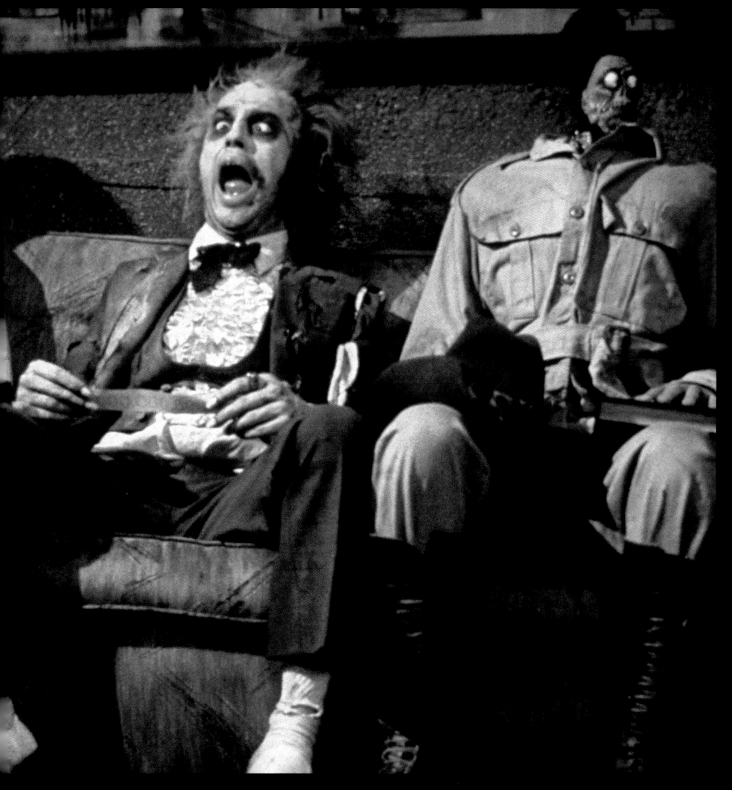

35

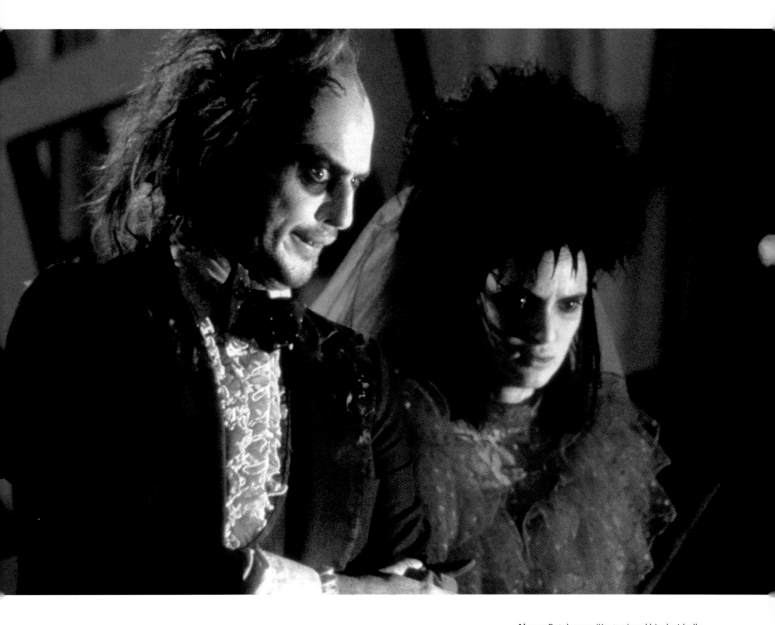

Above: Betelgeuse (Keaton) and his decidedly reluctant bride-to-be Lydia Deetz (Winona Ryder). Feeling very much disconnected from her awful family, the uppity Lydia is the story's representative of Burton himself.

TIM BURTON

Beetlejuice sets into motion an approach that became the guiding principle of *Burtonesque* – the way he gives 'voice' to a project via the fantastical world he imagines for it. The characters are as much a part of the fabric of these worlds as the sets and special effects. They often define the look: Betelgeuse is the vulgar embodiment of this scuzzy afterlife.

With $13 million in his pocket, he began a technically demanding but relatively happy ten-week shoot on the Culver Studios lot at Culver City, with ten days on location in East Corinth, Vermont, as the site of Winter River. What made the shoot difficult was the decision to create the effects shots *during* production wherever possible. This was both to save on budget – they had a miserly $1 million set aside to fulfill the 300 effects shots – and to satisfy Burton's

unconventional vision. 'It was hair-raising and exhausting,'[22] recalls visual effects supervisor and longtime collaborator Rick Heinrichs. They were using methods that went back to the silent era, and the whole production would regularly grind to a halt because of an uncooperative cable or motor.

The line between Burton's beloved models and reality is deliberately muddled. Over the opening credits, echoing *The Shining*, we fly across the New England countryside, which then (just about) seamlessly dissolves into the model of Winter River, that Adam (Alec Baldwin) is building. Production designer Bo Welch calls it 'a hierarchy of reality that leads you into unreality.'[23]

'They are, in a sense, a step *backward*,' admits Burton, who likes to think that this gives his special effects more humanity. 'They're crude and funky, and also very

personal.'[24] In other words, deliberately corny. 'We were conceptualizing the stupidest concepts,'[25] delights Burton: bannisters that transform into giant snakes, statues that come to life, severed heads that pout, and Geena Davis rearranging her face so her eyeballs gape out of her mouth. Here is an early signal of phantasmagoria of *The Nightmare Before Christmas*.

For every outlandish idea, there is an equal and opposite matter-of-fact response. Lydia Deetz (Winona Ryder), a misunderstood goth teen cut from the Burton cloth, takes an unruffled attitude toward Maitlands, which embodies the film's lackadaisical attitude toward the supernatural. Likewise, the afterlife itself is depicted as an overburdened bureaucracy, where the Maitlands are assigned Sylvia Sydney's Juno as their testy caseworker.

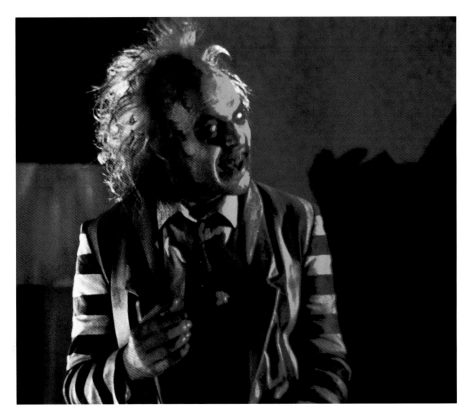

Left: At the heart of Burton's aesthetic is a childlike predilection for stripy, chequered or spotted clothes or surfaces. To which you could add goggles, umbrellas, bow ties, top hats, bat-shapes, and pumpkin heads as fashion statements.

HAPPY HORRORS

The waiting room (heavenly or otherwise – the *Handbook* doesn't specify) is chock-full of bored stiffs, and stands as one of Burton's most celebrated creations. Inspired by Terry Gilliam's *Brazil*, here the staff are consumed by mountains of paperwork. But it is the recently dead, born out of Burton sketches, who are so unforgettable: a magician's assistant who has literally been sawn in half, the charred corpse of a smoker, and a game hunter with doleful eyes whose head has been absurdly shrunken to the size of a baked potato. In fact, Burton overran with potential deceased beyond the means of the budget, including an actor in a Godzilla suit with a model plane lodged in his head.

The sequence also demonstrates Burton's lax approach to interior logic. Where all the other victims in this purgatorial lounge bear the hallmarks of their demise, Barbara and Adam show no signs of the car crash that killed them.

Similarly captivating, despite only 17 and a half minutes of screen time, Michael Keaton's Betelgeuse provides the film's deranged heartbeat. Burton would later say that his passion for wacko individualists was the reason he wanted to do the film. 'I love extreme characters who totally believe themselves,' he says. 'That's why I had fun with Betelgeuse.'[26]

The studio had resisted Burton's initial idea to cast Sammy Davis Jr. (then 62) as Betelgeuse and give the character a cheesy Vegas lounge lizard vibe. Instead, Geffen suggested Keaton. Burton had no idea who he was, but agreed to meet and recognized straightaway just how right he was (a pattern that would be repeated with Johnny Depp on *Edward Scissorhands*). His roving eyes suggested white waters coursing beneath.

But Keaton, who had made four films in a row, turned them down. He really didn't

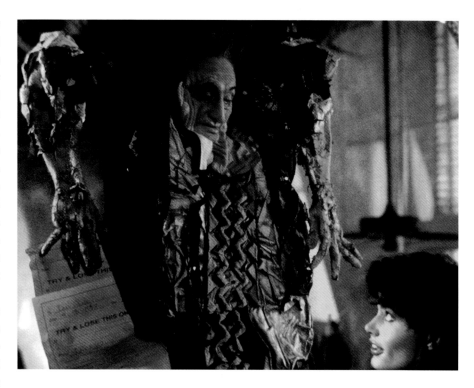

get the script, and he really wasn't in the mood. Originally, the character was Middle Eastern and more overtly sinister. Burton insisted that he was completely open to whatever Keaton might make of him. Invited to create his own shtick, the actor began to assemble the concept of this bug-chewing hobo wizard without a pulse.

Betelgeuse has no interior life – everything is on the outside. The voice, like a chain-smoking Bugs Bunny, is deadbeat and hyperactive. The plug-socket hair reflects a hebephrenic mindset so extrovert he could have been a *Batman* villain. His complexion is that of a rotten corpse, with moss and mould growing on his face and hands.

It took three weeks to come up with the appalling finished look, and Keaton loved it – he had never been so transformed before, and it unleashed his inner ghoul. (It would win an Oscar for make-up artist Ve Neill.) "You just show up on set and go fuckin'

nuts,"[27] says Keaton. There was also an element of wish fulfillment for the director: the likes of Pee-wee, Betelgeuse, and the Mad Hatter offer Burton another, preferable version of himself. If Burton himself is more akin to the internalized Lydias and Batmans, these liberated egos exhilarate him. In his array of prison-bar suits and crumpled velvet tuxedoes, Betelgeuse is a sure signal of the Joker just around the corner, and has had a more lasting impact. There have been other Jokers, there has only been one Betelgeuse. ✪

Above: The waiting room to the afterlife is one of Burton's most celebrated creations. All the recently deceased, bearing the hallmarks of their demise, were inspired by an extensive series of sketches by the director.

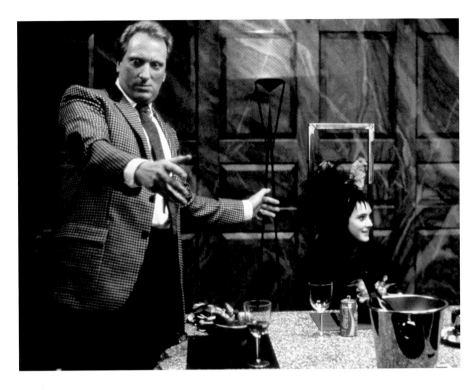

Okay, Beetlejuice or Betelgeuse? McDowell had named both film and the character Betelgeuse after the eighth brightest star in the night sky. The name also refers to the name of one of the 'benign gods' in H.P. Lovecraft's Cthullu mythos. While the character retained the correct spelling, the film took the more approachable how-to-pronounce-it version McDowell had provided for studio execs.

Inevitably, Warner struggled with even 'Beetlejuice', calling high-level meetings where they talked it through with their weary director. 'As a joke I said, "Why don't we call it Scared Sheetless?" When he suggested 'House Ghosts', the studio perked up. 'I was like, "Oh, man, straight to video."'[28]

Thankfully, the name *Beetlejuice* stuck, with its delicious suggestion of stellar otherworldliness mixed with gross effluent (literally, the juice of a beetle) and the film became a cult classic.

A sequel, *Beetlejuice in Hawaii* (or *Beetlejuice Goes Hawaiian*) was actually written by Jonathan Gems across 1990–1991. The abandoned concept took the bio-exorcist to Hawaii of all places, where Charles Deetz is developing a hotel complex on an ancient burial ground. It was to be a German Expressionist beach movie. Burton hints that he still has a sequel in his plans, including rumours of *Beetlejuice in Love*.

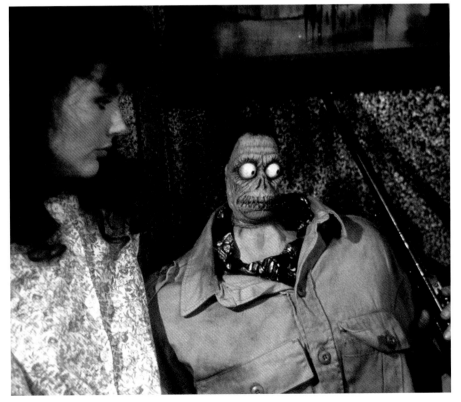

Above left: Jeffrey Jones as real estate player Charles Deetz possessed by the urge to sing Harry Belafonte's *Banana Boat Song*. The heavily improvised scene would require the hurried creation of puppet shrimp.

Left: Geena Davis, as pragmatic ghost Barbara Maitland, goes eyeball-to-eyeball with the, perhaps, even unluckier game hunter who has had his head shrunk, bizarrely while still connected to his body.

HAPPY HORRORS

STRANGE HEROES

Superheroes and fairy tales

In 1978, when Tim Burton was still busily not fitting in at school, he took a trip to Comic-Con. It was still months before the opening of Richard Donner's big-budget adaptation *Superman: The Movie*, but there, at the San Diego fan convention, the boy who would grow up to be a headline act was amazed to find Warner Brothers giving a slide-show presentation promoting their forthcoming blockbuster.

Even then, long before the proliferation of superhero movies, the ballroom was packed to the gills. Beneath unkempt fringes, gimlet eyes glared at the screen as a Warner foot soldier endeavoured to elaborate on Donner's sunny vision for DC Comic's most famous superhero. Scepticism was hanging in the air like poisonous gas, but it still came as a shock when one outraged fan sprang to his sneakered feet and began screaming. 'Superman would never change into his costume on a ledge of a building,' he shrieked. 'I'm going to boycott this movie and tell everyone you are destroying the legend!'[1] And with that, he stormed from the hall followed by a thunderclap of applause.

'From that moment on,' recalls Burton, 'I always knew in the back of my mind the enormous problems facing anyone taking on a film version of a comic-book hero.'[2]

Right: Tim Burton was seeking a new kind of *Batman* experience that combined the comic-book heritage, the new, darker graphic novels, and the director's own experience of the television show.

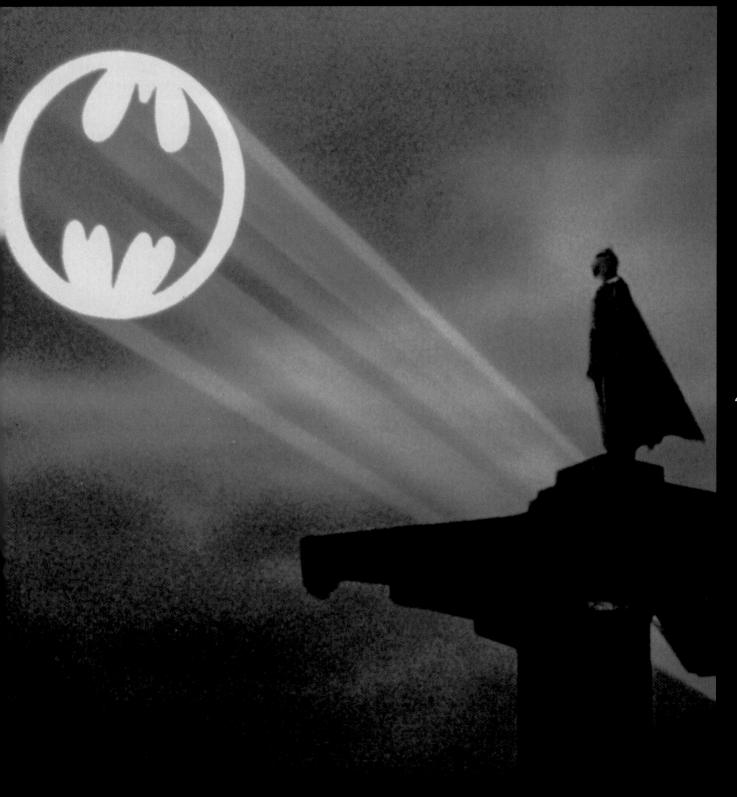

41

STRANGE HEROES

Batman

'Batman and the Joker, the two of them together,' reflects Burton, savouring the image that inspired him to enter the perilous world of comic-book adaptations, 'they are perfect complements; they are perfect as images.'[3]

And yet, the opportunity to pair these iconic characters was struggling to find its feet at Warner. Seven years had passed since producers Mike Uslan and Benjamin Melnicker had purchased the rights from DC Comics, ready to follow the success of Donner's *Superman* with the next most famous superhero in the comic-book canon. The idea was to adapt the origin story set down by creators Bob Kane and Bill Finger in 1940 and cemented to most fans' satisfaction in a series from the late seventies written by Steve Englehart. Englehart pointed to the murder of Bruce Wayne's parents as the motivation behind the character's dual-identity. In the new film, Batman's arc would be paralleled by the rise of his nemesis – the Joker.

In 1981, Melnicker joined forces with producing partners Peter Guber and Jon Peters, and a deal was done at Warner for a budget of $15 million. By 1983, the budget was up to $20 million. Over the years there were ten writers and ten different scripts, each stalling over budgetary issues or a creative impasse. Then Guber and Peters were introduced to Burton, who was preparing *Beetlejuice* on the Warner lot. Peters was impressed: 'He had a passion for *Batman* and a desire to do something completely different with it.'[4]

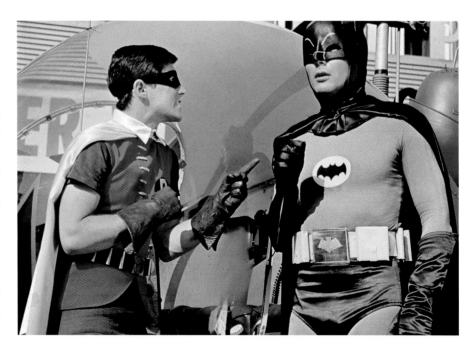

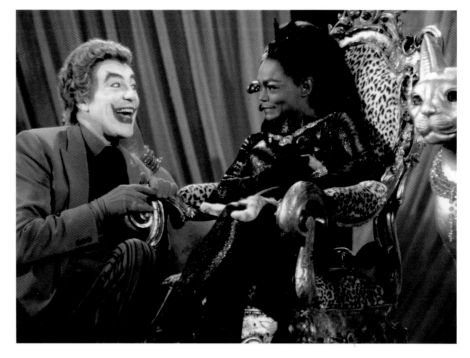

Above: Cesar Romero as the Joker with Eartha Kitt as Catwoman from the 1960s television series; Romero's cackling mania helped make the Joker the most iconic comic-book villain.

Top: Burton had clear memories of dashing home to catch the latest episode in the adventures of television's Batman (Adam West, right). Here standing with Robin (Burt Ward) and the Batcopter.

Tossing aside the piles of accumulated plot, Burton appointed Sam Hamm to write a new script based on a thirty-page treatment by Julie Hickson. Introduced only recently on the Warner lot, Hamm was another impressed by how the director was able to filter 'junk culture through an art-school sensibility.'[5]

Surprisingly, Burton had never been a fan of comic books. He recognized their place as an American mythology, but his restless mind couldn't tell where to start or which box to go to next. Batman, with his split personality and moody atmospherics, was the only hero Burton related to. He would race home from school to catch the latest episode of Adam West's stoic caped crusader trading punches ('Kapow!') with a menu of outlandish villains on the weekly ABC television series. The signature dish: Cesar Romero's cackling rendition of the Joker.

That said, Burton had been attracted to the sophisticated reinvention of the comic-book heritage in the seminal 1980s double bill: Alan Moore's *The Killing Joke* and Frank Miller's *The Dark Knight Returns*. However, Moore's graphic novel, taking place over the course of a single day, pitched Batman versus the Joker – each as psychologically unhinged as the other – had the bigger influence. *The Dark Knight Returns*, with its older hero and political subtext, reinvented the concept of Batman.

'My tone fell somewhere between the TV series and the new dark comics,'[6] notes Burton, who realized how easy it was to repurpose these larger-than-life characters. 'There's no such thing as a bible,'[7] he insists, determined to go his own way no matter how zealous Batman's followers.

While Burton directed *Beetlejuice*, he and Hamm would get together at weekends to work through the script, pleased by their progress. They were also encouraged that co-creator Kane publically approved their route to Gotham. Warner had hired him as a creative consultant and to help subdue fan discontent – unsuccessfully, it would turn out. ✪

Below: Attending Comic-Con in 1978, Burton was impressed by an early presentation of Richard Donner's *Superman: The Movie*. But he also learned how the established fan base can be very difficult to please.

43

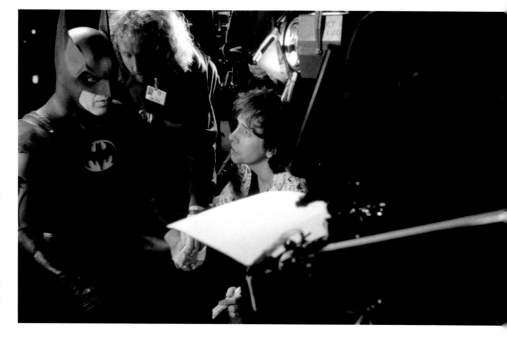

When it came to casting Burton's 'duel of the freaks'[8], fans feared that his choices ran from the ridiculous to the sublimely ridiculous. There had been other potential Batmans, of course. The director had met with 'good, square-jawed actors'[9], but couldn't envisage them needing to put on a Batsuit to sort out their personal issues. Each of them seems unimaginable now. Charlie Sheen? Mel Gibson? Pierce Brosnan? Burton was adamant that it was impossible to portray Batman as if he were Superman. If a man were built like Arnold Schwarzenegger, why would he need to dress up? Burton wanted to emphasize the human beneath the outlandish exterior. The suit was as much psychological armour as real protection. This was the image Bruce Wayne wanted to project to Gotham; dressing up was something he was compelled to do. 'You look at Michael,' relishes Burton, 'and you see all sorts of things going on inside.'[10]

Michael Keaton had actually been Jon Peter's suggestion, but he immediately appealed to Burton, who had been considering Bill Murray. Betelgeuse's wild energy would be bottled up in the Batsuit, but we would still see it bubbling away in his eyes. Moreover, at 1.75 metres (5 feet 9 inches), Keaton didn't exactly have a superhero's physique. With *Beetlejuice* not yet released, the actor was still best known as the star of *Mr. Mom* (1983).

The fans, at least a highly charged minority of them, decided casting him was the ultimate killing joke. More than 50,000 letters piled up in the Warner Brothers mailroom protesting at the madness. Burton's reboot can make a decent claim to being the catalyst for the rise of the comic-book genre to cinematic supremacy, but it was met with a comic-store petition asking fans to 'Stop the Batman Movie'. Quite how they were going to blow the tyres on this studio juggernaut, whose budget was now tipping $35 million, was never made clear, but the *Wall Street Journal* was running headlines on the negative buzz. That was enough to cause the Warner share price to take a nosedive. One particularly colourful dissenter wrote into the *Los Angeles Times* claiming that 'by casting a clown, Warner Bros. and Burton had defecated on the history of Batman.'

Quite apart from external pressures, Keaton struggled. A natural improviser, he felt restricted – literally by the suit and the introverted role, but also by the constantly changing script and gloomy production. Yet his performance is a subtler take on the antihero than many subsequent versions. He conveys the idea that Batman is less a hero than the compulsion of a troubled mind. 'It was a lonely time for me, which was great for the character, I suppose,' says Keaton. 'I would run at night in London just trying to get tired enough so I could sleep. I didn't talk to people much.'[11] Even as Bruce Wayne, he suggested someone who wanted to duck out of the room and retreat to the shadows.

And such is the fickle temperament of fans that by the sequel *Batman Returns*, Keaton was appreciated as the perfect foil for these flamboyant villains.

Ever since Kane had taken a still of Jack Nicholson in *The Shining* and drawn over it the likeness of the Joker, the star had been considered the perfect fit for the clownish terror. Indeed, Burton can't think of a time when he wasn't their villain of choice.

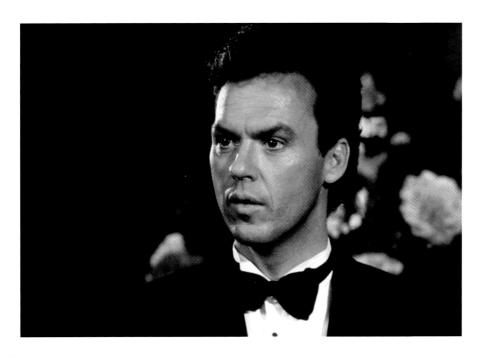

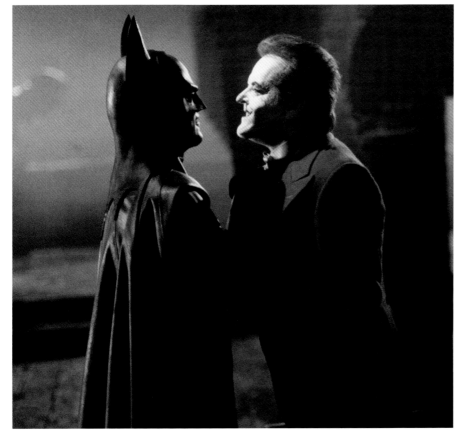

Still, other names have been mentioned: Christian Slater, David Bowie, Willem Dafoe and Robin Williams. In fact, when Nicholson initially turned the role down, Warner leaked that they were on the verge of casting Williams, causing Nicholson to hastily rethink his stance. (A staggering $6 million up front with a percentage of the gross, plus an 'off-the-clock' allowing him to set his working hours, sweetened the deal.)

Nicholson sprang at the role with *Shining*-like rapaciousness, despite two hours a day in the make-up chair. (His character, knave Jack Napier is dunked in a vat of chemicals and transformed into a leering clown with electric green hair, deformed both inside and out.) Burton thrilled at Nicholson's performance, fascinated that the chalky complexion and fixed grin formed its own mask, marvelling at the actor's ability to do six takes with six different flavours of psychosis. Whenever Nicholson walked on set the energy levels would lift.

45

The Batman-Joker duality is the film's most dynamic theme. 'They're basically two fantasies,' says Burton. 'Two sides.'[12] You get the depressive and the manic. On one side there are those trying to figure out life, on the other those who get to be completely free. ✪

Above left: Even in the guise of Bruce Wayne, the natural improvizer Keaton struggled to come to terms with the suit, the introverted role and the constantly changing script.

Left: It was the confrontation of freaks, Batman and the Joker together, which initially inspired Burton to take on the blockbuster comic-book adaptation. He loved the idea that they were almost opposites.

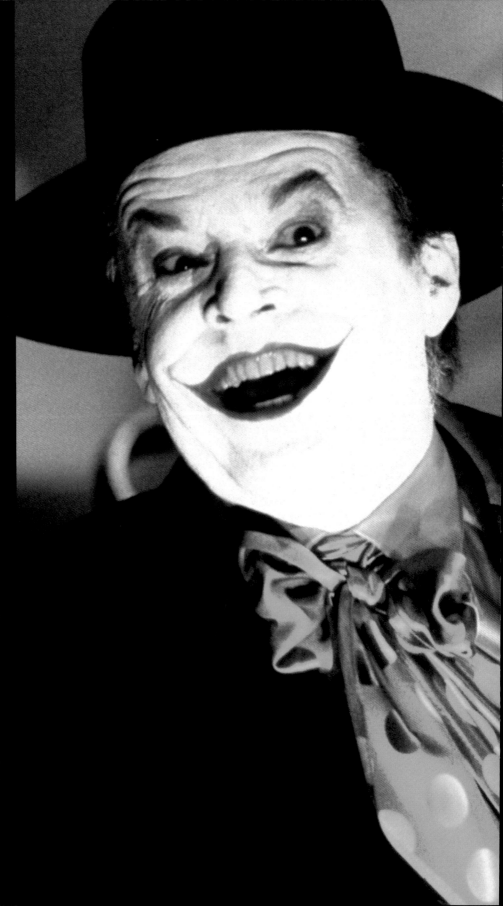

Burton was 29 when filming began in the winter of 1988. By the time he finished the following spring, he felt closer to 90. Shooting at Pinewood was a boon in some senses: it had 95 acres of backlot on which they could construct their primal city, and he would be thousands of miles from the epicentre of hype. That gave him space to think.

Far out of the thoroughfare of studio expectations, *Pee-wee's Big Adventure* and *Beetlejuice* had been relatively low maintenance. Now, though, they were working six-day weeks, constantly catching up, and he feared his mental condition was ill-equipped to cope with the 'different energy'[13] of this kind of film, and the problems began to build up.

Most hinged on the fact that the script wasn't finished; whole sequences, as Burton puts it, hadn't been 'solidified'. The studio had decided the script needed an eleventh-hour rewrite. It all felt like mind games, a jostling for power, as new writers – Charles McKeown, Warren Skaaren, and an uncredited Jonathan Gems – were drafted to pick things apart rather than sew them together. The ending was reworked again and again. The process was, Burton says, 'like unravelling a ball of yarn.'[14]

There simply wasn't psychological space in the film for Robin, so he was cut. An early draft thrusts Dick Grayson/Robin into the action when the Joker, pursued by Batman on horseback, crashes into the Grayson family circus. Peters had even toyed with casting Eddie Murphy in the role.

Then, just two days before shooting, the team had to reconfigure the role of Vicki Vale (prying photojournalist and Bruce Wayne's love interest) after Sean Young fell off a horse and broke her collarbone. Burton shocked himself with his hard-nosed

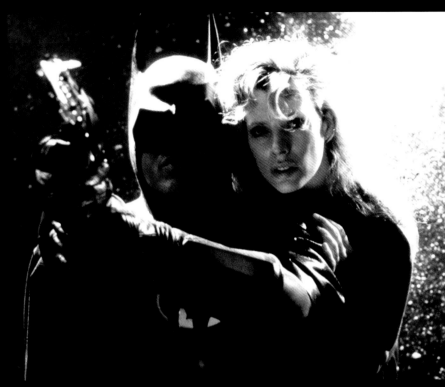

response – okay, well, find another actress. Enter: Kim Basinger.

Dialogue was being rewritten as they went, much of it by Burton and the actors. They were trying to make something inherently absurd as real as possible – which has essentially been Burton's modus operandi throughout his career – but the plot became unaccountable. 'Why am I going up the stairs?' Nicholson asked quite reasonably during the shooting of the climactic bell tower sequence. 'I don't know,' his director shrugged, 'we'll talk about it when you get to the top.'[15]

Against the mounting pressures, Burton strained every sinew to give the film something of his own personality. Surely, he had been hired to invest the flat notion of a blockbuster with, as the *New York Times* later put it, 'a vital spark of compelling strangeness, mystery or wit.' ✪

Above: Batman (Keaton) with love interest Vicki Vale (Kim Basinger). Basinger was cast just two days before shooting began when original choice Sean Young broke her collarbone in a riding accident.

Opposite: Ironically Jack Nicholson, the number one choice for the lunatic Joker, was the man who kept Burton sane through the tough days of the production, reminding him to believe in himself.

STRANGE HEROES

Working with production designer Anton Furst was one of the few genuinely fulfilling experiences of *Batman*. Burton had been a fan of the fairy-tale phenomena Furst had provided *The Company of Wolves* (1984), and tried to hire him for *Beetlejuice*. 'The spectacular thing about Tim,' said a delighted Furst on set in 1989, 'is this extraordinary ability to get into the pulse of a movie and define its atmosphere and general spirit.'[16] Tragically, Furst committed suicide in 1991, leaving Burton devastated. There had been an instant affinity between the two: he and Burton thought the same way and dressed the same way (black), perfectly in tune with one another's otherworldly sensibilities.

To Burton's mind, there had been few great movie cities. And two of them, the astonishing urban spectacles of *Metropolis* and *Blade Runner*, were off limits. The director was adamant Gotham look like neither – a charge that may not have been wholly met.

Burton preferred to think of Gotham as a parallel New York with a slightly period feel. Select elements of the design recall the 1940s or 1950s, like the zoot-suited hoodlums of Napier's gang. Terry Gilliam's gimcrack dystopia of *Brazil* (1985) was a significant influence, as was *The Phantom of the Opera* (1925). We are within Batman's world; he is not in ours. The nooks and crannies of the Batcave represent his state of mind. The smog-bound decrepit streets signal a city rotten to its core. At a cost of $5.5 million, Furst's noir masterpiece soared into the midnight sky, its 12 metres (40 foot) tall belfry set appearing to be 290 metres (960 feet) above the Gotham streets after the special effects had been applied. The design would win Furst an Oscar for Best Art Direction. It was also built to last. It would remain as a standing set at Pinewood awaiting the sequel.

Top: Terry Gilliam's dystopian masterpiece *Brazil* (starring Jonathan Pryce, pictured here) would have a huge influence over the nightmarish look of Gotham City, created by designer Anton Furst.

Above: Burton liked to think of Gotham as an alternative New York that could easily be in the 1940s or 1950s. Across all his films, it is often hard to define the time in which many of them are set.

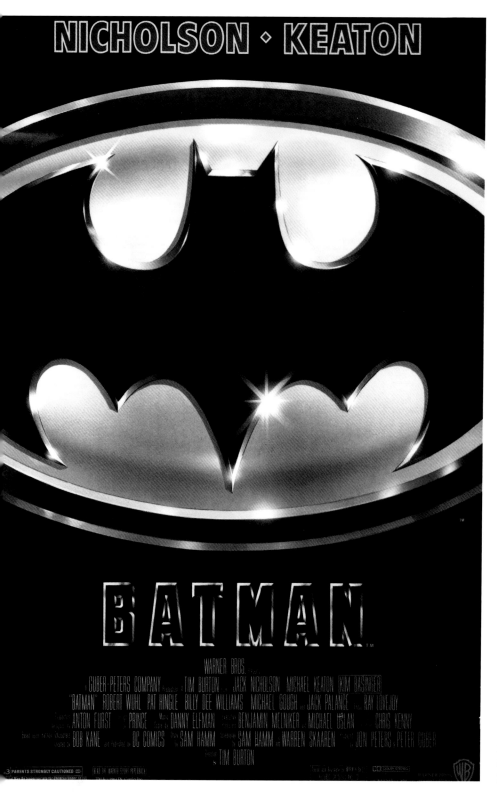

Looking back, writer David Edelstein views *Batman* as the first cult blockbuster. 'Those in its cult love what others liked least: its melancholy spirit and depressed superhero.'[17] This wasn't quite the blockbusting *Batman* everyone expected.

Still, audiences were eager to try it out. *Batman* was the first movie to make $100 million at the American box office in ten days, going on to become the fifth biggest film of all time. Nevertheless, the more you study this confounding but beautiful fable, the more the sensational box office figures seem like an aberration since this movie seems almost too strange to be so popular. *Batman* was a phenomenon almost despite itself. Perhaps, in modern parlance, he was just too big to fail. Add on the associated toys and product lines, the ill-considered Prince album (with two songs crammed into proceedings like gate-crashers) and Warner was ecstatic.

49

'It was so surreal it didn't really affect me,' says Burton, recalling how his life changed in the summer of 1989. The world went bat-shit crazy and he was now the biggest director in the world. 'Right after I finished *Batman* I went to make *Edward Scissorhands*, which we shot in a small town east of Tampa, Florida. When you're staying in a mosquito-infested condo in a third-rate golf resort and there's a plastic fish hanging on your wall, it's hard to feel like you're king of the world.'[18]

Left: *Batman's* famous poster launched one of the most successful marketing campaigns in Hollywood history, leading to the biggest opening weekend box office of all time.

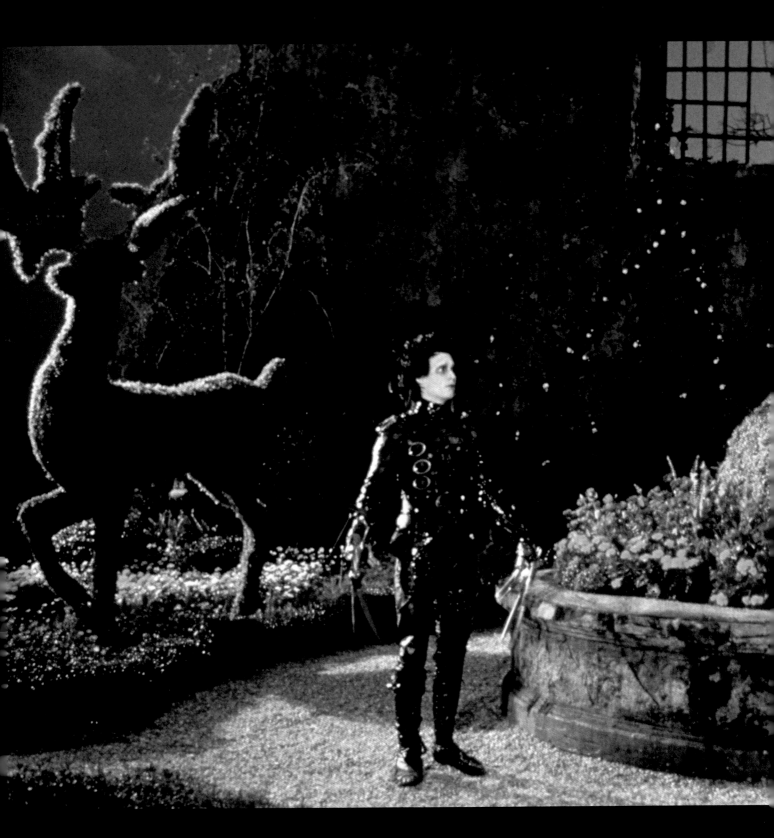

TIM BURTON

Edward Scissorhands

Asked to name the first Tim Burton film that springs to mind, most people, not just fans, would say *Edward Scissorhands*. This remains the one that set the seal, the most harmonious example of Burton's contradictory vision: charming yet ominous, unique yet brimful of references to other films and stories, heavily (almost painfully) autobiographical, and located in a world where fantasy and reality are held in perfect balance. One degree stranger or more realistic, and the film would expose its crazy clockwork or slip into the confines of genre.

The tale of this man-made boy, left incomplete with scissor blades for fingers when his maker dies in front of his horrified eyes, is the most cherished of all Burton's creations. And, upon return viewings, the most articulate and profound. Michael Wilmington in the *Los Angeles Times* called it, 'an icon of tenderness and artistic alienation.' We can't help but draw so much about its maker's mind from the sad motions of Edward's fairy-tale heart.

Yet in the making, it is the tale of three happy collaborations with three contrasting but equally kindred spirits. The first was a writer who could have been a sister. Burton had met Caroline Thompson shortly before making *Beetlejuice*. Born only two years before the director, Thompson had settled in Los Angeles as a freelance story analyst and gotten a peculiar horror novel published. *First Born* followed a foetus that returns to haunt the woman who aborted it. The book's whimsical, loaded shocks had, unsurprisingly, appealed to Burton, while Thompson had loved the unhinged vibe of *Pee-wee's Big Adventure*.

'She was very in tune with my ideas,' says Burton. 'We connected almost psychically.'[19] One night at a bar, he told her about a drawing he had made as a teenager. It was, Thompson recalls, 'this figure who had scissors instead of hands, and I basically said, "Stop right there! I know exactly what to do with that!" And I went home and I wrote like a seventy-page treatment, and essentially that's the story that we shot.'[20]

The drawing expressed, as so many Burton sketches do, something he was unable to articulate. As a teen there had been a long period where he had just been powerless to connect with anybody, or form a lasting relationship. From his family outwards, he felt as if he couldn't get close to anyone. The sketch was in effect a dramatic self-portrait of that teenager: cadaverously thin, a thatch of untameable hair, cocooned in black leather, with long, sharp shears for fingers. His expression is one of concentrated sadness – the poor soul who would harm anyone who got too close. ✪

51

Left: Edward Scissorhands (Johnny Depp) admires his handiwork. Tim Burton's most beloved film takes place in a world where reality and fantasy are held in balance.

Thompson's script would concoct wonderful elaborations on the image. Edward would be an artificial boy, made by an eccentric inventor, Frankenstein being an obvious yardstick. The film can be read as a sweet-natured embodiment of all those misrepresented monsters who took sanctuary in the recesses of Burton's psyche: 'It's *Frankenstein*. It's *Phantom of the Opera*. It's *Hunchback of Notre Dame, King Kong, Creature from the Black Lagoon* ...'[21] From his misbegotten 1984 Disney short *Frankenweenie*, it's a theme he keeps probing like a loose tooth.

Edward's unnamed Inventor dwelled alone in a hilltop castle that was rather more movie set than ancient edifice. This gothic pile could have resided in any of the slew of Universal horrors from the 1930s starring the likes of Boris Karloff and, notably, Bela Lugosi. To play the Inventor, Burton would return to the long-standing friendship formed on *Vincent*. Horror icon Vincent Price was the second of the film's key collaborations, though his role amounts to little more than an honorary cameo.

'I was very happy that he did it, and I got to know him better,' says Burton. 'His role probably had a lot to do with how I felt about him, and how he was my mentor, so to speak.'[22] Now, the star appearing in person, in such an elegant, sorrowful, symbolic role that included an eerie death scene, confirmed how intimately Burton was wrapped up in the material. The parallels between director and star are immediate – they are *both* Edward's creators.

More than a horror film, *Edward Scissorhands* is a fairy tale. It is framed by a wizened Kim (Winona Ryder in thick prosthetics) telling the story to a small child, 'Snuggle in, sweetie. It's cold out there ...'[23] Thompson's script distils Burton's teen

torments into a fable, exactly as fairy tales conceal the psychosexual trials of coming-of-age. 'I've always loved fairy tales,' he explains, 'like Little Red Riding Hood or Hansel and Gretel.'[24] Who is the Inventor but Geppetto to Edward's Pinocchio?

Burton realized that the way in which a fairy tale embodied emotions on a symbolic scale could be applied to something contemporary and personal. And within that context, he would be freed from those tiresome requirements to be literal. You didn't need to question why this overgrown castle was situated just beyond normal American suburbs. You didn't need to worry about how Edward actually worked. Burton could apply his imagination without being shackled to the demands of plot.

Above: Lon Chaney in *The Phantom of the Opera*, one of the misunderstood monsters that would have an influence on Edward. Notice also the similarities in look with the interior of The Inventor's castle opposite.

Opposite above: Kindly Avon lady, Peg Boggs (Dianne Wiest), pays a visit to a lonely gothic castle, absurdly just up the hill from her suburban community. Burton loved the visual freedom of a contemporary fairy tale.

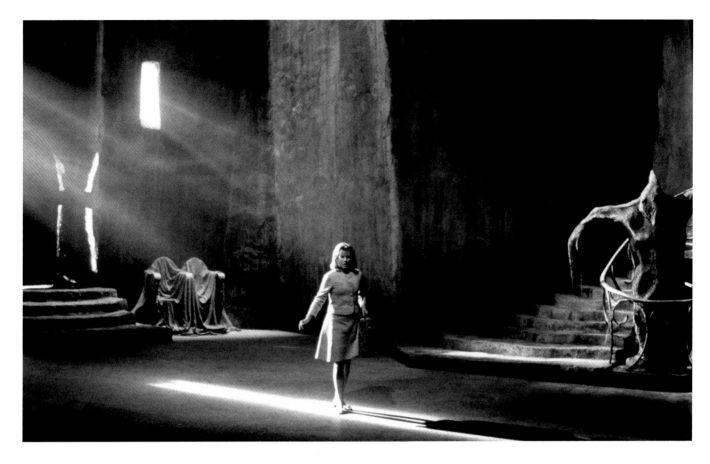

53

'It's weirdly complicated,' he explains, reaching for how fairy tales capture the profound. 'They acknowledge the absurdity, but in a way that is more real.'[25]

Rather than expose the script to the trials of studio development, to have so personal an idea pulled out of shape by marketers, trying to make lucrative product placement deals with scissors companies, Burton developed the project in secret. He would pay Thompson a small fee, thousands of dollars, to write the script, figuring it would cost little more than $8 million or $9 million to make. Early on, they even conceived it as a musical (Burton suggests an opera) – a desire that would manifest itself in both *The Nightmare Before Christmas* (also written by Thompson) and *Sweeney Todd*. 'So, in

my original treatment, there were actual musical interludes, including lyrics,' says Thompson. 'One of the songs was called "I Can't Handle It".'[26]

Only as he was about to jet to England and begin *Batman* did Burton feel the time had come to find a studio for this quaint story. There would be no haggling. He wanted full control, giving a prospective studio two weeks to say yes or no.

Studio executives were perplexed. What was he doing pitching such a modest fantasy? He was now a director of mega-productions. 'I'd been penalized for making some sort of big movie,' he says. 'It is a weird trap.'[27] Warner, offered first refusal, did just that, and it was 20th Century Fox who took up his offer. Head of production Scott Rudin had

a taste for the unconventional and he was keen to get into the Burton business. This was a director who had made two hits out of nothing at all.

However, while Burton was away making *Batman*, the studio experienced a regime change, a new set of heads growing in place of the severed ones. Fortuitously, incoming chief Joe Roth thought the fairy-tale tenor in keeping with films like *E.T.* and *Pinocchio*. He willingly green-lit the film and even upped the budget from $8 million to $20 million. ✪

54

TIM BURTON

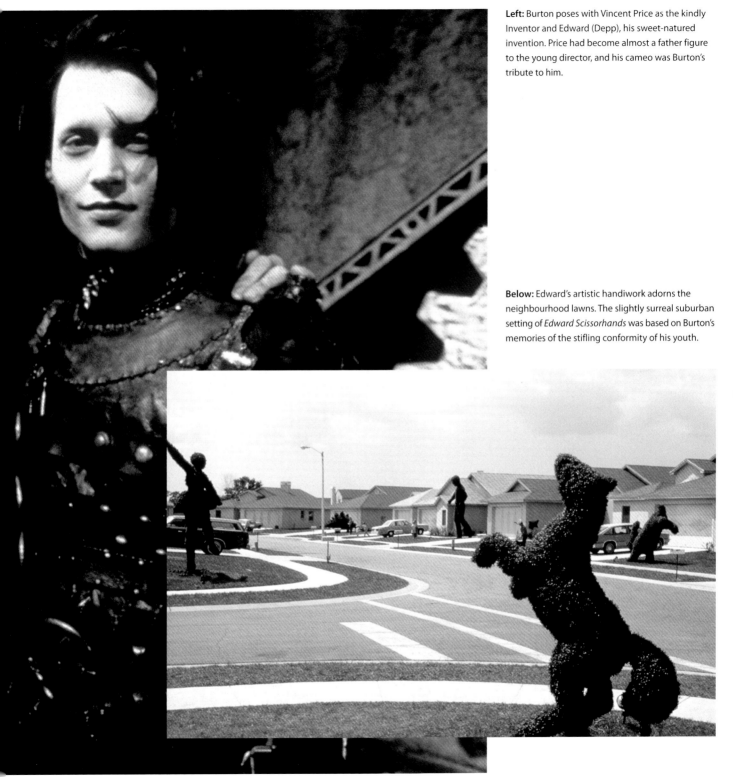

Left: Burton poses with Vincent Price as the kindly Inventor and Edward (Depp), his sweet-natured invention. Price had become almost a father figure to the young director, and his cameo was Burton's tribute to him.

Below: Edward's artistic handiwork adorns the neighbourhood lawns. The slightly surreal suburban setting of *Edward Scissorhands* was based on Burton's memories of the stifling conformity of his youth.

STRANGE HEROES

What gives Thompson's script for *Edward Scissorhands* such an edge is the concept of plucking Burton's forlorn figure out of a fairy tale and plunging him into the even stranger realm of suburbia.

The film would mark Burton's definitive foray into the suburban desert of his youth. A place, he claims, that was culturally devoid of artistry. Thus you manufacture your own versions, and Burton manufactured an entire career, twisted and surreal, from the blank canvas of his upbringing.

Thompson was as obsessed with the mechanics of suburbia as her collaborator, and while writing the script she was living in and feeding off exactly the same bland corner of Burbank where Burton grew up. 'It was a hilarious neighborhood in that whenever anything dramatic went on, everybody came out of the house to watch. So it was very much the world of the film.'[28]

Nevertheless, they would shoot a long way from Burbank, taking over a community on the outskirts of Dade City in Pasco County, Florida, where they co-opted 50 individual houses. The actual residents would be put up in a local Super 8 motel for three months as these mad movie folk repainted their houses in pastel shades dubbed sea-foam green, dirty flesh, butter, and dirty blue; reduced the size of their windows ('to make it look a little more paranoid,'[29] says production designer Bo Welch); and landscaped their gardens with the exotic topiaries created by Edward to express his artistic gifts. (A sign at the entrance to the location warned prospective homebuyers that the area didn't normally look like this.)

'Tim Burton realized it in such a way that it was of no time and no place,' contends Thompson, 'as if it was our memories.'[30] The setting was to be a queasy place of nosy parkers and listless routine, and the director

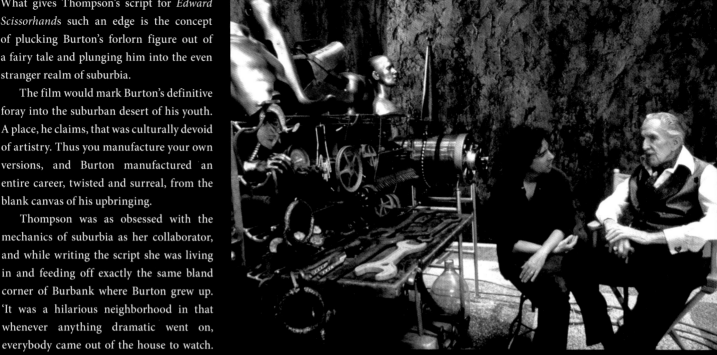

encouraged cast and crew to read Bill Owen's *Suburbia*, a photographic study of suburban life in 1970s California.

The gothic mansion overlooking such creepy domesticity was constructed on the Fox backlot. Filled with the Inventor's Heath-Robinson contraptions, it was lit with ominous shadows like a German silent film (a metaphor for both Edward's inner workings and the knick-knackery of Burton's film-making approach). The bright interiors of the homes are crass-courses in swag lamps, flocked wallpaper and acres of shag-pile – a scholarly eye for kitsch that Burton would display again in *Mars Attacks!*, *Dark Shadows* and *Big Eyes*. A canary-yellow tuxedo spotted in a prom-night photo on a sideboard is identical to one he once wore to a prom. 'You've seen *Carrie*, right?" Burton giggles. 'Prom night and all? I went on my first date to this girl's prom. I guess I went dressed as a bumblebee. It didn't go real well.'[31]

Above: Burton and Price steal a quiet moment during the shoot. The Inventor's array of strange Heath Robinson contraptions adds to the otherworldly feel of the film. It is as if the entire movie runs by clockwork.

This Floridian enclave proved a trying environment in which to make a film. Temperatures topped 43° Celsius (110° Fahrenheit), the humidity turned the air to glue, and they had landed at the height of bug season. At certain points of the day, the air grew so dark with blizzards of lovebugs they couldn't shoot. These unpleasant critters got everywhere – and only creature-feature aficionado Burton enjoyed the aura of apocalypse that came with them. 'Maybe it's growing up with those bug movies of the seventies,'[32] he giggles.

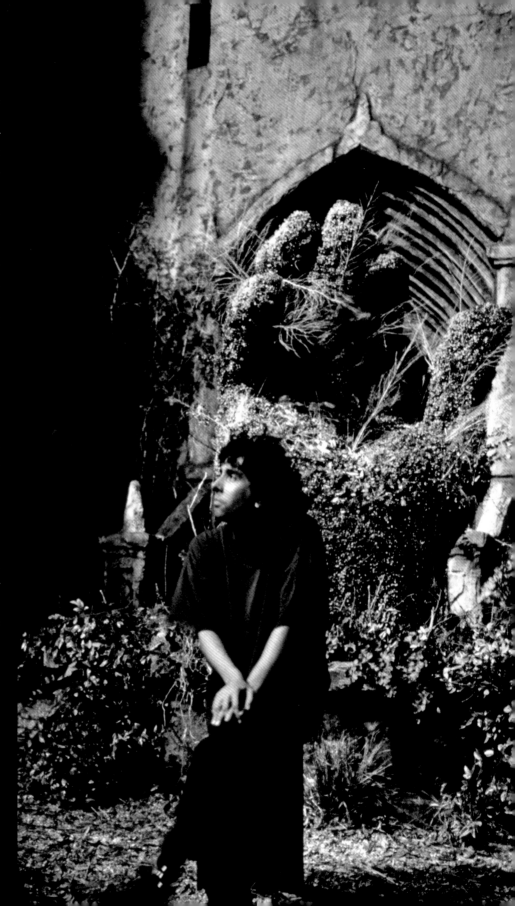

'I could tell you each character and who they are,' says Thompson, who had a real-life counterpart for everyone, 'and how they kind of fit together to make this like fairy-tale puzzle of the beauty and the horrors of suburban life.'[33] Religious nuts, sex-starved housewives, high-school jocks with daddy issues: it wasn't the most functional community. Even the relationship between Peg, Diane Weist's compassionate Avon lady who takes pity on Edward, and her mild-mannered husband Bill (Alan Arkin) evokes the unquestioning mood of the Burton childhood household.

'They get along beautifully,' explains Arkin, who plays the friendly, absent-minded Bill with a terrifying, pod-person composure. 'But do they communicate? No. It's like everybody is pretending to have relationships.'[34]

Everything is deliberately off-centre. Ryder doesn't quite fit the idea of blonde cheerleader, Anthony Michael Hall the bad-apple quarterback. For Edward, life will be all barbecues and backslapping until they turn on him and we see how alike they are to the villagers of *Frankenstein* and *Frankenweenie*.

And yet, Thompson thinks there is something deceptive in the perception of Burton as anti-suburban. His work, she says, has a real affection for neighbourhood life .. He's escaped some fundamental damage that shuts most people down.'[35] ✪

Right: After the turmoil of making *Batman*, Burton thought it was the right time to make something far more personal in *Edward Scissorhands*. He was amused that the studios were perplexed by how little it was going to cost.

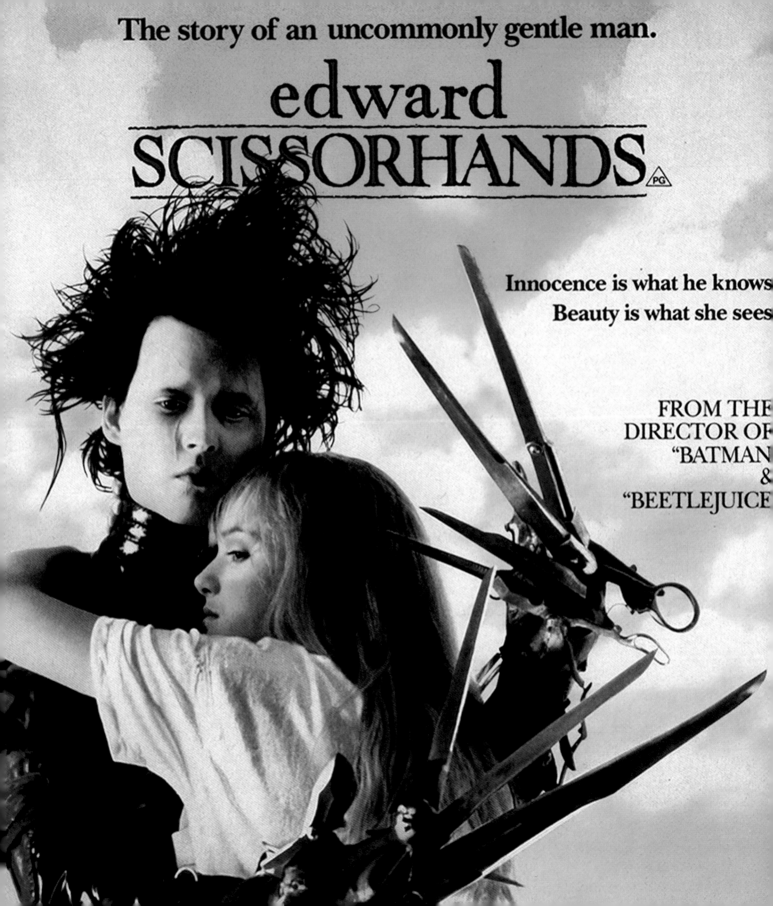

'Johnny … you are Edward Scissorhands,' the voice on the other end of the line was saying. And with that the third and most lasting of the Scissorhands collaborations was made, transforming the film and beginning one of modern cinema's great actor-director partnerships, the mad-wig-and-stage-blood equivalent of John Ford and John Wayne's Monument Valley machismo. Johnny Depp puts it in even grander terms: 'I owe the majority of whatever success I've been lucky enough to have to that one weird, wired meeting with Tim.'[36]

The truth is, Burton had thought the actor was just some kid from a popular TV show who had gotten hold of the script from his agent and was now begging for a meeting. Still unsure where he might find Edward, Burton acquiesced.

The studio had expended a lot of effort trying to woo Tom Cruise to play Edward. Burton understood why – Cruise was at the height of his box office appeal – but the actor didn't exactly fit his image of the character. Cruise, meanwhile, had taken several meetings, which had generated several doubts. As Burton sees all too often, 'There comes a point when their fears are too great.'[37] What would playing this near-silent naïf do to Cruise's established brand as action hero? Was it masculine enough? Could he even go that long without cracking a smile?

Edward presented a unique challenge. He required the qualities of a silent movie star, someone who could express complex emotions through body language alone as his face remained quizzical at most. He must be childlike, good with slapstick, and yet project something angelic. He must be an unsettling, alien presence, but never lose the audience's sympathy. He must be ET, Charlie Chaplin, Frankenstein and James Dean all squished together beneath a skin-

tight leather onesie. William Hurt, Tom Hanks and, enticingly, Robert Downey Jr. (who made a natural Chaplin in the 1992 biopic), were all options. As was Michael Jackson, supposedly. Depp, therefore, would be a choice somewhere to the left of left field.

Right then, he was a TV heartthrob wilting beneath the assembly line schedule of undercover-narc serial '21 Jump Street'. Despite having recently completed *Cry Baby* with outré director John Waters, he hadn't made the studio's list. That counted in his favour for Burton, who wanted the audience to view Edward without judgement.

Above: At the time, Depp was only known for the television series '21 Jump Street'. The studio had pursued Tom Cruise, but Burton was determined Depp had the necessary make-up for Edward. It was the start of a beautiful friendship.

Opposite: While not the box office sensation that *Batman* was on its initial release, *Edward Scissorhands* has gone on to become a Hollywood classic and, arguably, Burton's signature film.

When he read the script, Depp claimed to have 'wept like a newborn'[38]. He didn't just want the role; it had gotten to a place where he couldn't conceive otherwise. 'This story had now taken residence in the middle of my heart and refused to be evicted,'[39] he says. He had caught up with Burton's previous films, impressed by how off the Hollywood path he was willing to venture. But arriving at the coffee shop, where he was due to meet the director and producer Denise Di Novi, he didn't even know what Burton looked like. He scanned the tables, and behind a row of potted plants, spotted 'a pale, frail-looking, sad-eyed man.'[40] The way the director waved his hands in a frenetic semaphore confirmed his suspicions – this guy *was* Edward Scissorhands! Over too much coffee, they shared a mutual regard for outsiders and the weird appeal of resin grapes. But agonizing weeks would pass before his phone rang ...

Depp's touching performance (so restrained compared to the chatterboxes and caricatures of his later success) came instinctually. 'I kept thinking of the faces of dogs I had owned ...' he admits. 'Dogs have that unconditional love.'[41] He got deep into Edward's mental state by wearing the 25-cm (ten-inch) Scissorhands appendages around the house, fumbling with his daily routines. The shears were created by special effects guru Stan Winston (who had brought the Terminator to life), and he had helpfully added a roach clip among the insane Swiss Army paraphernalia so that Depp could smoke on set. Beneath a mane of permanently windblown locks and clad in black, Depp resembled Burton's mutant twin.

The director's daily regimen of black, more or less, remains a lifestyle choice. 'I think people should dress how they feel,' he says, 'and I do feel a kind of heaviness

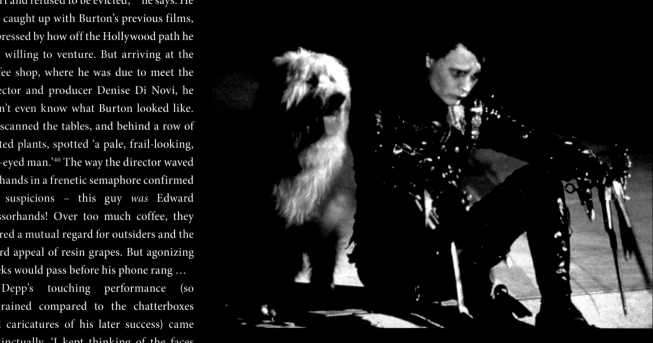

sometimes and a darkness, and yet I use that as a catharsis.'[42]

There is Scissorhands DNA to be found in Ed Wood, Ichabod Crane, Willy Wonka, and Victor Van Dort: Depp's Burton alter egos to come. Even Sweeney Todd is good with a blade. And Depp's ability to translate his director's often obscure instructions was equally a matter of instinct – he could simply decipher the half sentences, scattershot thoughts and flailing arms like a sixth sense.

'I never really analyze that too much,' says Burton, asked to decrypt the uncanny link he formed with Depp. 'I think there's a connection with people, and it's not an intellectual decision. We have shared similar tastes in things, in movies and certain weird, lower suburbia upbringings.'[43]

Above: A disconsolate Edward (Depp) finds his only friend in a local mutt. Depp partially based his performance on dogs he had owned, and how they offered such unconditional love.

Opposite: No one was missing the fact that with his windblown locks and the all-black get up, Depp's Edward bore an uncanny resemblance to one Tim Burton.

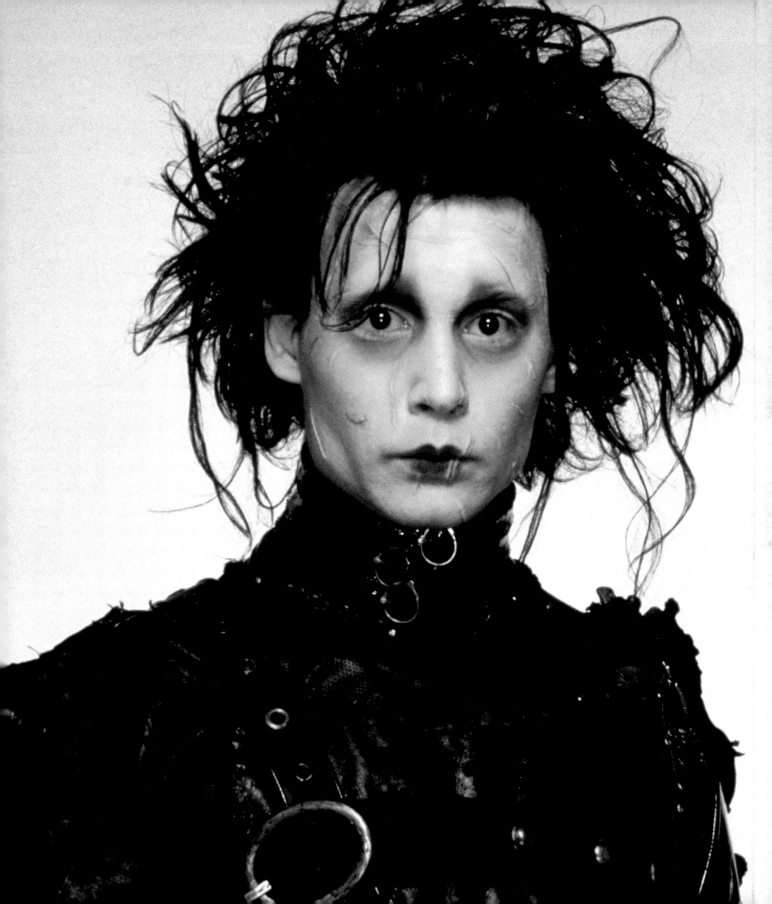

POETRY INTO PLOT
Nightmares and dreams

Tim Burton only made a sequel to *Batman*, because he wanted to make good on the first film. 'There was a feeling I had hoped to get by doing the first *Batman* that I didn't get,' he admits. 'I wanted another chance to capture that feeling.'[1]

Fetchingly, Burton refers to all his films as 'mutated children'[2]. *Batman* is just that bit too mutant. 'I only liked certain sequences'[3] is the best he can muster. His decision to use jerry-rigged effects, as in *Beetlejuice*, had been a mistake – they didn't fit the scale and lost their charm. The script had become distorted and the whole process was debilitating. Retreating to the personal realm of *Edward Scissorhands* had partially served as therapy.

Still, Warner had gone ahead and commissioned a script from Sam Hamm, who provided the much-maligned rise-of-the-Joker blueprint for the first film. Hamm introduced the next felons in the accepted hierarchy of *Bat*-villainy – in Catwoman and The Penguin – but Burton found his treasure-hunt-in-Gotham plot prosaic.

'The thing I really liked about Batman as a comic-book property was that they're all fucked-up characters,'[4] he says. So he enrolled Dan Waters, whose script for the Winona Ryder comedy *Heathers* had revealed a Burton-like subversion, concentrating on defining the new characters over assembling the scaffolding of plot. (Prior to production Warner would enlist Wesley Strick for rewrites – or, as they pointedly refer to it, 'normalization'.)

Right: Selina Kyle (Michelle Pfeiffer) and Bruce Wayne (Michael Keaton) get a glimpse beneath the masks. Tim Burton was not only drawn back to the world of *Batman* but the possibilities within the characters.

TIM BURTON

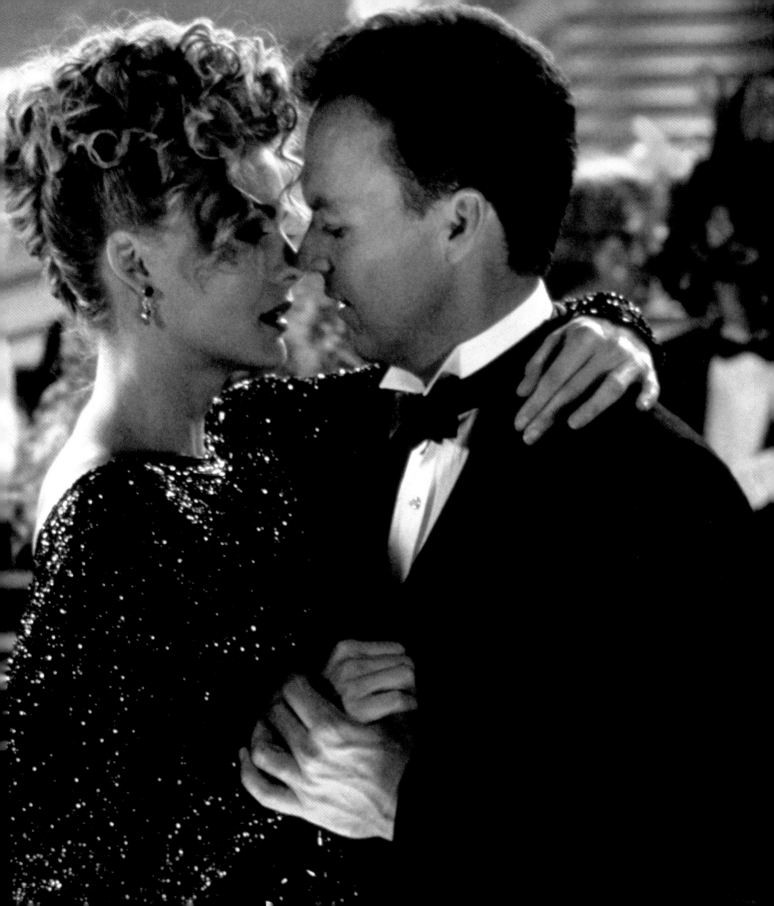

Batman Returns

What really got Burton going was Catwoman. By day a harried secretary, by night a deviant criminal, Catwoman is both sex bomb and feminist icon sewn into a patent leather jumpsuit. As to who might don the role, defined by Julie Newmar on the television series, became the talk of the town. 'Every major movie star from 17 through the late 40s got in touch,'[5] claims producer Denise Di Novi. Most notably: Jennifer Jason Leigh, Sigourney Weaver, Lena Olin, Ellen Barkin, Demi Moore – and even Madonna.

Sean Young's pursuit of the part is now legend. Dressing in an improvised cat suit, she has snuck onto the Warner lot in search of the producers. Gossip has Burton cowering beneath his desk, but the truth is he simply wasn't there. She then went on 'The Joan Rivers Show' in her cat suit ('more appropriate for a female wrestling movie from what I saw,'[6] notes Burton), demanding to be cast. 'Hollywood is such a bunch of weenies,'[7] she sneered, suggesting she had the measure of Catwoman's nerve if nothing else.

The truth was, the choice had already been made. But a whisker away from shooting, Annette Bening discovered she was pregnant. 'We were very freaked out about it,'[8] admits Di Novi, recalling three minutes of silence on the phone to her director when the news hit. There was only one other choice.

Despite her zero hour call-up, Michelle Pfeiffer gives a sizzling performance as the conflicted Selina Kyle, unceremoniously shoved from a boardroom window, to be resurrected as the conflicted Catwoman. 'For me, her version of Catwoman was one of my favourite performances on any movie I had worked on,' savours Burton. 'I remember how she impressed me by letting a live bird fly out of her mouth … And dancing around on rooftops with high-heeled shoes on.'[9] Such are the ways to Burton's heart.

Pfeiffer had her own obsession with Newmar's Catwoman, having begged Burton for even a single scene as the conniving kitty in the original *Batman*. 'I said I would do it for free,'[10] she laughs. So this was pure serendipity. Nevertheless, the shoot would sorely tax her with weeks of after-hours training with a bullwhip (Burton professes she became more proficient than the stuntwomen) and learning to pull roundhouse kicks in high heels. And that cold wasn't just ornamental: the sets had to be refrigerated to keep the (real) penguins happy – and, wags hinted, because Burton wanted an icy vibe. 'The suit was no protection at all,' she grumbles of *Batman*'s baptism by attire.

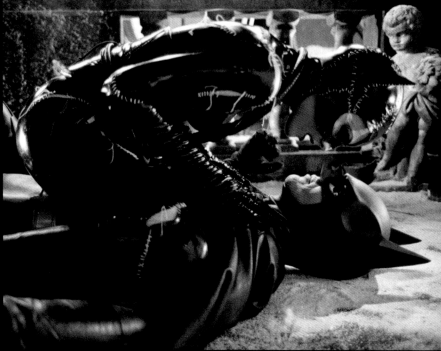

Left: Catwoman (Pfeiffer) momentarily gets the better of a prone Batman (Keaton). Burton theorized that the two characters revealed more about themselves when they had the masks on.

Right: The astonishing Pfeiffer may have been drafted in at the last moment, but she was already obsessed with Catwoman, and had once begged Burton to give her a cameo in the original Batman as the feline villain.

FILMOGRAPHY

The Island of Doctor Agor (Short)
Director, Writer, Actor

The Fox and the Hound
Animator

1971

1978

1979

1981

1982

The Lord of the Rings
Artist

Luau (Short)
Director, Producer, Writer, Actor

Vincent (Short)
Director, Writer, Production Designer

The Muppet Movie
Actor

Doctor of Doom (Short)
Director, Writer

Tron
Animator

Stalk Of The Celery Monster (Short)
Director, Writer, Producer, Animator

Tim Burton's The Nightmare Before Christmas
Writer, Producer

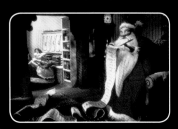

Hoffa
Actor

1995

Batman Forever
Producer

1994

1993

Ed Wood
Director, Producer

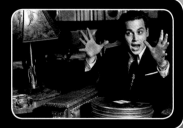

Family Dog (TV)
Executive Producer, Design Consultant

Cabin Boy
Producer

Beetlejuice
Director

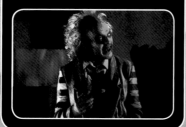

Edward Scissorhands
Director, Writer, Producer

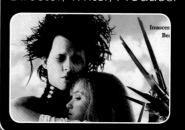

1988

1990

1992

1989

1989–91

Batman
Director

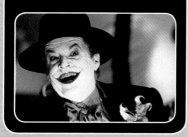

Batman Returns
Director, Producer

Stay Tuned
Design consultant

Singles
Actor

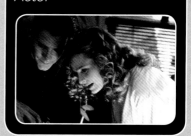

Beetlejuice: The Animated Series
Executive Producer, Writer

Faerie Tale Theatre: Aladdin and His Wonderful Lamp (TV, Season 5, episode 1)
Director

Frankenweenie (Short)
Director, Writer

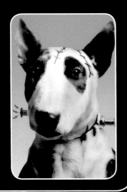

1987

Amazing Stories: The Family Dog (TV, Season 2, episode 16)
Executive Producer, Animation Designer

1986

1985

1983

1984

Alfred Hitchcock Presents: The Jar (TV, Season 1, episode 20)
Director

Hansel and Gretel (Short)
Director, Writer, Production Designer

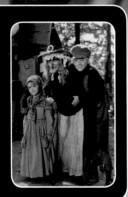

Pee-wee's Big Adventure
Director

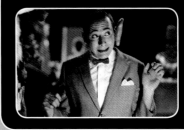

The Black Cauldron
Conceptual Artist

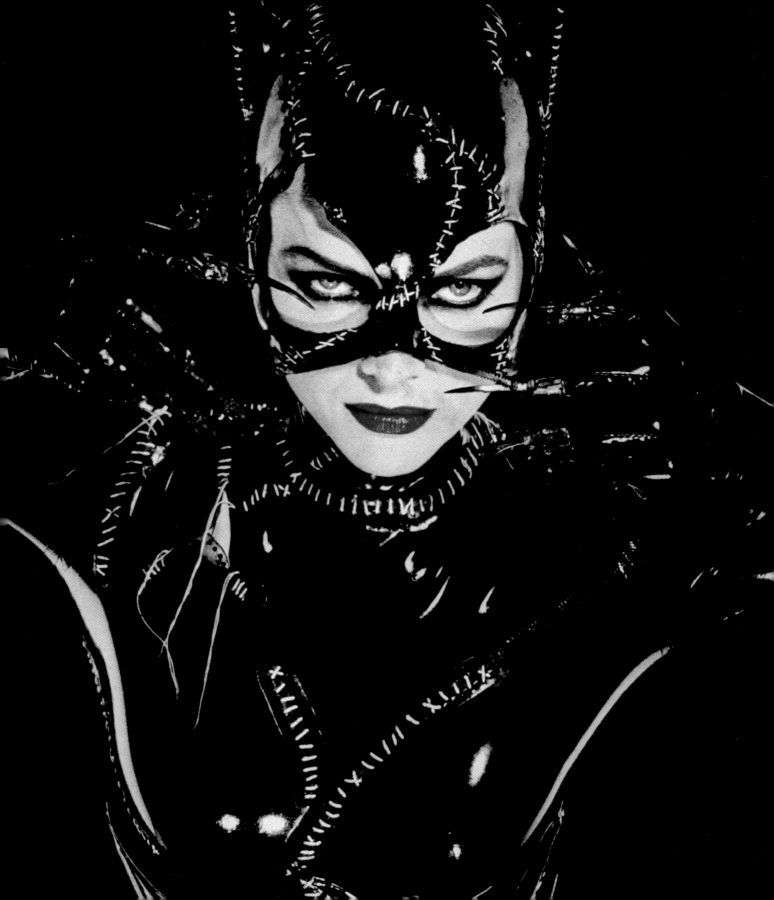

Pfeiffer stirs up the film like the only (unstable) grown-up in town, rolling her enormous eyes at all these absurd men. 'Really, I see it as metaphorical,' she says mulling over the feminist angle. 'When Selina Kyle turns herself into Catwoman, it's a statement about women coming into their own power, which is a strong thing in our society.'[11]

Burton's imagery may often be primal but it is rarely sexual. 'Tim's films have an innocent darkness to them,' agrees Pfeiffer.

'It's as profound, as honest, as a six-year-old can be before he gets screwed up.'[12] *Batman Returns* is the exception. In Burton's films romance is everywhere but the bedroom. *Batman Returns* is the exception (although *Dark Shadows* reveals some vampiric urges). The characters are driven less by criminality than by the urge to scratch their S&M itch: the Penguin is all slavering carnality, a testicle on legs, while Catwoman jolts to orgasmic bursts of animal instinct.

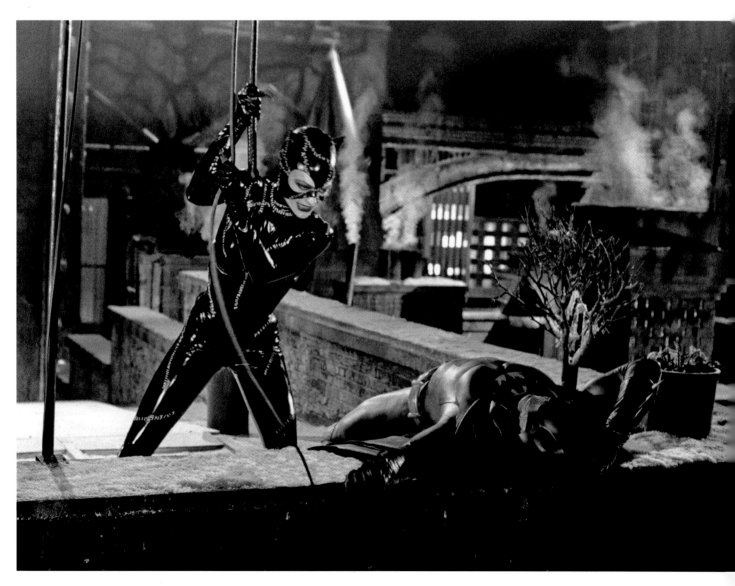

If Burton was initially drawn to Catwoman, it was the Penguin that solved the riddle of the sequel. This was not a character he had ever loved, but he rediscovered a sketch he had done of a toddler with strange clipper-like appendages for fingers (the squat cousin to Edward Scissorhands). The caption ran, 'My name is Jimmy and they call me the hideous penguin boy.' (It can be found in *The Melancholy Death of Oyster Boy & Other Stories*.)

The Penguin, or Oswald Cobblepot, would be transmogrified into a homuncular vessel of gangster, mutant, and demon lashing the world with Dickensian grandiloquence, dribbling unexplained black fluid between green teeth (in fact, mixture of mouthwash and food colouring). Much to Burton's glee, Danny DeVito went full method, never breaking out of his cackling, slavering mode, willingly eating raw fish (seasoned in lemon).

Analogous to Batman, Cobblepot is an orphan, abandoned Moses-like as a baby. Arising as Gotham's perverse id at the head of a gang of circus freaks (Burton's imprimatur now dominant), he has Biblical vengeance on his bird brain. And like Nicholson with the Joker, DeVito felt preordained when the announcement came. Burton was determined to have nothing of the quack-in-spats routine created by Burgess Meredith on television – although he did keep the cigarette holder in tiny tribute, and there was talk of Meredith playing Oswald's late father. The flashback role eventually went to Paul Reubens. And who is The Penguin if not the curdled offspring of Pee-wee Herman?

Keaton, for his part, was looking for a considerably bigger paycheck before he would even pick up the Batphone. He had to take much of the criticism of the first film on his chin. 'There was something in that negative attitude that stirred in me what I'm going to call a healthy "attitude",'[13] he says. Persuaded by Burton to return, he had the Bat-bit between his teeth. 'I had to become the character again, without anything else getting in the way.'[14] ✪

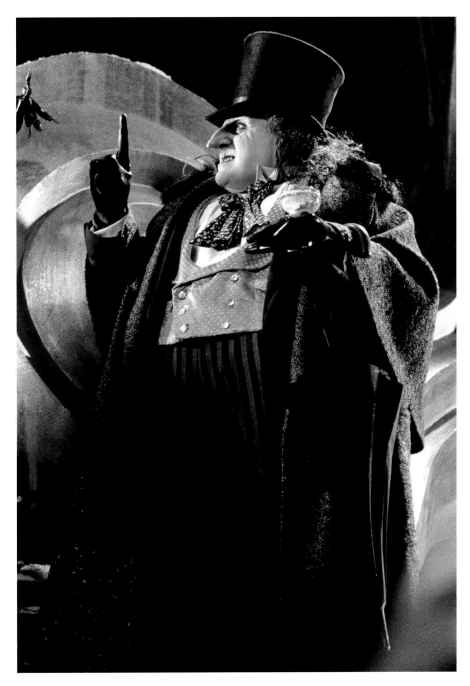

Above: Danny DeVito as the revolting Penguin taking vengeance upon Gotham. The actor had relished the chance to unleash his inner animal and gives an underrated performance.

67

Left: We can see the influence of *Edward Scissorhands* on Burton's new, quasi fairy-tale version of Gotham. Without a single exterior, it took up every soundstage at Warner Brothers – another alternative, comic-book world.

Opposite: The Batmobile crashes through the Penguin's army of circus players. With its circus imagery and dream-like quality, the darker sequel is far more *Burtonesque* than the original

Keep in mind that Burton's re-engagement with the material centred on the fact he had been given carte blanche to make *his* Batman film. He wasn't concerned about maintaining a consistent mythology. Only Keaton, Michael Gough (as Alfred), Pat Hingle (as Commissioner Gordon), and a slightly updated Batmobile maintained any kind of chronology.

Even so, much like the first Batman, the bones of the plot were still being reorganized as the cameras began to roll. Billy Dee Williams had been set to return as

TIM BURTON

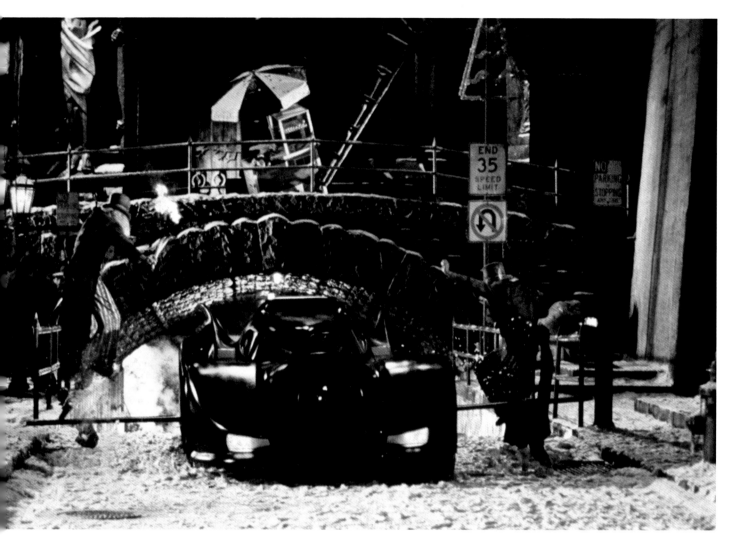

Harvey Dent, slowly being transformed into Two-Face, a part rewritten as Christopher Walken's corrupt businessman Max Schreck.

Gotham – or, at least, the set left standing at Pinewood – was out too. Burton elected to shoot in LA, and remake his city from the ground up. He claims this was a practical decision, with the availability of people and resources, but it also helped erase the past. 'Pinewood would have seemed like going back over old territory,'[15] he admits, adding that he felt *Batman* suffered from a 'British subtext'[16].

Turning to regular designer Bo Welch, Gotham Mk II is another wonder of Burton's universe – an intoxicating temple of high artifice, drawing upon *Metropolis* (1927) and the nocturnal atmosphere of the Brothers Grimm. Temporally speaking, the film simultaneously mixes Bat-tech and big business with nineteenth century Europe.

Beneath the sunless, frosty veneer of its Christmastime noir (Danny Elfman infiltrated the score with phrases from 'The Nutcracker Suite'), *Batman Returns* confounds the notion of a summer movie.

Without a single exterior, the shoot spilled out of Warner onto Stage 12 at nearby Universal, which housed the Penguin's cold-hearted lair – a tank with a capacity of half a million gallons, a simulated ice floe, half a dozen actors in penguin suits, 36 mechanical penguins, and an army of 36 real penguins. 'I am not a human being,' bellows DeVito as The Penguin meets his downfall, reversing the poignant line from David Lynch's *The Elephant Man*. 'I am an animal!'[17] ✪

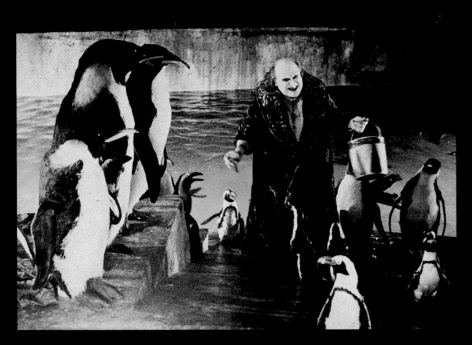

Left: The Penguin's bird-brained army included 36 mechanical birds and 36 real penguins. Burton, an animal lover, insisted the set be kept refrigerated so the birds, if not the actors, would be happy.

Opposite: Sold on the proposition of the three characters, the sequel, like its predecessor, set new box office records on its opening weekend. But attendances would begin to drop heavily, as families resisted its darker side.

Below: As well as needing to be kept cool, the Penguin's underground lair featured a tank containing half a million gallons of water. The level of production was so demanding, Burton was left disillusioned about filmmaking.

70

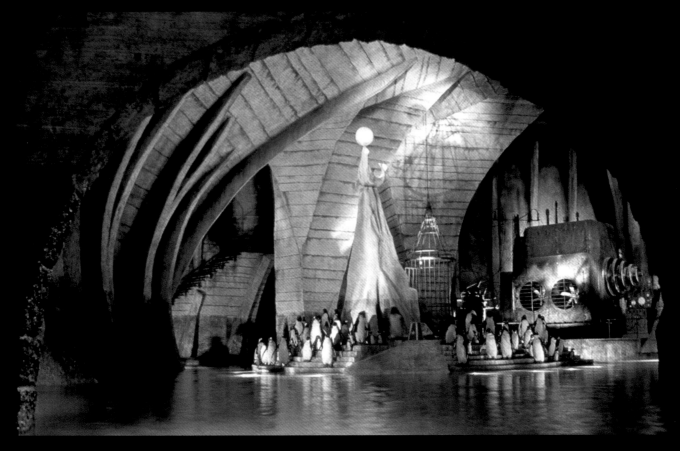

TIM BURTON

Reviews swept from the adulatory to the outraged. Certainly, there were those who noticed that the film was made in the shadow of a presidential election (which would be won by Bill Clinton), and that it possessed a streak of political satire in its depiction of rigged elections. It remains one of Burton's most barbarous satires on America.

If anything, the film was celebrated more for its subconscious effect. Peter Travers of *Rolling Stone* effused, it was a film that led us 'into the liberating darkness of dreams'. For *Time*'s Richard Corliss, Burton had elevated the blockbuster from 'plot into poetry'.

The immediate success was considerable. The box office take of $47.7 million on the opening weekend then stood as the biggest opening of all time (it would be crushed by *Jurassic Park* the following year). It went on to make $266 million worldwide, considerably less than the $411 million made by the original. The shortfall was blamed on a backlash led by parents appalled at the seething psychosexual overtones. The fast food chain McDonalds, who had unsuspectingly agreed to a Happy Meal tie-in, found itself hastily backtracking, claiming that the tie-in wasn't a recommendation to *see* the film.

Then it was precisely Burton's deepening and darkening of the mythology that has made the film so valuable. Rather than a quick-buck action movie, this demonic fairy tale is one of his most enduring creations.

But he was done with Batman. Something in his psyche resisted Gotham. The material came booby-trapped with expectations. The scale of the production inevitably involved too many prying eyes, too much second-guessing. To the secret relief of the studio ('I put them through a lot,'[18] he admits), the idea of returning for a third appalled him. 'Batman movies,' he reflects, 'are a perverse kind of business.'[19]

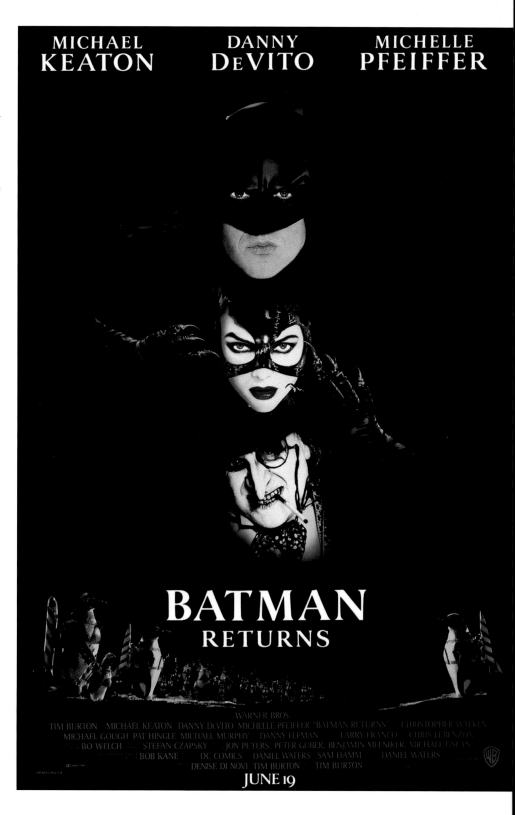

Ed Wood

Stand back, and *Ed Wood* appears an unlikely Tim Burton film. It is set in the real world, albeit on the seamier side of Los Angeles, and concerns real people. Special effects are minimal as the story gently hovers between Hollywood satire and relationship drama. Not even a romance at that, but a study of the weird co-dependent friendship that develops between a washed-up star and an inept director. There are no burning windmills or sinister clowns, although there is a malfunctioning octopus.

Gleaming in fifties-style monochrome, for many critics and fans *Ed Wood* is the high watermark of Burton's career. 'No more affectionate, even admiring tribute to a failure has been made,' was Derek Malcolm's spot-on assessment in the *Guardian*. Wood holds the unfortunate reputation for being the worst director of all time, and his life is one of fascinating contradictions. He was a marine cited for bravery in the Pacific theatre of the Second World War, where he had most of his teeth knocked out. He came prospecting to Hollywood in 1947, first as an actor and then director, fancying himself the next Orson Welles but untroubled by half-dressed sets, visible booms, or plank-like performances.

By 1953, he embarked on the first of the three films that would earn his strange fame, *Glen or Glenda*, in which Wood starred as a transvestite. It was heavily autobiographical. Later, between pitiful stints in television and other exploitation flicks, he would make *Bride of the Monster* (1955) and shambolic alien invasion movie *Plan 9 from Outer Space* (1957), now 'celebrated' as the worst movie ever made. He died in ignominy, a penniless alcoholic and pornographer, in 1978, aged 54.

Johnny Depp's performance as the dotty director is a work of sublime equipoise – the devastating truth of Wood's heroic lack of talent held at bay by the force field of his monomaniacal goodwill. Calibrated to the director's nonspecific tone, by turns melancholy and hilarious, this biopic embodies a neglected theme in Burton's work – his celebration of a true heart. Like Edward Scissorhands or Pee-wee Herman, Edward Davis Wood Jr. is a valiant dreamer. (Like Timothy Walter Burton, too.)

Ed Wood came the director's way only by chance. Screenwriters Larry Karaszewski and Scott Alexander, who are drawn to offbeat biopics – *The People Vs. Larry Flynt* (1996), *Man on the Moon* (1999) – had pitched the idea to *Heathers* director Michael Lehman as a low-budget independent. The producer of *Heathers*, Denise Di Novi, was now working with Burton. Lehman wondered if they might persuade Burton to put his name to the project ('Tim Burton presents Ed Wood!'), and thus help land the necessary budget.

Above: The poster for Ed Wood's alien invasion movie *Plan 9 From Outer Space*, arguably the director's best-known mishap. Naturally, Burton had loved the film's ramshackle science fiction when he saw it as a teen.

Top: Barbara (Dolores Fuller) hands her angora sweater to Glen (Edward D. Woods Jr.) in Wood's notorious transsexual drama *Glen or Glenda*. This very scene would be referenced in Burton's *Ed Wood*.

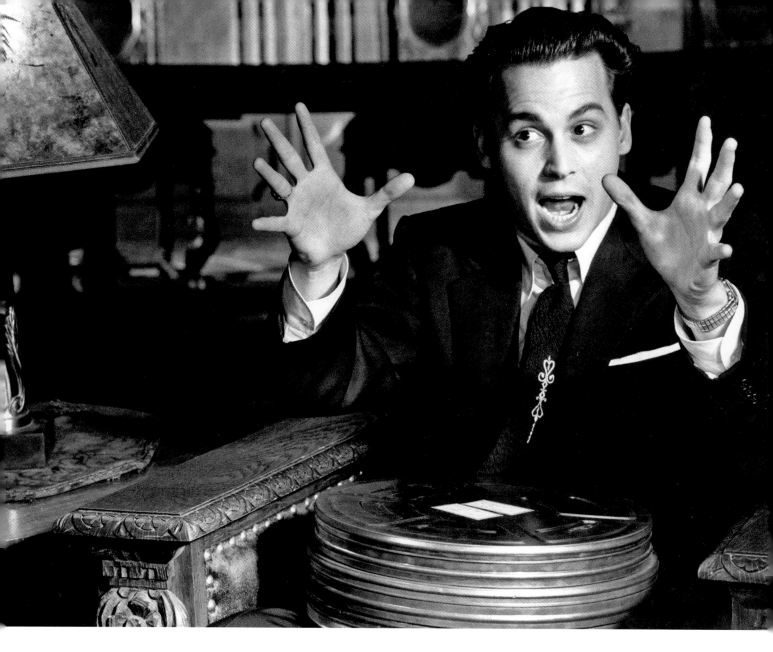

'We got the treatment to Tim and he flipped out over it,' recalls Karaszewski. 'He really identified with the material.'[20]

'I grew up with *Plan 9* and I love it,'[21] Burton acknowledges, and it was a key influence on *Mars Attacks!*. What he loved in Wood's films was their timeless, indefinable quality, 'halfway between brilliant and tacky'[22].

Apart from a pre-credits scene lifted, dolly bump and all, from *Plan 9 from Outer Space*'s overture, Burton focused on the makeshift filmmaking going on behind Wood's films. Watching actual behind-the-scenes footage of the making of *Ed Wood* is surreal. A gangly, excitable Burton shoots Depp as an excitable Wood shooting Martin Landau's Bela Lugosi thrashing about in a pond with a giant octopus prop. The film is permeated with the shambolic ambience of Wood. ✪

Above: Johnny Depp makes his pitch as the implacably upbeat Wood. It's hard not to glimpse some of Burton's own experiences of pitching his dreams to studios in Wood's screen endeavours.

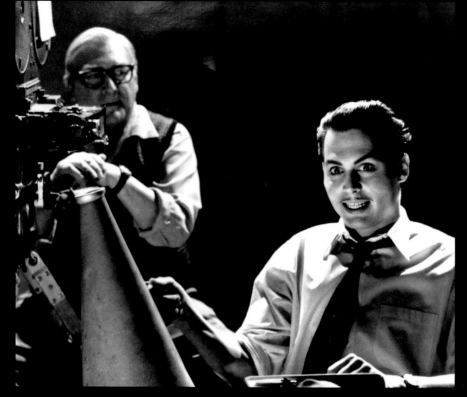

'When you read his letters, you realize he thought he was making *Citizen Kane*,' marvels Burton. 'That's what fascinates me about that character. He was very weird.'[23]

Fundamental was Wood's unstoppable optimism. Such titanic levels of denial was what held Wood together. On one level this is Burton's most upbeat project since *Pee-wee's Big Adventure*. Except, rather than the American Dream, it ponders the American Delusion.

Fatefully, Burton had been holed up in a farmhouse in Poughkeepsie, New York, birthplace of Ed Wood, when the concept came his way. There he read Rudolph Grey's biography *Nightmare of Ecstacy*, a compilation of often-contradictory perspectives. Realizing that there was no accepted history, Burton knew he had to direct the film.

There were, however, a number of roadblocks. Not least, the fact that this was still Lehman's project. Lehman, aware that Burton possessed considerably more chance to get it made, manfully stepped aside. (Conveniently he had another film ready to shoot, in rock comedy *Airheads*, 1994.) For his part Burton had walked away from *Mary Reilly*, a take on Robert Louis Stephenson's Dr. Jekyll and Mr. Hyde seen through the eyes of his maid, which became a notorious flop for Julia Roberts.

Karaszewski and Alexander, their heads brimming with Wood-lore, delivered Burton a 147-page script within a month. 'Tim had no notes at all,' remembers Karaszewski, 'and his intention was to simply shoot our first draft.'[24]

And he intended to do so in black and white. Colour felt less real, somehow. Old

Hollywood, to his mind, existed in black and white. Which meant true black and white film. Not converted colour stock, which had none of the richness.

This would prove the final straw for Columbia. Despite green-lighting the picture upon Burton's signature, the studio backed out. Here was another example of his through-the-looking-glass relationship with Hollywood: studios vie for his dreams, then mess with his head when he tries to carry on being Burton. It was Disney, looking to cultivate a relationship revived on *The Nightmare Before Christmas*, who gave him the $18 million to make his film in black and white.

a Hollywood satire, but an affectionate one, mocking the demands that executives make of Burton via Wood's endless compromises in order to land some finance.

It was only their second film together, but the idea of Depp being a cypher for Burton – *he's playing a director* – was hard to miss. Depp was also mixing in elements of Andy Hardy, Ronald Reagan, and Orson Welles (but not the talented part).

Depp also needed to be able to wear high heels. For Wood had his own defining dual identity: unbeknownst to his girlfriend Dolores (Sarah Jessica Parker), he was a transvestite, with a particular affection for angora sweaters. It was something never played for laughs, but as another thread in the rich tapestry of this extraordinary character.

Fittingly Wood is aided in his dreams by a wonderful troupe of misfits, Burton likens to faded royalty, or an artistic movement – the surrealists of the drive-in circuit. Alongside Landau's wistful Lugosi are The Amazing Criswell, a phoney-baloney psychic-to-the-stars played by Burton regular Jeffrey Jones; voluptuous TV vampiress Vampira, played by Lisa Marie, with whom Burton had begun a relationship; poker-faced transvestite Bunny Breckinridge, played by Bill Murray (who secretly waxed his chest for the part); and erstwhile wrestler Tor Johnson, played by erstwhile wrestler, George 'The Animal' Steele. Who, it turned out, had such surprisingly nimble feet that weights were put in his shoes so that he could adequately ape Johnson's lumbering gait. ✪

What really resonated with Burton in *Ed Wood* was the echo of his brief, tender friendship with Vincent Price in Wood's devotion to Lugosi. 'Vincent was fundamental to my decision in making the film,'[25] he confirms, although the two relationships were markedly different. Wood exploits a sick old man (Lugosi wrestled with morphine addiction), while offering him a weird closure to his career. Lugosi suffers his own strain of delusion. So desperate is he to recapture his halcyon days as Dracula, he has convinced himself that Wood is a halfway competent director.

'There was a resemblance between them, but the differences are striking,' iterates Burton. 'Vincent had a much more positive end.'[26] When Price lost his battle to lung cancer during production, the shooting of Lugosi's funeral sequence took on great poignancy.

As Lugosi, the 64-year-old Martin Landau would be honoured with an Oscar for a performance filled with nuance and pathos. Landau watched thirty-five of the Hungarian actor's films, catching the details – how his eyes were lidded, how he never showed his teeth. Instead of replicating Lugosi's Hungarian accent, he caught his attempts to stifle the accent that he felt was holding him back. Landau invested the character's careworn features with his own from a lifetime filled with the 'peaks and valleys'[27] of an actor's career: enrolling in Lee Strasberg's famous New York acting class alongside Steve McQueen acting for Alfred Hitchcock, then plastic television work on 'Mission: Impossible' and 'Space: 1999'.

The film also invites us to compare Burton to Wood, pitching his wacky ideas to blank-faced Hollywood suits. The film is

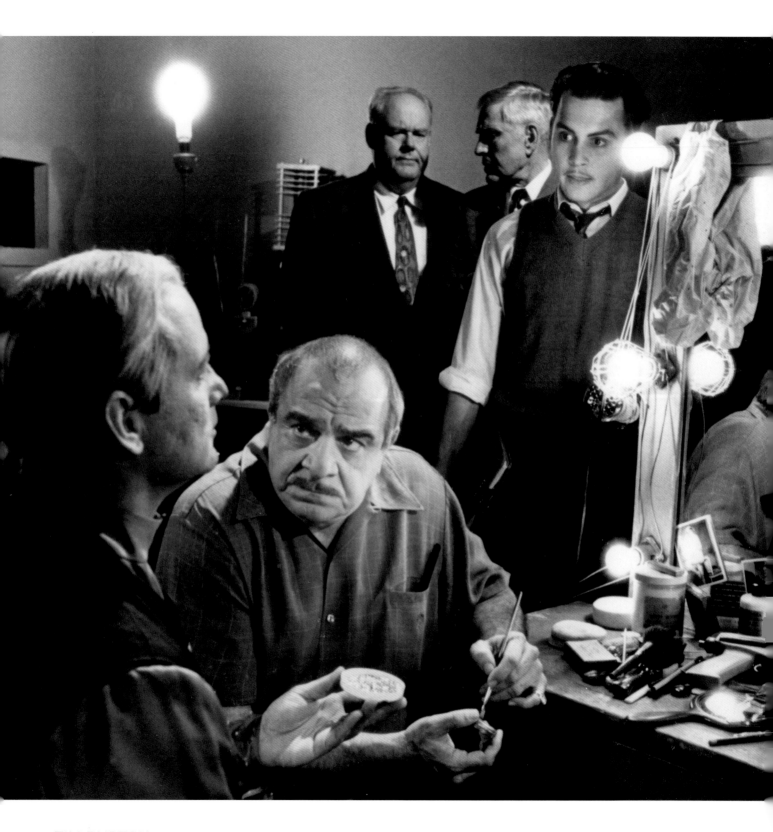

TIM BURTON

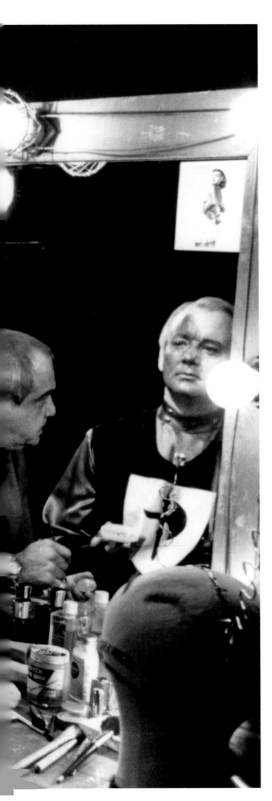

Left: Wood (Depp) with Bill Murray's Bunny Breckinridge, the flamboyant drag queen who featured in Wood's films. Murray was so dedicated he had his chest waxed for the part, even though he never appears topless.

Right: Burton directs Depp and Sarah Jessica Parker, who plays Wood's bemused girlfriend and leading lady Dolores Fuller. The director never set out to mock Wood, the film celebrates his tireless capacity to dream.

Compared to the trials by scale of *Batman Returns*, the small scale *Ed Wood* was a contented experience. Burton felt he had started out in his career with something like Wood's 'weird, perverted optimism'[28] (although it is hard to picture quite the same gee-whizz glee in the tyro Burton), but that spirit had become eroded in Gotham, and he wanted to recapture as much of it as he could.

Over the very same four-block area around Hollywood Boulevard where Wood once hustled his hopeless flicks – as the opening credits roll, the camera hovers over a gimcrack model of Hollywood, spotlighting landmarks and Woodian motifs – this was undoubtedly a return to the personal terrain of *Edward Scissorhands*. There is even some of the giddy abandon and self-parody of *Pee-wee's Big Adventure*. But for all Wood's antics, Burton was taking him seriously.

In tribute to Wood's ramshackle methods, Burton dispensed with storyboards. He thrilled to be improvising scenes with the actors, not quite knowing where he was headed next. Yet unusually for him the film possesses an elegant three-act structure built around Wood's quest to bring his three most infamous films to whatever screen would have them, culminating in the 'triumph' of *Plan 9 from Outer Space*.

According to Stefan Czapsky, who had served as Burton's cinematographer on his previous three films, picking something small showed that the director could be 'creative with the most simple and basic things'[29]. Which, of course, is the point: Burton wasn't making a film in the nuts-and-bolts manner of Wood. He was making a lovingly textured, at times gorgeous film about the creative process.

And wouldn't you know, with a take of just $5.9 million at the US box office, *Ed Wood* remains his biggest flop. Although much like its subject (if for contrasting reasons) this biopic has become a cult item since. Unfazed, Burton chose to take it as a salutary lesson. 'Any of my movies could go either way, they really could, and so the line between success and failure is a very thin one … Who knows, I could become Ed Wood tomorrow.'[30]

POETRY INTO PLOT

DROP-DEAD GORGEOUS
The stop motions

Study his trio of stop motion feature films, and you'll discover ley lines connecting them. They are all highly personal projects, spaced at distinct intervals throughout his career. Two of them are fairy tales, one a monster movie; perfect examples of the lightness with which Burton portrays the dark.

Viewed together, they are the purest distillations of *Burtonesque*, and arguably his most complete pieces of storytelling. And one common ancestor inspired them all – Ray Harryhausen.

'I knew his name before I knew any actor or director's names,' rhapsodizes Burton. 'His films had an impact on me very early on, probably even more than Disney. I think that's what made me interested in animation – his work.'[1]

He had loved how Harryhausen gave his monsters pathos even as they perished, allowing them a last gasp of air or a last rattle of the tail before their motion is stopped forever. It is often said of Burton that he makes live action films as if they were animated, but the reverse is also true: he makes animated films alive with human detail.

This is also why he has resisted the lure of computer animation. He enjoys the sometimes sublime output of Pixar, and two of Pixar's great pioneers, John Lasseter and Brad Bird, are friends from his CalArts days. But generally he finds it 'unappealing looking'. Even when necessity forced him to use CGI on *Mars Attacks!*[2], he bid his computer animators to replicate the heartbeat of stop motion.

He had, of course, experimented with small segments of stop motion in his first two films. Indeed, Stephen Chiodo's work in *Pee-wee's Big Adventure* and *Beetlejuice* signalled Burton's preference for the medium and the ghoulish possibilities it offered.

'There's something very tactile about it,' Burton says, a man who will fly the flag for stop motion until his dying breath. 'There's a set and the lights, the characters are going in and out of shadows – you see that. That's why I loved Ray Harryhausen's work. You can see the hands on it, you know? You can feel an energy to it.'[3]

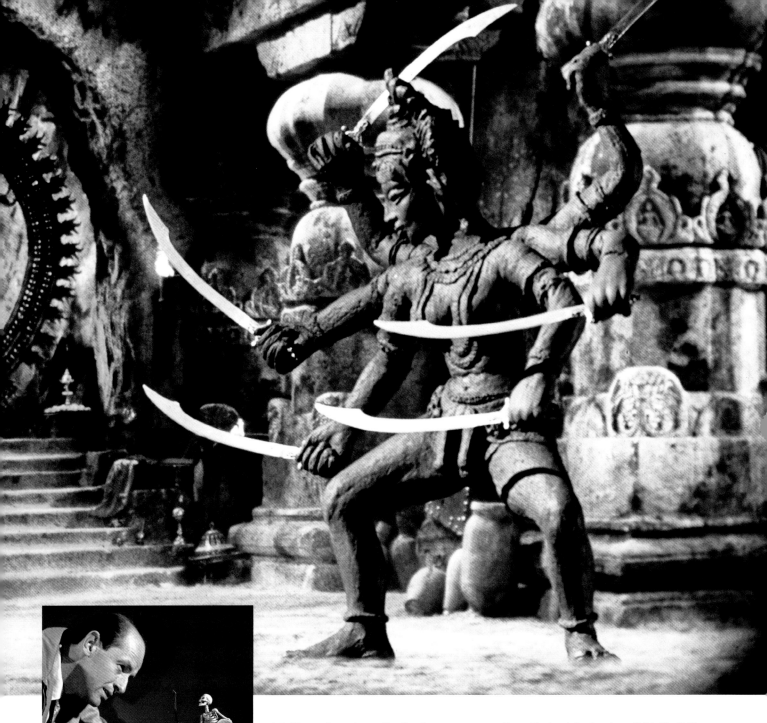

Left: The peerless animator Ray Harryhausen, pictured with one of the skeletons from *Jason and the Argonauts*, was one of Tim Burton's biggest influences. He somehow created pathos in his stop motion monsters.

Above: The heroic hunks take on Kali in *The Golden Voyage of Sinbad*, a quintessential example of Harryhausen's genius. Burton always loved the tactile quality of his models compared to CGI.

DROP-DEAD GORGEOUS

TIM BURTON

Tim Burton's The Nightmare Before Christmas

As a boy, Burton watched as a local department store window changed from a Halloween display into a Christmas tableau. The cogs of his imagination began to click. What if these were two self-contained worlds, each devoted to a holiday? Burton loved the holidays. Virtually overnight the blank streets of Burbank were transformed into a fairy-tale kingdom.

As the concept quietly marinated in his brain, Burton added the seasoning of Clement Clark Moore's 'The Night Before Christmas', Dr. Seuss' *How the Grinch Stole Christmas!*, Rankin and Bass's *Rudolph the Red-Nosed Reindeer* (1964), and his devotion to holiday specials. The result was a poem called 'The Nightmare Before Christmas', which he imagined Vincent Price reciting, just as he had narrated *Vincent*. The year was 1982, and Burton was intent on this becoming a full feature film made in stop motion for his employers at Disney.

The poem told the tale of Jack Skellington, the kindly but despondent King of Halloweentown, depository of all the unloved freaks and fiends. He's in charge of throwing the perfect Halloween every year, and you could say Jack was a director, except he has grown bored, and fancies swapping genres to attempt Christmas instead. *Tim Burton's The Nightmare Before Christmas*, to give it its later full title, was to be the most bountiful expression of Burton's desire to place monsters in a good light.

Disney didn't understand it at all. They had little faith in stop motion, and less still in such disturbing material. A rag doll who

can unthread a limb? A crippled scientist able to open his head like a bin lid to give his brain a scratch? 'You couldn't give it away,'[4] sighs Burton. Once established as a director, he would mention this dream project in interviews, only to lament how it was still locked away in Disney's vault. Given that he had originated the idea while under contract, they retained the rights. 'You signed your soul away in blood,' Burton notes sourly, but following *Batman*'s success, he wondered if he had the influence to prise it free. 'I kind of gently said, "Could I just have it back?"'[5]

Since his leaving, the company had become a cannier outfit. A new regime was keen to make amends for previous shortsightedness. 'We were looking to do something completely unique,'[6] says David Hoberman, then President of Walt Disney Pictures. Who better than the prodigal Burton to help them 'think outside the envelope'?[7] This would be Disney's first-ever stop motion feature. And their first film to feature an obese baby with eyelids sewn together.

There was one caveat – while it was obviously a personal project, Burton wouldn't direct. 'If I had,' he laughs, 'I would be dead before I ever saw the final version.'[8] Experience had taught him that he lacked the mental capacity for the glacial momentum of animation. His name would be added to the title, explicitly demonstrating the power of the Burton brand, but he would hand direction to his old friend Henry Selick.

Another CalArts peer adrift in the halls of Disney, Selick had ended up cutting stop

motion idents for MTV. The pair were two black-eyed peas in a pod. While Burton delighted in spindle-limbed spectres, Selick was heavily into experimental German animation. For both, the opportunity to subvert Disney's candyfloss philosophy was sweet revenge. ✪

Above: Among the many influences on *The Nightmare Before Christmas* was Rankin and Bass' stop motion tale *Rudolph the Red-nosed Reindeer*, which had stuck with Burton since he was a child.

Opposite: Santa Claus comes in for some manhandling from the crew of Halloweentown. The chance to subvert Disney's candyfloss philosophy was sweet revenge for Burton on his former employers.

DROP-DEAD GORGEOUS

Left: Burton poses with models of Jack Skellington and Sally. 'Stitched together' characters like Sally frequent Burton's films, from *Edward Scissorhands* to the *Corpse Bride*.

Opposite: Jack tries to sing away his Halloween blues. Composer Danny Elfman wrote all the songs and provided Jack's singing voice. The film was Burton's first experiment with the musical genre.

So whose *Nightmare* is this exactly? Pinpointing the driving creative force behind the film has become a hotly contested issue. It's impossible to downplay Selick's contribution. He was the de facto director, devising the elaborate camera moves and theatrical lighting. And it was Selick who set up the team in July 1991, a crew of 110, working across 230 miniature sets. At any one time, twenty sets were active as if a toyshop opened in an insane asylum.

While Burton was locked away in the human-scale fairyland of *Batman Returns*, *The Nightmare Before Christmas* inch-by-inched into existence at a rate of – at best – 70 seconds a week in San Francisco's South of Market district. That location was as much a matter of mining local stop motion talent as escaping the psychic boundaries of Hollywood.

Over two sun-starved years, the team created the most painstakingly detailed stop motion film ever made. Jack alone had 800 different replacement heads (for different expressions) – and two puppet rooms housed parts for seventy-four individual characters.

There were as many as 540 movements in each shot (most stop motions average 100), captured by a probing camera. Selick likens the concentration levels required to neurosurgery.

Nevertheless, there is little doubt whence its ghoulish marvels originated. *The Nightmare Before Christmas* is unequivocally the most amount of Burton it is possible to squeeze into seventy-four vibrant minutes. In the helter-skelter design of Halloweentown there are hints of Edvard Munch, Charles Laughton's *The Night of the Hunter* (1955) and Disney's *Fantasia* (1940). In the head-scratching Dr Finkelstein, the inventor of poor stitched-together Sally, is a reflexive nod to James Whale's *Frankenstein*. And who else would dare the unthinkable of a leading man without eyes to express with?

Alongside *Edward Scissorhands* (the story of a man who brings a puppet to life) and *Ed Wood*, this is the film Burton feels closest to.

Another key contribution came from regular composer Danny Elfman. For *The Nightmare Before Christmas* might also be described as Burton's first musical. Not in the Disney mode of brief musical pep talks to gee up flagging spirits, this was to be fully fledged opera, a story crafted in song. Before a single puppet had been made, Elfman had composed ten tracks in the grand, narrative fashion of Broadway genius Stephen Sondheim (composer of *Sweeney Todd: The Demon Barber of Fleet Street*). He was also determined to provide the singing voice for Jack. 'I made demos of all the songs,' he explains, 'but I felt with Jack's character I had nailed it.'[9] No one else, he felt, would be able to express the existential crisis of a skeleton in quite the same way. Chris Sarandon provides Jack's speaking voice. ✪

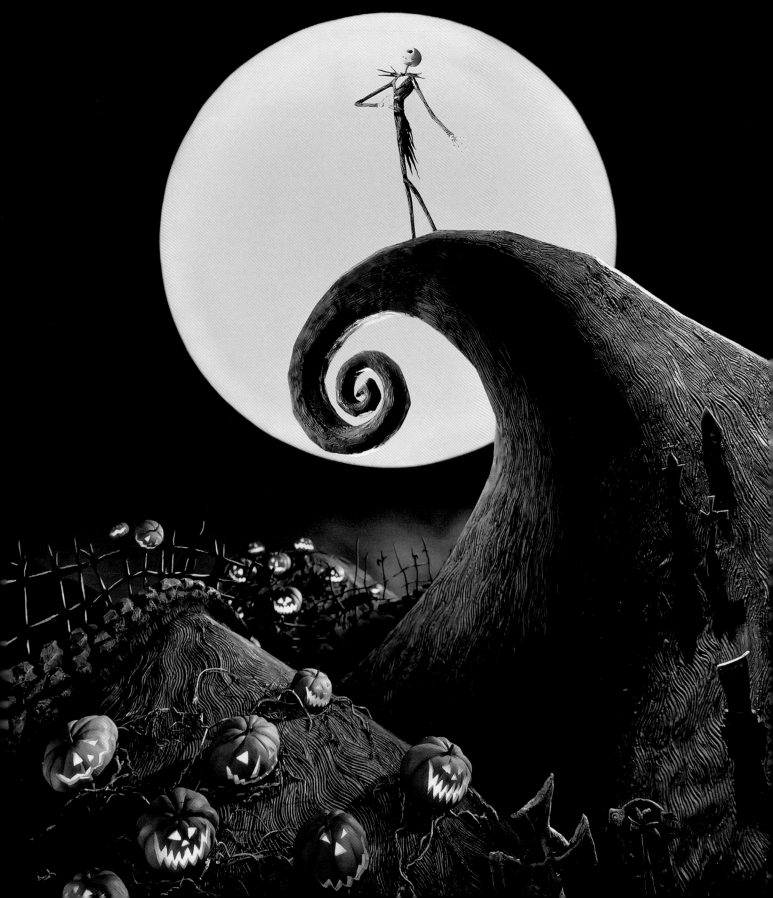

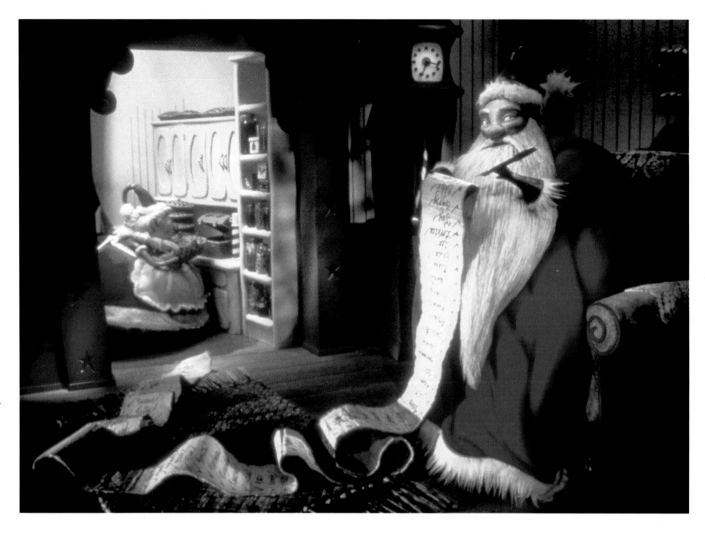

Above: While not an instant sensation on its release, *The Nightmare Before Christmas* has been re-released almost yearly and has become a seasonal tradition of the very kind it set out to parody.

The film failed to set the box office alight on its initial run. Disney, despite their bluster, released it cautiously. Budgeted at $18 million, it made a not unrewarding $51million, but it was only on DVD and video that it prospered. *The Nightmare Before Christmas* is a gift that keeps on giving. Revived at cinemas every Halloween – or Christmas – it has become a seasonal tradition of exactly the kind it set out to parody. It's a wonderful afterlife.

And it is only in the light of its cult status that the question of credit even arose. Any difficulties during shooting were never

great. Burton would, when he felt it was required, intervene: the production was shut down for a week when he decided he needed Halloweentown to feel darker. 'I was very comfortable with my role,'[10] he maintains. He knew Selick's talents and trusted him.

Yet, as the film and Burton's part in it are venerated, Selick often adopts a wounded tone. After all, Burton produced Selick's *James and the Giant Peach* (1996), and no one contests whose film *that* might be. 'I don't want to take away from Tim,' he says carefully, 'but he was not in San Francisco when we made it.'[11] He estimates Burton

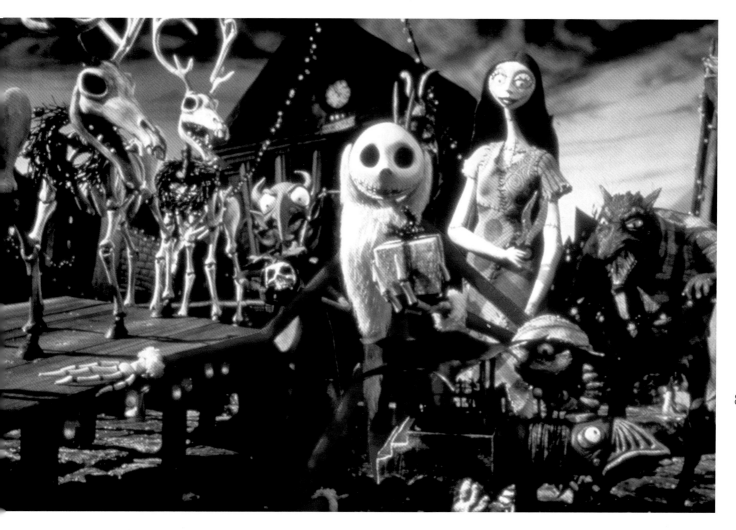

spent no more than ten days on set, although he was there for the meticulous edit.

Then again, you simply can't escape that Halloweentown is like a glimpse into Burton's psyche. A classic outsider figure, thin and austere, Jack wants to break free from his creative rut. Although, as it turns out, he's not very good at mounting the commercial glitz of Christmas. Best leave Christmas to Santa, warns the film; Jack should stick to Halloween.

Critic Kim Newman sums up the dilemma perfectly in *Sight & Sound*: 'Nightmare seems to be a film *about* rather than *by* Burton.'

Interestingly, there is a deleted scene on the DVD, where the vampires are playing ice hockey, but no longer with a Jack O Lantern as in the finished film, with Burton's severed head.

Above: The multitude of characters was first envisioned by Burton as sketches and watercolours, many of which dated back to his time as an animator at Disney in the early 1980s, when he first pitched the film.

DROP-DEAD GORGEOUS

Tim Burton's Corpse Bride

Once upon a time Tim Burton's house was filled with the sweet-wrapper bright figurines made to celebrate Mexico's *Día de Muertos*, or Day of the Dead. All these doll-sized skeletons dressed in their Sunday best looked just like his stop motion puppets. To his eye, they were utterly charming. 'They'd always have these nice scenes with them in clothes,'[12] he delights, inspired by their humour.

In other words, Burton wanted to laugh in the face of death. And this folk tradition, mixing Christianity with Aztec mysticism, taught children not to be afraid. In the same way, he's always considered his own films to be life-affirming. Not least *Corpse Bride* (officially *Tim Burton's Corpse Bride*), his second stop motion film, boasting an underworld of hipster undead motivated by the *Día de Muertos*. It is the world of the living that is terminally depressed.

Burton was always intent on returning to stop motion, but other films kept getting in the way. Before he knew it, more than ten years had passed since *The Nightmare Before Christmas*. And in the meantime, Pixar had risen to the summit of animation.

It's ironic, then, that it was a member of the Pixar fraternity who had suggested *Corpse Bride*. Joe Ranft, who died in a car crash in 1995, was a gifted story editor and fellow CalArts old boy. Now a major creative force at Pixar, he had been drawn to a nineteenth-century Jewish folktale that had its roots in central Europe (or even as far east as Russia). Little more than a paragraph long, it told of a callow groom-to-be returning home, only to mislay his wedding ring on the corpse of a murdered bride. Springing back to 'life', she insists they are now engaged.

Zombie brides? Uncertain heroes? A story set between a snowy, shuttered real world and the cavernous realm of the dead?

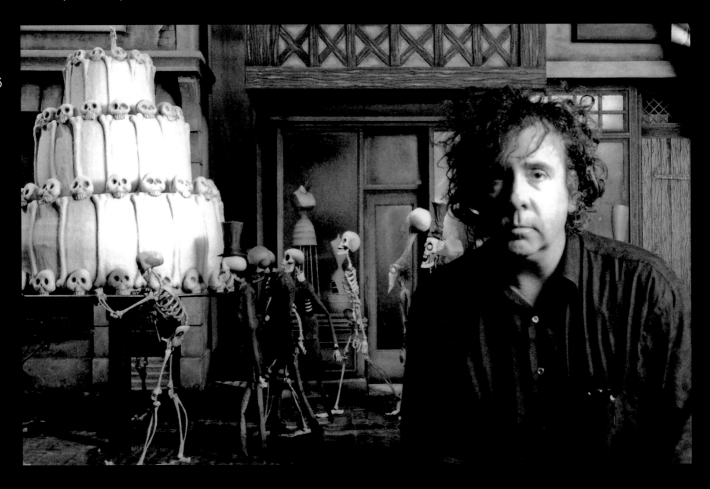

TIM BURTON

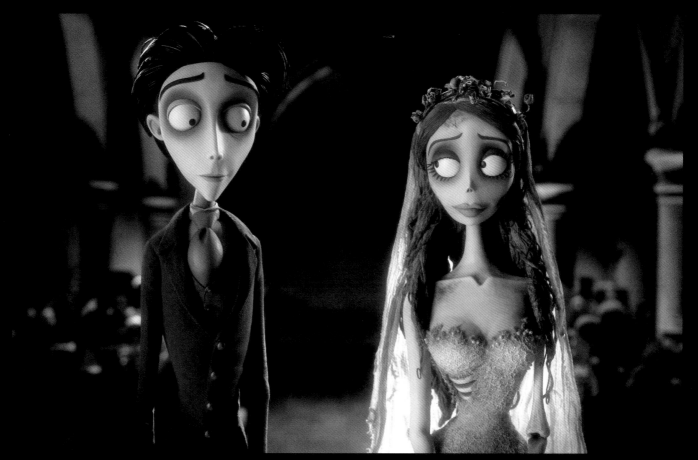

Above: Victor Van Dort (Johnny Depp) warily eyes his deceased bride-to-be (Helena Bonham Carter). The beauty of the story for Burton was that all the characters were outcasts in their own way.

Opposite: Burton poses with Bonejangles (voiced by Danny Elfman), his skeleton crew and an undead wedding cake, in what would become a traditional shot of the director and his model cast.

Ranft immediately thought of Burton. And Burton was instantly hooked. 'The purpose of folktales for me is a kind of extreme, symbolic version of life,'[13] he says. Sort of like fairy tales, but located in a particular culture.

He loved how it was almost an extension of the love story in *The Nightmare Before Christmas* between rag doll Sally and Jack. That emotional quality which he found in Harryhausen's monsters would be redoubled for this spooky love triangle. 'That's what gave it its poignancy to me,' he says, 'and its bittersweet and sort of hopeful and sad quality altogether.'[14] Something CGI could never match. So Burton began to sketch out the characters, breathing life into the idea. Only it lay dormant.

The reason was partly studio indifference. *The Nightmare Before Christmas* was not yet viewed as a success, and its team had long since dispersed. Meanwhile, Burton had struck a first look deal with Warner Brothers, who were sceptical about the process after *Mars Attacks!* had turned to CGI instead of stop motion to realize its aliens. The greenlight finally came in 2004, when animation was assumed to be lucrative enough to encompass even the mannered techniques of yesteryear. (A correct assumption: *Corpse Bride* would eventually make over $100 million worldwide). ✪

This time, Burton was very much at the helm. Although, directing this fable in tandem with *Charlie and the Chocolate Factory* in 2005 necessitated a co-director in Mike Johnson, who had been an assistant director on *The Nightmare Before Christmas*. Johnson managed the day-to-day work, reporting in to Burton, acting as his eyes and ears among the myriad tiny eyes and ears on set. 'I feel we complemented each other well,' says Burton. 'It was just a different movie, a different process.'[15]

For one thing, production took place in the UK, at Three Mills Studio in East London. And for another, the technology had come on in leaps and bounds: not just digital still cameras, but also puppets with clockwork heads operated by tiny keys, liberating the animators from the rigmarole of swapping between 800 heads to change expressions. Nonetheless Burton immediately fretted that the advancing technology might smother the human touch.

Perhaps to settle his nerves, Burton, Johnny Depp and Helena Bonham Carter made a pilgrimage to Ray Harryhausen's home in London. It was the first time the director had met his hero, a meeting that went well enough for Harryhausen to come to the set. Burton laughs, remembering how his animators stopped to bow before their idol. 'Production sort of ground to a halt that day.'[16] The film itself offers a further tribute: as Victor picks out notes on a grand piano, you can see that it bears the nameplate 'Harryhausen'.

Pamela Pettler and *Big Fish*'s John August each took a turn rewriting Caroline Thompson's script – and, to Burton's mind, bringing it into focus. *Corpse Bride* is one of the most rounded stories Burton has ever told, beautifully balanced between humour and emotion.

On the bare bones provided by producer Ranft grows a touching, if strange, love story between Victor Van Dort (Depp), timid son of a canned fish dynasty; Victoria Evelgort (Emily Watson), daughter of a haughty clan laid low fiscally speaking; and the Corpse Bride (Bonham Carter), slain on her way to the altar. 'They are all outcasts in their own way,' Burton points out, 'and that's the beauty of the story to me.'[17] The story juggles themes of class and social constraint versus the freedom to be who you are and the twinned natures of love and death. Danny Elfman added songs (wistful for scenes in the world above, jazzy for the world below) but it was not, strictly speaking, a musical.

Depp and Burton were on set of *Charlie and the Chocolate Factory* when Burton suggested they head over to the recording studio and try to give Victor a voice; simple as that. With no preparation, and barely time to get out of his Wonka wig, Depp found himself voicing his first animated movie.

'Great thing is he likes to work spontaneously too, and really in that one session he got it,'[18] says Burton, who never suspected otherwise. Depp found Victor familiar: 'He's a character that's not so far

88

Corpse Bride doesn't boast the vivacious free rein of *The Nightmare Before Christmas*, it has a more controlled, lyrical beauty. Keith Ulrich on Salon.com called it a 'minor-key horror fantasia'. But there are many who found themselves in tune with its cool hues and flares of exuberance. 'Like all Burton's best work,' wrote Tasha Robinson at The A.V. Club, 'it takes place in a distorted, vividly colored, meticulously crafted world where whimsy and gleeful ghoulishness mix freely.' To be exact, like its predecessor, it is located in *two* meticulously crafted worlds: a very literal representation of Burton's ever-present duality.

The World of the Living: this unnamed European city comes embalmed in a silvery gloom, with glints of purple, crimson and blue. The living have the pallor of death in their cheeks, citizens of a repressed Dickensian, even Kafka-like municipality where no one has any fun at all. It is more dead than the world of the dead.

The World of the Dead: the underworld unfurls in a nightclub palate of greens, golds and reds, inspired by those Mexican Day of the Dead celebrations, only mixed with a Creole vibe. Here can be found Burton's familiar skeleton crew, including a severed headwaiter and a green worm with the snivelling pitch of Peter Lorre, who lives behind the Bride's eyeball.

Left: With its wintery, Dickensian gloom, the meticulous sets for the world of the living were designed to appear far more lifeless than the more colourful world of the dead.

Below: The Corpse Bride drifting through the world of the dead. The jazzy underworld bore quite a close resemblance to Halloweentown in *The Nightmare Before Christmas*.

away from other characters that I've played in the past for Tim, like Edward Scissorhands, a little bit of an outsider. A bumbling, deeply insecure nervous character.'[19] He could be Ichabod Crane's twin.

He is a tentative, undernourished specimen with a bearing of both Burton and Depp. But he's not a hopeless case. Even though he loves Victoria, he has the goodness to help the Corpse Bride who first drags him down to the Underworld, where he finds death to be a lively place. ✪

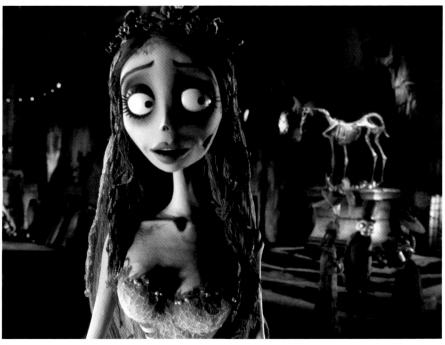

DROP-DEAD GORGEOUS

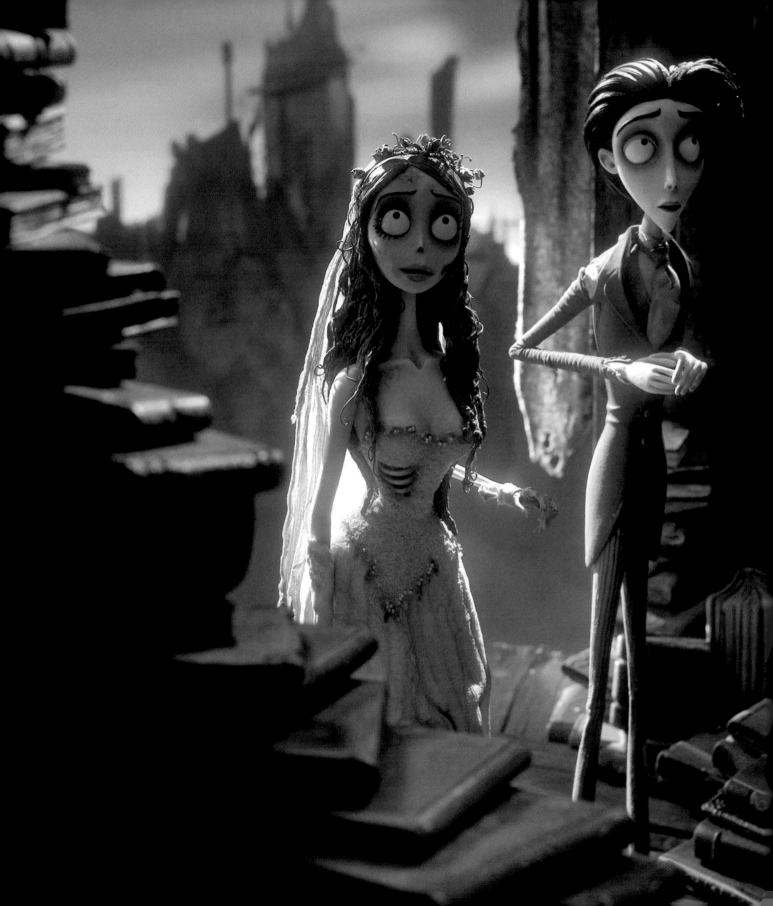

Left: The Corpse Bride (Helena Bonham Carter) guides Victor Van Dort (Johnny Depp) through the confines of the World of the Dead. The facial expressions of the puppets were adjusted by hidden clockwork, which was engineered by a Swiss watchmaker.

DROP-DEAD GORGEOUS

Frankenweenie

Tim Burton can tell you exactly where his 2012 version of *Frankenweenie* takes place, down to the postal address. 'Off Victory Boulevard, Hollywood Way, moving toward North Hollywood, but the flatlands of Burbank. And a little bit of the downtown area, up where the City Hall is, but mainly the flats.'[20]

Frankenweenie is explicitly a psychic journey back into Burton's doleful youth, remaking his 1984 short (shot in Pasadena). His third stop motion movie doesn't take place in an imaginary world per se, but in a very specific model of his former haunts.

Preparing the exhibition of his artwork for the Museum of Modern Art in 2008, he had come across the 'abstract' sketches he had made for the original. They stirred up something very peculiar – *affection*. 'The heart of it then, is still the heart of it now,'[21] he says, summing up his recalibration of the story. A precocious but sullen boy named Victor resurrects his deceased mutt Sparky by harnessing a lightning bolt, like Baron Frankenstein.

Significantly, John August provided the final script. He was the writer for *Big Fish*, another film contemplating the proximity of memory and imagination. And *Frankenweenie*'s real-life framework would be embodied by a stop motion suburban monster movie based on the panoply of creature-features filed away in Burton's memory bank from afternoons spent glued to the box.

'If you grow up liking a certain movie, it's always part of you,' he admits. 'And no matter how hard you try to you can't shake those feelings from earlier on in your life. I liked making Super 8 films. I wanted to be a mad scientist – not a regular one, a mad one … That's what's fun about memories – it's like a dream.'[22] ✪

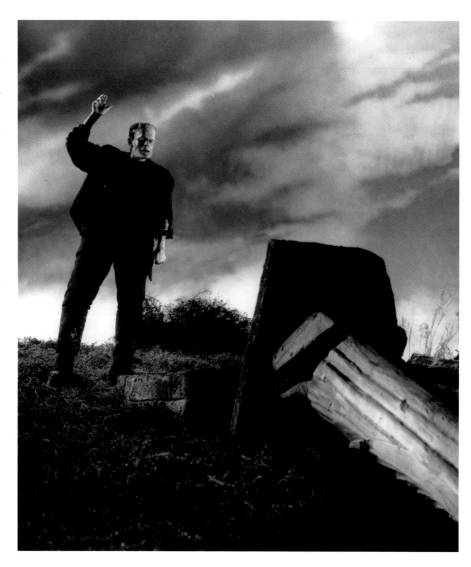

Above: James Whale's classic 1931 adaption of *Frankenstein* has had a huge influence right across Burton's career, but never more so than on Burton's remake of his own *Frankenweenie*.

Opposite: The original live action version of *Frankenweenie* was buried by Disney in 1984. The remake gave Burton another chance to make good on his disappointing early days at Disney.

A FILM BY TIM BURTON

DISNEY

FRANKENWEENIE

Like *Corpse Bride*, *Frankenweenie* was filmed at Three Mills Studio in London from July 2010 to the latter half of 2011. (Look for the mention of *Drei Motens* beer, German for 'three mills'.) Much of the same team as *Corpse Bride* operated the 200 puppets, whose mechanics were fine-tuned versions of those used in Burton's previous animation. Swiss watchmakers had been enrolled to fashion the tiniest parts. But where *Corpse Bride* had merely been drained of colour, *Frankenweenie* would follow *Ed Wood* and be shot in resplendent black and white.

'If it were colour, I wouldn't have done it, because it's part of the emotion of it, the black-and-white,'[23] explains Burton.

Disney was now fully simpatico. Don Hahn, the interim head of animation, remembers showing around John Lasseter, who had recently taken over as Chief Executive Officer. Tentatively listing off potential new projects, Hahn told his new boss, 'Oh, yeah, and Tim wants to do *Frankenweenie*.' To which Lasseter responded, 'Oh, that's great.'[24]

Expanded to encompass all sorts of dabbling in the unnatural by Victor and his eccentric classmates at New Holland Elementary School, *Frankenweenie* is a feast of references to black and white horrors,

94

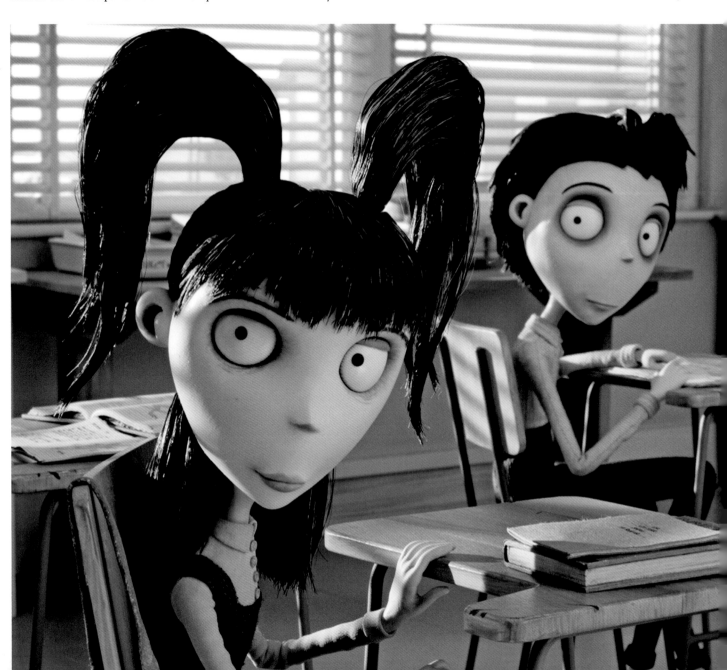

Japanese Kaijus, atomic-age B-movies, and Burton's own catalogue of weird wonders. All delivered with a cornball innocence …

The pigtailed girl next door is named Elsa Van Helsing like the famous vampire hunter. Her poodle Persephone, named after the reluctant queen of the underworld in Greek myth, gains a shock of white hair as Elsa Lanchester does in *Bride of Frankenstein* (1935). Winona Ryder plays Elsa, a happy

reunion with Burton after *Beetlejuice* and *Edward Scissorhands*.

Victor's émigré science teacher Mr. Rzykruski (like 'Rice Krispie') looks and sounds awfully like Vincent Price – as impersonated by Martin Landau, who played Bela Lugosi in *Ed Wood*.

But it is in Victor's peers, and their complicated pets, that the film takes flight into the past. Tall, brooding Nassor is a bit

like Lurch, manservant to The Addams Family, but mostly like Frankenstein's monster as played by Boris Karloff. Snivelling toady Edgar E. Gore is an obvious Igor (assistant to so many Gothic villains), who turns a jar of sea monkeys into a Gremlins-like batch of razor-toothed critters. Weird Girl is directly lifted from *The Melancholy Death of Oyster Boy & Other Tales*, while her cat, Mr Whiskers, is transmogrified into a Draculaesque vampire cat. Most specifically, Victor's science geek rival Toshiru is a tribute to Ishiro Honda, auteur of the early Godzilla movies. Toshiru uses Miracle Grow to mutate his turtle Shelly into a giant, caterwauling Gamera-like monstrosity while capturing it on his Super 8 camera.

'I tried to make sure that the enjoyment is not based on knowing what those references are,' insists Burton. 'It was more about trying to give the flavour of those films.'[25] ✪

95

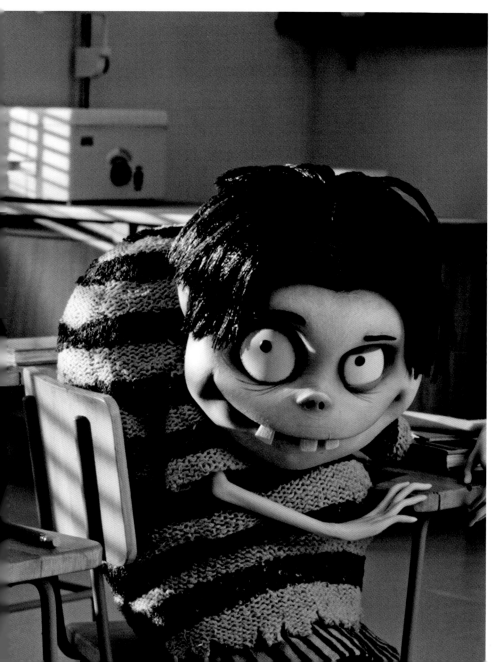

Left: Elsa Van Helsing (Winona Ryder), Victor Frankenstein (Charlie Tahan), and Edgar 'E' Gore (Atticus Shaffer) turn on a classmate. While made in a spooky, horror-movie black and white, Burton was specifically referencing childhood memories.

DROP-DEAD GORGEOUS

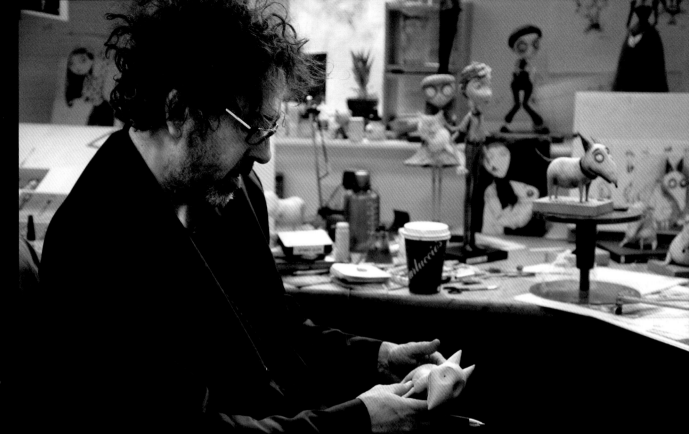

Above: Burton examines an incomplete model of Sparky. The ghost dog in *The Nightmare Before Christmas* and the skeletal one in *The Corpse Bride* are often considered ancestors of the undead Sparky.

Once asked whether there really had been a kid who looked like Igor or Frankenstein in his class, Burton avowed there was. Well, to an extent: 'There was definitely a Weird Girl – I specifically remember her. And some of the people there were a mixture of types.'[26]

Frankenweenie gently splices his memories of watching movies with those of watching real people to the point where even Burton can't quite tell where the exaggerations begin. For instance, Victor's befuddled parents (voiced by two of Burton's favourite improvisers, Martin Short and Catharine O'Hara) are loosely his own parents, only more optimistic and sympathetic.

Victor, who spends too long in the attic with his experiments, will be cajoled onto the baseball field where canine disaster strikes. And Burton did once have a dog he felt closer to than anything else. He was a mongrel called Pepe – he can remember him like yesterday. 'Like your first love,' he says. 'It was powerful.'[27] Only a dog can give unconditional affection, and a pet dying is often a child's first experience of death. Edward Scissorhands was based on both Depp's and writer Caroline Thompson's pet dogs.

'I had the dog when I was, I think, probably really young, like three-ish, and it wasn't supposed to live very long, because it had distemper, so there was always this

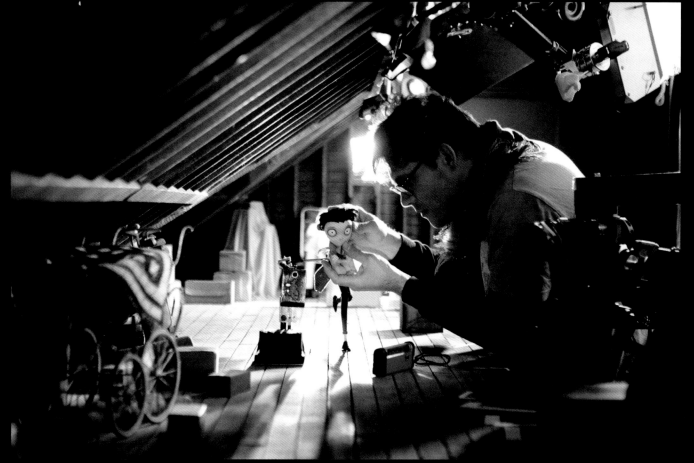

spectre that, you know, your friend wasn't going to be around very long, and it ended up lasting quite a long time …'[28] Burton has kept dogs all his life, especially Chihuahuas. A fact celebrated in his films: some theorize that Sparky's bull terrier is a descendant of Scraps, the skeleton mutt in *Corpse Bride*, who in turn is the offspring of Zero, the red-nosed ghost dog from *The Nightmare Before Christmas*.

And that graveyard where Sparky is temporarily interred, like so many *Burtonesque* graveyards, finds its source as the Pierce Brothers Valhalla Memorial Park, the 63-acre Burbank cemetery where Burton roamed as a child. Although, it has to be

said, the real one has fewer gargoyles, fewer crypts out of which might lurch mummified hamsters.

'I like the film. I can't say that about a lot I've filmed,'[29] concludes Burton in a rare moment of satisfaction. Critics tended to agree that animation suited him. *Variety*'s Justin Chang noted the film's 'artistic coherence'. Lisa Schwartzbaum was swept away in *Entertainment Weekly* by its 'exquisite, macabre mayhem'.

For all the good will, however, there were diminishing returns. The film, which cost $39 million, would make only $81 million worldwide. No turkey, admittedly, but stop motion was looking like an indulgence.

Above: An animator at work in Victor's attic-cum-laboratory. Burton didn't feel it was necessary for the audience to know all the references to horror films. It was all about investing the film with the flavour of the films he had grown up with.

HEAD CASES
Aliens and demons

Only on a Tim Burton set could the fish be divas. For what would turn out to be *Mars Attacks!* most beguiling sequence, Lisa Marie's mysterious stranger infiltrates the White House via Martin Short's lusty press secretary Jerry Ross, transfixed by her torpedo breasts and gum-chewing nonchalance. She is, of course, a Martian plant with her magnificent beehive hiding her giant *This Island Earth*-style brainpan, and her swishing gait, surging forward whenever Short's back is turned, manages the remarkable feat of appearing exactly like the special effects.

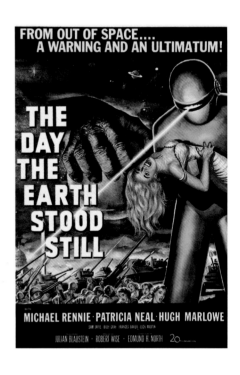

With his own below-decks White House love pad, opened by a switch hidden in a presidential bust (a reference to the Batcave trigger in the 1960s 'Batman' TV series), Short's Austin Powers-like stooge was read as a direct jibe at Dick Morris, the disgraced advisor to President Clinton's disreputable administration. This was another flash of the satirical fangs in Burton's B-movie-with-a-budget positing the attempt by psychotic Martians in a fleet of Ed Woodian flying saucers to wipe out the (mostly) deserving population of the world – as (mostly) exemplified by Americans. The desired tone

was anarchic B-movie mayhem – although such wackadoodle bedlam would prove an acquired taste.

Marie's chewing gum, by the way, provisioned Martian Girl with nitrogen (they don't dig oxygen, hence the bell jar headgear), gave her a 1950s hipster-chick detachment, and was a reference to the strip of pink bubble gum that came with a pack of Topps trading cards (more on which in a moment).

The shot in question required Short to leer through his large fish tank at his alien catch. And, in the reverse, for Marie to stare blankly back. The only problem was that whenever the cameras rolled, the fish darted

Above: Robert Wise's celebrated science fiction movie, *The Day The Earth Stood Still*, was openly referenced in *Mars Attacks!* not only in the giant Martian brains, but by the portentous scientific dialogue.

to the bottom of the tank. Long nets were finally used to coax these introverts from their hidey-holes.

Fish or no fish, Burton was having a blast. 'I laughed every day on this movie,' he remembers happily, 'and got a real joy out of seeing these fine actors just pretending. I almost thought of releasing the movie with no Martians so you could see what these people were reacting to – nothing!'[1]

Openly prone to depression, Burton had been in a bad place since *Batman Returns*. *Ed Wood* might have offered a temporary reprieve, but the struggle to make the sequel and the negativity surrounding its supposed darkness had left him feeling alienated and uncommunicative. 'I remember him saying that he wanted to give it up,' says Jonathan Gems, the British screenwriter of *Mars Attacks!* 'He wanted to just be a painter.'[2]

Much of the credit for reviving Burton's appetite for film-making was put down to former Calvin Klein model Marie. They had fallen in love shortly after *Ed Wood*.

The director's good vibes were infectious. Short was dancing around set, whistling disco tunes. 'Cheese,' he would demand of no one in particular, 'I need more cheese!'[3] He didn't mean dairy, either. This was the term cast and crew had coined for the blockbuster's out-there tenor of B-movie insincerity and madcap comedy. The correct level of cheese was vital.

Right: Lisa Marie's luminous Martian Girl. Marie had spent hours getting the exact scuttling movements of the Martian correct in a *tour de force* of a cameo.

99

Above: Tom Jones (as himself) and Barbara Land (Annette Bening) attempt to give the Martians a taste of their own medicine. The dotty sci-fi comedy remains Burton's only true ensemble piece.

Mars Attacks!

In the summer of 1994, Gems was wandering around Wacko a self-proclaimed pop culture toy shop with a punk rock attitude (a fine definition for *Mars Attacks!*) on Melrose Avenue in Los Angeles. Gems, an erstwhile playwright who had adapted George Orwell's *Nineteen Eighty-Four*, had come to know Burton doing a rewrite on *Batman*. Milling around the tin wind-ups and Japanese robots, he discovered a pack of Mars Attacks! trading cards from The Topps Company, Inc. Enthralled, he purchased them, eager to show his friend.

Founded in 1938, Topps was a tobacco seller that ventured into bubble gum in the 1950s. They soon cottoned on to the fact you could sell more gum by packaging it up with trading cards. They started with Western heroes, and by the 1960s hit upon the idea of a modern War of the Worlds series. Entitled 'Mars Attacks', Topps' 55 depictions of alien malevolence were launched in 1962 at the height of the Cuban Missile Crisis but hastily discontinued after an outcry over their gory depictions of charred human remains led to mixed sales.

Burton was besotted. 'I just loved the way they looked,' he says, 'I love the naïve quality of the original cards, and the style of painting is just beautiful.'[4]

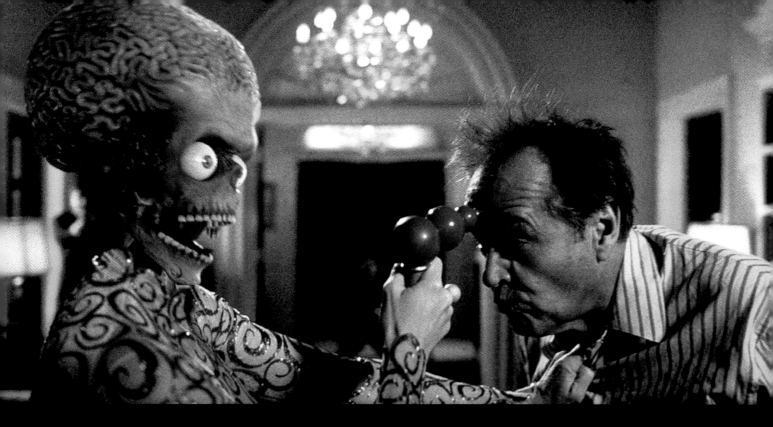

He had been toying with a series of cost-effective 'Friday-night date-type movies'[5] for Warner, in keeping with the low-rent schlock that had awed him as a teen. And the Mars Attacks cards evoked exactly the right mood. At first, he wondered if Topps' Dinosaurs Attack cards (a comic-book tie-in from 1988) would make the better movie, but was dissuaded from a cheesy dinosaurs-attack-suburbia comedy, fearing it might look like a copycat Jurassic Park. Testy aliens in tin-pot flying saucers were the way to go.

Some critics have seen Mars Attacks! (the exclamation mark was a Burton addition) as a 'thematic sequel'[6] to Ed Wood. While not actually employing the bona fide ineptitude of the cult director, Burton's film does possess a pseudo-wooden sensibility that harks back to Wood's zeal for sci-fi movies. 'I remember

reading stuff when I was doing Ed Wood about how much he was into them,' he recalls. 'For a lot of people, myself included, they are the inspiration in wanting to do movies.'[7]

Gems puts it more directly: 'Here was the chance to do something like Plan 9 from Outer Space, with a bit more money of course.'[8]

Their process of fashioning a story from a pack of bubble gum cards was more in keeping with the automatic writing games of the surrealist tradition than circumscribed Hollywood plot construction. Gems and Burton simply scattered the cards on the carpet and picked out the ones that appealed to them, leading to such striking vignettes as Burning Cattle (#22), Destroying a Dog (#19) and The Shrinking Ray (#24). Amusingly, they never sussed that Topps had already provided a narrative on the reverse of each card.

For all the talk of reviving a drive-in sensibility, both director and writer were keen for the film to feel big. Unlike movies such as Earth vs. the Flying Saucers (1956) or It Came from Outer Space (1953), where the invasion seems to happen to just one guy and his girlfriend. They wanted global destruction.

Above: Jack Nicholson comes a cropper as the ineffectual President James Dale, one of two roles the superstar took in the film. Initially, he had proposed playing every role in the film.

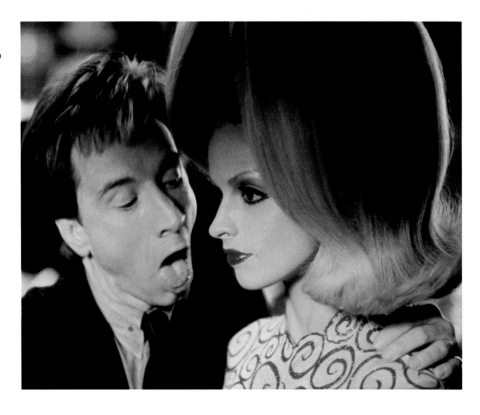

102

Still, there is big and there is big. Gems' first draft was priced at an out-of-this-world $260 million. 'Warner wanted to make it for no more than $60 million,'[9] he laughs. A cast of more than sixty characters needed to be pared down. 'There was literally a three-page index at the back of the script to help you keep track,'[10] says Larry Laraszewski, the *Ed Wood* writer who did two uncredited passes with Scott Alexander. They lost scenes of Martian destruction in China, India and Russia, among others – though we do still see the critters fry the Eiffel Tower, Taj Mahal and Big Ben. The final shooting script was the fifteenth draft, and the budget had crept back up to $80 million.

Any resemblance to *Independence Day* — released the same year — was purely coincidental, but Burton and his team had no qualms about feeding from *The Day The Earth Stood Still* (1951), for the portentous scientific dialogue; *Forbidden Planet* (1956), for the art deco Martian technology; and *This Island Earth* (1955), for the big-brained Mutants that had already inspired Topps' Martians. Most obviously it was a spin on *The War of the Worlds* (both the novel and the 1953 film adaptation), and Burton was as indifferent about providing a motive for the invasion as H.G. Wells. 'We know not of their ways,'[11] he teases. While he would eschew Wells' famous tripods, the Martians are equipped with a fabulous old-school giant robot like one of the clockwork toys sold in Wacko!

However contemporary it alleges to be, *Mars Attacks!* is carried by a tractor beam back to a cartoon 1950s: Marie's wobbling hairdo, the tacky neon coating of Sinatra-era Vegas, and the curvy Robbie-the-Robot designs all point to this lurid, fantasy America. A lot of this had to do with the aesthetic of the Topps cards and B-movies. But it is as much to do with Burton's nostalgia for bygone cheese.

Even the special effects had to appear slightly underdone. Burton decided to create his aliens in herky-jerky stop motion animation like Ray Harryhausen's work on *Earth vs. the Flying Saucers* (1956).

He first approached Henry Selick, who had directed *The Nightmare Before Christmas*, but he was in the thick of *James and the Giant Peach* (1996). So, Burton turned to the UK-based Ian Mackinnon and Peter Saunders, who set up a 70-strong team in Burbank to make stop motion Martians. But the process proved to be exhaustingly intricate and slow, and the director was forced to go with head over heart and use the quicker, cheaper and more versatile CGI. His instructions to Industrial, Light & Magic were simple: make the Martians look exactly like stop motion. ✪

TIM BURTON

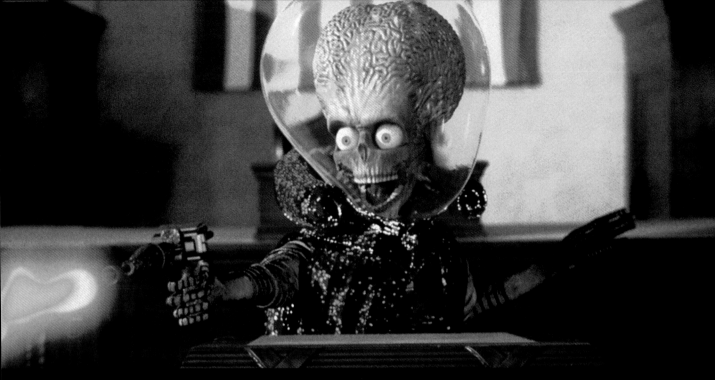

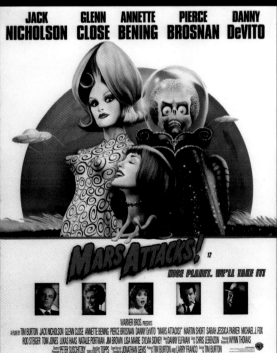

Above: Mars, indeed, attacks! Burton had originally proposed creating the alien marauders using Ray Harryhausen-style stop motion. However, when time pressures forced him to use CGI, he made sure they still moved like stop motion.

Left: The European poster for *Mars Attacks!*. Despite claiming he knew nothing about *Independence Day* during production, Burton's alien invasion was written off as a copycat movie.

There is a message in *Mars Attacks!* mischief. Burton sees it as a comment on the First Gulf War, or rather on the way the conflict was presented on the nightly news, with theme music and credit sequences. Paul Winfield's General Casey is a deliberate parody of General Colin Powell, chief military strategist of the George Bush administration.

Gems saw it more as a straight satire on American culture, from venal hucksters to gung-ho hicks to preening TV hosts and their befuddled heads of state – if the monsters aren't necessarily sympathetic, they are no more objectionable than the Earthlings.

Here too was Burton's chance to try out a disaster movie. Watching *The Towering Inferno* (1974) as a child, he loved how you never knew which of the A-list stars would survive and which would fall prey to the flames of the star-soaked Irwin Allen epic. Allen ploughed a line in star-driven blockbusters flaunting deadly calamity in various modes, such as *The Poseidon Adventure* (1972), *Cave-In!* (1979) and the defiantly self-explanatory *The Night The Bridge Fell Down* (1983).

And now here was his chance to blast Hollywood's great and good with Martian ray guns. This, in turn, offered a break from the past. All his previous films had centred on an outsider struggling to fathom his place in the natural order of things, an alter ego often even dressed liked Burton. *Mars Attacks!* was an ensemble piece where people struggled to get two thoughts in a row.

There is a Burton-figure in Lukas Haas' low-flying doughnut seller who saves the day, but lies at the margins of the potpourri of outlandish figures. In fact, so idiotic is the mix of hicks, crooks, and politicians that Gems claims they had trouble landing a cast at all. 'Agents didn't want to see their star clients play loser roles.'[12]

However, with a canny sense that this was exactly the brand of celebrity roughhousing he would warm to, Burton sent the script to Jack Nicholson with the offer of whichever role took his fancy. They had narrowly missed out on making an adaptation of Richard Brautigan's cowboys vs. creature novel *The Hawkline Monster* together when co-star Clint Eastwood left the project, and shortly after sending over the script, Burton called to ask which role he preferred. Nicholson replied, 'How 'bout all of them?'[13] He was only half-joking, with a mind to besting Peter Sellers' celebrated three performances in *Dr. Strangelove or: How I Learned to Stop Worrying and Love the Bomb* (1964), directed by Nicholson's beloved Stanley Kubrick.

Indeed, Kubrick's nuclear satire exerts a sizeable pull on Burton's Martian enterprise. Rod Steiger's war-crazed General Decker is a direct version of Sterling Hayden's General Jack D. Ripper, and production designer Wynn Thomas channels Kubrick's modernist War Room for their military command.

Nicholson's response informed Burton that he had caught the tone straightaway, and they would compromise on two roles. Less successfully, Art Land: a yee-hawing Vegas land developer with a wig fastened to his Stetson. And sorely tried President James Dale, coming apart at the seams. To set the cheese quotient, 'Hail to the Chief' was played every time Nicholson walked on the set.

With their flagship launched, there followed a fleet of Hollywood stars willing to spend two or three weeks mostly being zapped to a crisp by an irate critter. There were Burton regulars: Danny DeVito, Sarah Jessica Parker, *Beetlejuice*'s Sylvia Sydney (in her last film). And there were new recruits: former blaxploitation stars Pam Grier and

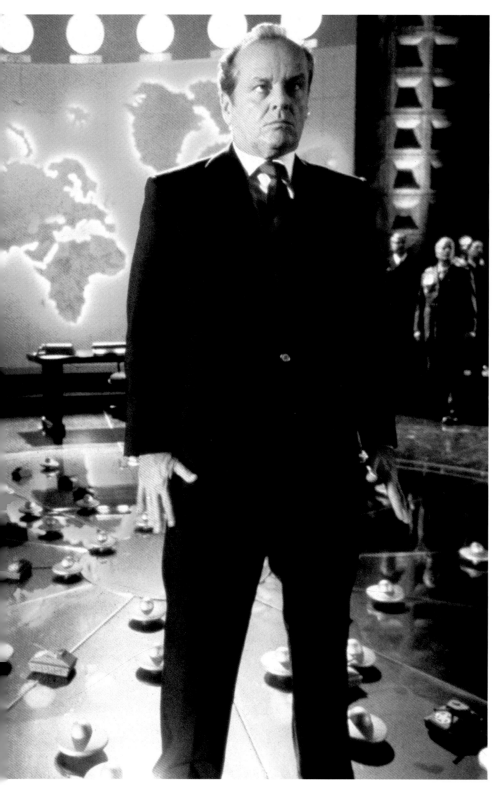

Jim Brown, Annette Bening, Michael J. Fox, Natalie Portman, Jack Black, Pierce Brosnan and Glenn Close. Tom Jones features as a cheesy Tom Jones. Among its many satirical targets, Burton was symbolically raining fire and death upon Hollywood. 'I don't think there was one overriding thematic thing,' he admits. 'But it seemed like a good idea just to blow away celebrities with ray-guns.'[14]

Many reviewers caught the caustic tone, even if in general they found the finished film empty. 'Almost in spite of itself *Mars Attacks!* has a silly, adolescent, satirical appeal,' granted Pete Stack in the *San Francisco Chronicle*. There were numerous unfair comparisons to *Independence Day*. Still, where one was a global phenomenon the other one was a big flop.

Mars Attacks! represented Burton's first major box office failure; it made a wheezy $38 million. (*Ed Wood* had knowingly had only marginal, arthouse appeal.) Certainly, *Independence Day* had cast a long shadow, but just as likely is that the ironic tone failed to translate to audiences who want to believe their planet is doomed.

'Often what I think is funny, other people don't find funny,' shrugs Burton. 'Or what I think is scary and disturbing, other people don't.'[15] For instance, he thought of a headless horseman as very funny.

105

Left: The military command comes under attack. There is a surprising vein of political satire in Burton's work.

HEAD CASES

Sleepy Hollow

Following the disappointment of *Mars Attacks!*, Burton's mind had flitted this way and that, trying to fix on a bearing that would see him into the future. He spent a disheartening year failing to get superhero adpatation *Superman Lives* off the ground with Nicolas Cage. There were more aborted projects: an adaptation of Katherine Dunn's novel *Geek Love*; a version of the manga character *Mai, the Psychic Girl*; and a remake of Roger Corman's *X: The Man with the X-ray Eyes*. He produced the television pilot 'Lost in Oz', sending contemporaneous teens to the Emerald City, but this never made it to a series.

The director would finally find his place with a period-set tale of a cursed headless horseman haunting a New England forest, offering the possibility of devising as many variations on a beheading that came to mind. (*Sleepy Hollow* has been read as a dark satire on Hollywood bureaucracy.) With Paramount's backing, producer Scott Rudin (who had first commissioned *Edward Scissorhands*) had developed the script for *Sleepy Hollow*, a very loose adaptation of Washington Irving's short story 'The Legend of Sleepy Hollow', first published in the collection *The Sketch Book of Geoffrey Crayon, Gent* (1819–20). Irving, an American literary great with a penchant for the fantastical, had inspired Edgar Allan Poe to take up his quill.

Andrew Kevin Walker, who would gain fame for his brilliantly depressing script for *Se7en* (1995), had taken Irving's eerie tale of the encounter between a gangly school master and the equine apparition and transformed it into another serial killer movie. At its heart is a murder mystery – who of the town's rapidly declining population is controlling the axe murderer? As we learn, the killer is a demonic Hessian horseman sent to the Revolutionary War long ago. The surprisingly detailed plot involves complex issues of inheritance amongst clans of Dutch colonial landowners, who would be played – almost as an inversion of the *Mars Attacks!* field of gaudy Americans – by a splendid array of British character actors: Michael Gambon, Ian McDiarmid, Michael Gough, Richard Griffiths and Miranda Richardson.

To serve the whodunit dynamic, Walker refitted Ichabod as a policeman whose rational commitment to science will dissolve in the face of the supernatural (an interesting theme that never really warms up). Pale skinned, wispy haired, and attired in Poe-like undertaker duds, this lily-livered waif is, of course, another category of Burton. Then the script had wormed its way into his skull via three connections to his childhood consumption of terrors. ✪

Right: Johnny Depp stars as Ichabod Crane, the milquetoast investigator out to fathom a spate of decapitations. While the invention of writer Washington Irving, Burton and Depp positioned Crane more as an Edgar Allan Poe-style character.

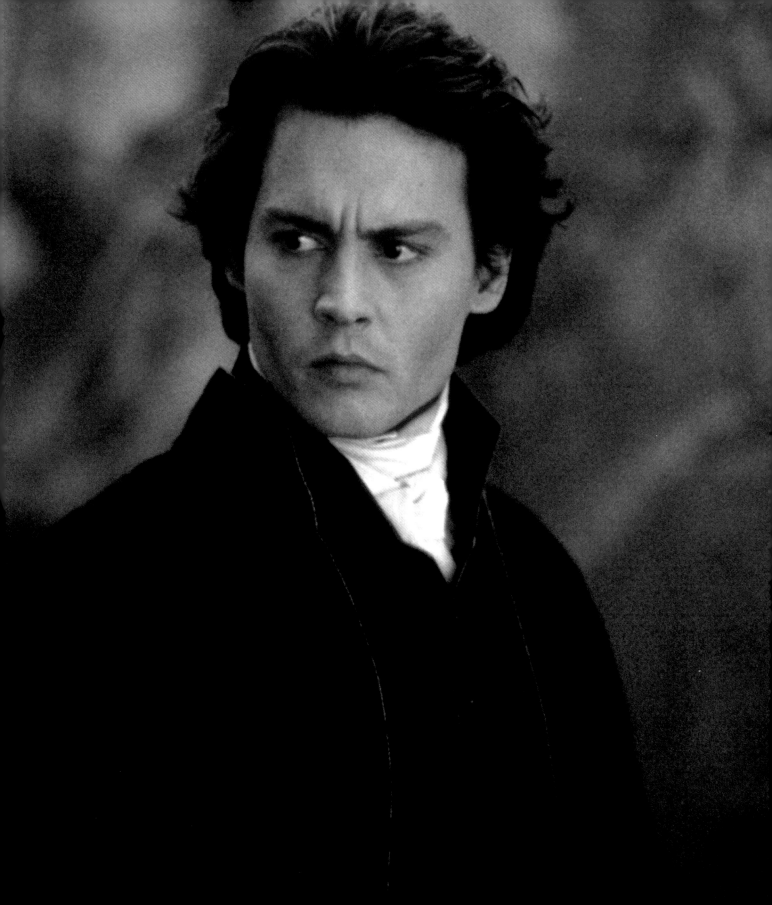

Not having read the book – glued to his television, Burton has never been much of a reader – his entry point to Irving's ghost story was the Disney version. *The Adventures of Ichabod and Mr. Toad* (1949) is the two-for-one animated feature adapting both Irving's tale and Kenneth Grahame's *Wind in the Willows*, and Burton was deeply affected as a child by its extreme camera angles and unsightly hero. 'It was one of those things that maybe shaped what I like to do,'[16] he says. He claims it is one of the reasons he ever wanted to work at Disney. And it was one of the chief sources of inspiration for this fine gothic thriller.

If *Mars Attacks!* awakened his glee at sci-fi's capacity for social destruction, then *Sleepy Hollow* resurrected his passion for the gruesome parables of horror. 'The best movies in the horror genre have a good mix of imagery and subject matter, and they just dive right into your subconscious,' says Burton, remembering a horror film festival he attended as a teen showing shockers throughout the entire weekend without stopping. It took something powerful to stave off sleep, and Mario Bava's *Black Sunday* (1960) was like a defibrillator to his eyeballs. 'It had such lurid, vivid and stark images,'[17] he exults.

'Our biggest frame of reference was *Black Sunday*,'[18] confirms cinematographer Emmanuel 'Chivo' Lubezki, appreciating how Bava's imagery was so clear and strong. The black and white revenge saga stars Barbara Steel as a seventeenth-century woman accused of witchcraft and summarily hammered into a 'Mask of Satan' – an iron maiden-type contraption that nailed into place – and who returns two centuries later to mete out revenge. It's a punishment that would be replayed to haunting effect in *Sleepy Hollow* with

Lisa Marie as Ichabod's doomed mother – such devices are a Burton motif.

The other lure of *Sleepy Hollow* was the opportunity it presented to pay homage to the melodramatic Hammer horrors of the 1960s. 'I remember when I read the *Sleepy Hollow* script, thinking of the windmill and the tree and the Headless Horseman,' says Burton. 'It was a real opportunity to try to do that imagery.'[19] ✪

Left: Tim Burton directs Depp as Crane midway through a scientific analysis. In some senses, it could be said that the intrepid, gawky but determined Crane is another on-screen version of Burton.

HEAD CASES

An $80 million horror movie about a milksop getting into deadly scrapes fathoming the unnatural activities of a ghoulish horseman already looked like a risk. And then Burton decided to recreate eighteenth-century America in a former Rolls Royce factory just north of London.

Intending to shoot on location, Burton had scoured upstate New York and the entire veld from the Hudson Valley to Massachusetts – but to no avail. He failed to be roused by the historical re-enactment parks as a possible base for their 1799 Dutch-colonial hamlet spooked by an endless forest. The real village of Sleepy Hollow had been turned into a ghastly tourist trap with Headless Horseman gift shops.

Then Rudin suggested London, and Burton realized that the film didn't require historical veracity at all, but a spiritual truth, the feel of a story. In other words, they would fake it. But fake it in such wondrous ways – *Sleepy Hollow* can be regarded as Burton's most beautiful film, a more elegant, atmospheric variation on his usual frenetic toy-box worlds.

Perpetually curtained in dry ice, the forest sprawled across soundstages at Leavesden Studios, leaving trails of dead leaves everywhere. Shot in a desaturated, silvery light (only the blood shows up as colour), it would be impossible to discern what was a set and what was an exterior. 'We were trying to create our own reality for the film – a fantasy that would seem real,'[20] explains Burton, noting that smoke, while a nightmare to work with, is marvellous at creating a nightmare. It lingers in virtually every shot.

The village of Sleepy Hollow was built from scratch on the Hambledern Estate in Buckinghamshire: church, stables, inn, houses and fetching wooden bridge. A

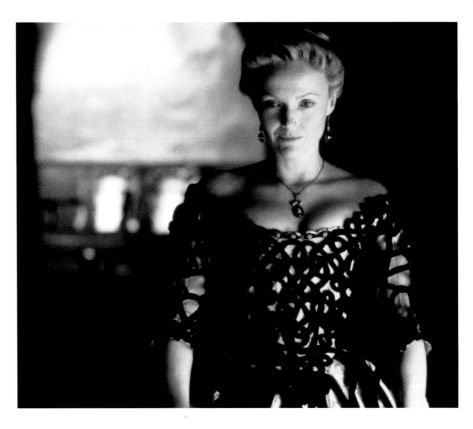

clapboard suburbia imagined by the Brothers Grimm or, as production designer Rick Heinrichs calls it, 'colonial expressionism by way of Dr. Seuss'[21]. The only location in the entire film, the town has a German fairy-tale vibe reminiscent of the storybook Gotham from *Batman Returns*.

When it came to the Hammer aesthetic, Burton was more interested in drawing a certain feeling or flavour from the old movies than simply Xeroxing them. There is always too much of himself spilling in from the margins to be able to literally copy another's style. Besides, the reality of Hammer wasn't quite as accomplished as their legacy might suggest. 'They're often more intense in your memory than they are when you actually watch them again,'[22] laughs Burton, though he still bade Heinrichs watch *Dracula Has Risen from the Grave* (1968). *Sleepy Hollow*

Above: British actress Miranda Richardson portrays the mysterious Lady Van Tassel. Plot has never been Burton's forte, but the web of family intrigue behind the killings was satisfyingly complex.

Opposite above: Christina Ricci as the demure Katrina Van Tassel. Burton has a penchant for casting brunettes as blondes, such as Winona Ryder in *Edward Scissorhands* and Eva Green in *Dark Shadow*s.

Opposite below: Michael Gambon as befuddled patriarch Baltus Van Tassel. If *Mars Attacks!* featured the best in American showboating, *Sleepy Hollow* had a venerable ensemble of British character actors.

110

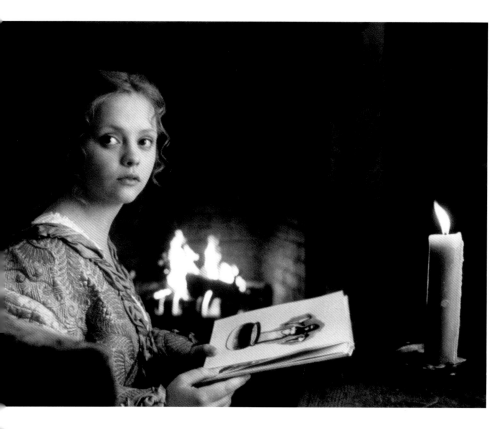

was less a throwback than a tribute to how horror nestles into your subconscious. A point reinforced by the casting of Hammer legend Christopher Lee as the stern burgomaster who first tasks Ichabod with putting a stop to the unseemly outbreak of death. 'Oh, man,' says Burton excitedly. 'I met him and it was like "I'm meeting Dracula!"'[23]

While sticking doggedly to its circumscribed time and place, the script was brought closer to a *Burtonesque* mood by a rewrite by Tom Stoppard, the playwright and Oscar-winning screenwriter. On Soundstage H stood the Tree of the Dead, a giant misshapen thing 50 feet tall, the nexus of the story, and a gateway to Hell: a classic Burton motif only more so than ever before.

So, however straight a horror movie Walker thought he had written (conceiving the story with make-up artist Kevin Yagher), the film would slip its macabre moorings and drift into other waters, including those that run darkly funny. There is a fabulously grim and witty tour de force of decapitation in which a small child, hidden beneath the floorboards, watches his mother's head roll across the floor and end up face down, staring at him through a gap.

Vitally, too, the part of the skittish, scatterbrained Ichabod would mark Burton's third collaboration with Johnny Depp. The studio had led their merry 'what's Mel Gibson up to?' dance (Brad Pitt and Liam Neeson were also suggested), but Burton held firm. ✪

HEAD CASES

On set Burton would delight in personally covering his leading man in blood. Smothering him in it, in fact, oodles of lipstick-bright Hammer-red blood splattered across his pretty face like the Devil's own graffiti. Depp would patiently sigh at his friend's delighted gurgles: 'Tim, what kind of sick movie is this?'[24]

A successful one to start with – *Sleepy Hollow*, defying the narrow appeal of its implied genre, had a bracing opening weekend of $30 million, on its way to making $80 million in America alone. The reviews were good too, praising the purity of vision if not the tightness of the mystery (but concentrate,

and it makes perfect sense). *Entertainment Weekly* praised it as ghoulish yet 'funny in its disjunctive kookiness'. The kind of movie where, as the hero chops into the roots of a dead tree, human blood will fountain up at him from a larder of severed heads.

Which is well and good. For this is essentially a film about Ichabod's head, and therefore Burton's own. 'What I liked about the Ichabod character was that it was very much a character inside his own head,' stresses Burton. 'That, juxtaposed with a character with no head, was a really good dynamic.'[25] Ichabod is smart, but he overthinks things. Or, as Depp so colourfully

describes him, he is someone so tight he couldn't fit a pin up his ass. Whereas, the Headless Horseman is all unbridled id, like Beetlejuice or the Joker.

'We all look at people's eyes to categorize them,' continues Burton. 'But here you've got this powerful, elegant character without a head. The Headless Horseman represents the subconscious.'[26] And all Burton's films are a visual form of the subconscious. For that is where stories come from and go to – especially horror stories.

As if he were one of Burton's sketches, Ichabod is described in the book as long and lank, with hands like shovels, and 'large

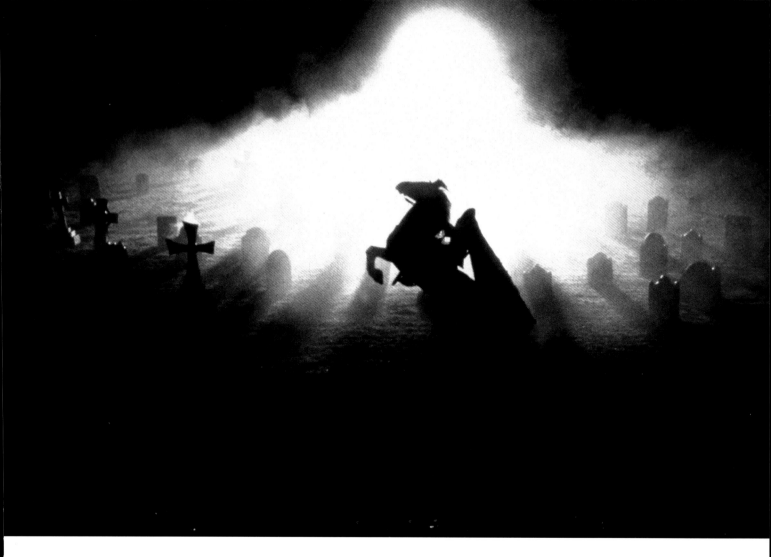

Above: Shot in a desaturated light, with every frame filled with dry ice, the film hovers on the verge of a nightmare. Everything feels very real and off-kilter at the same time.

Opposite: Christopher Walken as the Headless Horseman, albeit in a flashback while still in possession of his head. Burton loved the idea that without his head the character represented the subconscious.

green glassy eyes and a long snipe nose, so that it looked like a weather-cock perched upon his spindle neck.'[27] Depp had been all for the full transformation into this excitable scarecrow. 'I thought I'd wear a prosthetic nose but the Paramount people, bless their cotton socks, weren't very enthusiastic about that,'[28] he laughs.

It's a surprising compromise on one level, given Burton's predisposition to exploit visual drama before any commercial considerations (all his leading men had been freaks), but he was seeking the strange things that can be done with the human face. In this case, the make-up would have stifled the touchingly squeamish performance that Depp is giving.

Prone to shrieking at spiders, fainting at the sight of blood, and wearing a madly oversized pair of goggles when attempting scientific analysis, Depp describes the character as being, 'a little too in touch with his feminine side.'

'It's true,' concedes Burton, 'we may have made the world's first male action-adventure hero who acts like a 13-year-old girl.'[29]

HEAD CASES

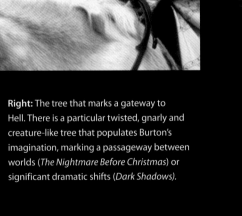

Above: Katrina (Ricci) often proves to have far more initiative than the supposed hero. Depp's Crane was written as a character rather stuck inside his own head.

Top: Crane's jerry-built scientific paraphernalia is a familiar Burton motif. He loves clockwork and over-elaborate machines such as The Inventor's machines in *Edward Scissorhands* and the array of dotty gadgets the Martians use in *Mars Attacks!*.

Right: The tree that marks a gateway to Hell. There is a particular twisted, gnarly and creature-like tree that populates Burton's imagination, marking a passageway between worlds (*The Nightmare Before Christmas*) or significant dramatic shifts (*Dark Shadows*).

TIM BURTON

TIME WARPS
Remakes and tall tales

It sounds a perfect marriage – Burton and talking apes. A world turned upside down, where a human outsider stares dumbfounded at an unfamiliar natural selection.

Not an up-to-date remake but a *re-imagining* of the 1968 classic starring Charlton Heston. Producer Richard Zanuck, who had run 20th Century Fox at the time of the original, certainly thought so. 'When you say *Planet of the Apes* and Tim Burton in the same breath,' he said, savouring the pitch on set in 2000, 'that idea is instantly explosive, like lightning on the screen.'[1]

Yet the film is now notorious as a creative low point in Burton's career. It was a hit, taking $362 million worldwide. But the outcome perplexed critics. 'A dumbed-down, screeching, gibbering, banana-peeling, PG Tips-drinking festival of nonsense,' barked Peter Bradshaw in the *Guardian*. A more even-handed Elvis Mitchell in the *New York Times*, spotted 'glimmers of wit and energy', but also detected how the film becomes 'slow-witted and condescending'.

And Mark Wahlberg, who stars as Captain Leo Davidson, whipped through a time portal to a planet where humankind is enslaved to a quasi-medieval civilization of apes, was man enough to admit things hadn't gone as well as hoped. 'They didn't have the script right. They had a release date before he had shot a foot of film. They were pushing him in the wrong direction.'[2]

Even Burton, self-critical to a fault, can only wryly acknowledge the whole situation had gotten out of hand. 'This one's a cautionary tale,' he jokes regretfully, 'about trying to remake science fiction films from the late sixties.'[3]

Right: The famous twist from the original 1968 version of *The Planet of the Apes,* revealing that it has been Earth all along. That ending was so famous, Tim Burton was determined his version could not be set on Earth.

116

TIME WARPS

Planet of the Apes

Time can do strange things. *Planet of the Apes* was a troubled production with an uneven outcome, never truly living up to the promise of Burton's remix of the hairy concept. But look again at the sci-fi epic, and something of Burton's neo-gothic fancy manages to escape the inconsistent tone, making for a film that is funnier, weirder and better plotted than you remember.

Like *Batman* (a production whose woes it uncannily mirrors), *Planet of the Apes* was a project that had been caught in what Burton calls the 'Hollywood spin cycle'[4]. Since 1988, it had hiccupped through various incarnations and major directors. Writers Adam Rifkin, Terry Hayes, and *Batman*'s Sam Hamm had lent their quill to augmenting the script for the 1968 film – Hamm's version ended with an ape-faced Statue of Liberty. And directors Oliver Stone, Philip Noyce, Chris Columbus, and James Cameron had all boarded. And then abandoned ship.

Finally, in the summer of 1999, Fox bade William Broyles Jr discard any attempt at sequels or remakes and instead create something completely new. Set on an entirely new planet, he christened it 'The Visitor, Episode One in the Chronicles of Aschlar', the first in a projected trilogy of epic ape movies.

Broyles claims Burton was instantly smitten, although Burton suggests a cooler courtship. He needed to think things over. He had his qualms, but something nagged at him; the original was another movie he cherished growing up. And the perversity of taking on a classic appealed to him.

'I love this material because it's a kind of "fuck you" to literal-minded people,' he relishes. Re-reading the source novel, Pierre Boulle's *Monkey Planet* he knew it was a

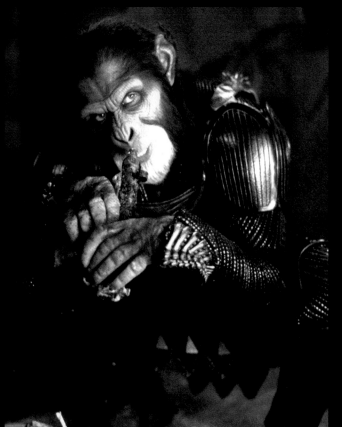

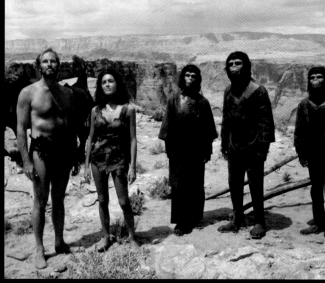

Above: Charlton Heston poses with fellow cast members on the set of the original film. Heston would be persuaded by producer Richard Zanuck to take a cameo in Burton's remake – but insisted it be as an ape.

Left: Tim Roth as villainous chimpanzee Thade. In earlier drafts of the script he had been an albino gorilla, but Burton personally finds chimps far more unpredictable and scary.

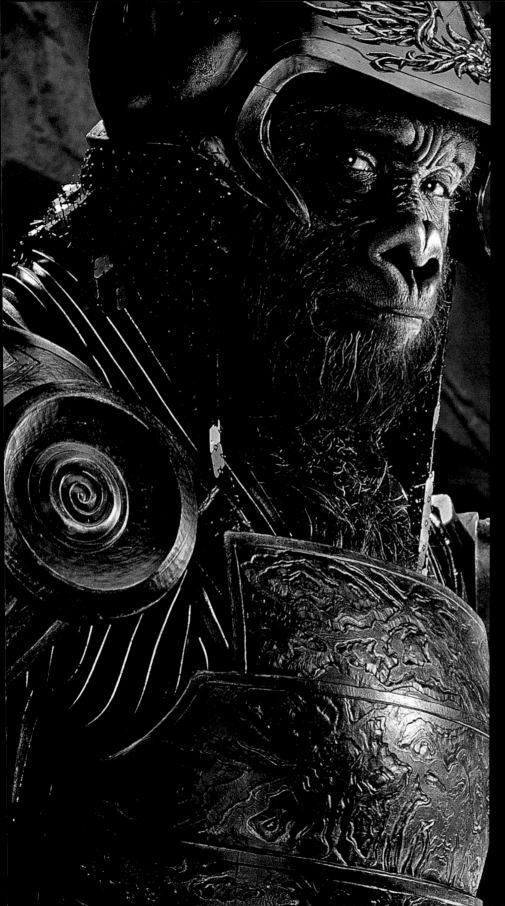

good fit. 'It makes you use both sides of your brain when literal-minded people don't want to.'[5] The decisive factor for him, though, was the term 're-imagining'. He could take something he loved and refashion it with his own features.

What he hadn't taken into account was that regime changes at Fox had resulted in the studio lacking a tent-pole movie for the summer 2001. Their solution was Burton's *Apes*. The schedule would be as insane as the concept – shooting would *commence* on 6 November 2000. Burton often recalls the first time they showed him a poster. On the bottom it read, 'This film has not yet been rated.' He smirks, 'I said why not be accurate and say, "This film has not yet been shot"?'[6]

Lawrence Konner and Mark D. Ronsenthal were hastily recruited to tighten up what Zanuck deemed a 'totally impractical'[7] screenplay to an affordable level. As it stood, it would have cost $200 million. 'It had monsters in it,' Zanuck reported, 'all kinds of other things, half-horse – half-man.'[8] Three battles were reduced to one grand confrontation, and the director chose instead to concentrate on character.

Burton considered Wahlberg the kind of solid actor 'who could serve as an anchor'.[9]

119

Left: Promotional art of Michael Clarke Duncan as Thade's hench-gorilla Attar. The extraordinary designs for the armour were conceived by Burton himself in his elaborate concept art.

TIME WARPS

Wahlberg was simply giddy with the potential of working with Burton: 'When you have a guy like Tim Burton, people come.'[10]

Undoubtedly, the director's fascination lay in actors as apes. 'When you cover up,' he says, 'you can let something else weird leak through.'[11] It was a much bolder concept of masks than ever before – these masks *were* the character.

'We tried to keep it as human as possible,' Burton goes on. 'That's why it was important to have good actors playing apes, not CGI.'[12] The inherent irony delighted him; the apes had to be recognizably human. With prosthetics needing to be supple enough to express complex emotions, he hired Oscar-winning make-up artist Rick Baker.

Weirder still, Burton also wanted his apes to retain more of their animal natures than they had in the original. Pee-wee, Betelguese, and Batman have all embraced their animal instincts. Thus Helena Bonham Carter, Tim Roth, Michael Clarke Duncan, Paul Giamatti et al. were enrolled in ape school. As well as interacting with live chimps, the students received movement training ('loping'[13]) from former Cirque du Soleil performer Terry Notary, who estimated they were 20 per cent simian, 80 per cent human. 'The most helpful image was to think of a nappy that was full between your legs, and you didn't want to spill it,'[14] reports Bonham Carter, whose performance, as liberal-minded chimp Ari, is the most charming in the film. Bonham Carter loves to re-run the call she got from the director: 'Don't take this the wrong way,' he had said, 'but you are the first person I thought of to play this chimp.'[15]

By the end of a day's shooting, the ape actors were ready to rip their faces off. Beneath the mask, their skin itched and sweated and it became unbearably hot.

Burton likens it to being 'buried alive'[16]. Lisa Marie, who makes an ape cameo, claims it felt 'like you're underwater'[17].

Nerves frayed, as actors were unable to communicate properly and could hardly hear through prosthetic ears. The protruding false teeth gave them a permanent lisp, meaning that a lot of the dialogue had to be re-recorded. To eat, they had to use a compact mirror to avoid smearing their faces. Smoking was expressly forbidden – the glue was flammable. And

going to the toilet was an entire production in itself. In fact, the actors tried to avoid bodily functions if at all possible.

Indeed, while Broyles' script had actually included ape-man relations between Davidson and Ari, Burton drew the line at bestiality. 'I'd like to stay out of jail a little longer,'[18] he laughs. The central relationships effectively form a platonic triangle between Davidson, Ari, and Estella Warren's pouty human slave Daena.

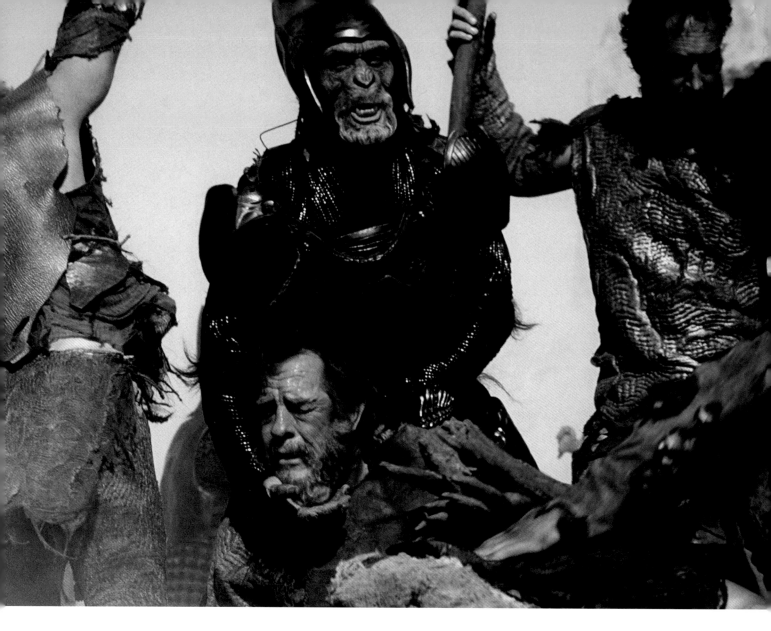

Above: Thade (Roth) springs into battle against the loathed humankind. All the actors who played simians had to go to ape school, where they learned how to move and gesture like the particular species.

Opposite above: Helena Bonham Carter (as the liberal-minded chimp Ari) claimed the ape makeup was a nightmare. The primate cast had to eat using hand mirrors to avoid getting food on their faces.

Or is that a square? The chimp-general Thade is also conniving an advantageous union with Ari. At the same time, this quasi-fascist (his name an anagram of 'death') is determined to eradicate humankind. In Broyles's original draft he had been an albino gorilla, but Burton found the concept of an evil chimpanzee far more terrifying. 'They actually murder each other, and they can be cannibals,' he insists. 'They like to throw shit at you from their cages. But I guess if I were trapped in a zoo, I'd probably throw shit at people as well.'[19]

Thade is played with malicious glee by Roth, who relinquished the role of Professor Snape in all the Harry Potter films for the potential of going ape with Burton. 'I think he's nuts,' he says. 'If you go back and look over his films, they're all crazy. And I wanted to be a part of the madness.'[20] ✪

The shoot itself could have been one of Burton's surreal creations. After a misjudged leap, actor Michael Clarke Duncan had to be rushed to hospital with a broken ankle – in gorilla prosthetics. (Burton's biggest regret of the whole enterprise was not being there with his camcorder to capture the faces of the hospital staff as this creature burst into the emergency room.)

Wahlberg would be hit with an errant fireball during a battle scene. And Burton himself would take a tumble and end up with a broken rib, shooting much of the movie through a veil of pain. And the scale was Biblical.

Three units filmed simultaneously. Baker had a team cycling through ninety ape transformations a day, requiring the production to run as a twenty-four-hour operation. The screenplay, meanwhile, was experiencing its own daily makeover as the studio constricted the budget. Once Davidson escapes Ape City, the story was reduced to a straightforward dash to the revelations of the finale.

Yet there are evocative layers to the world. Ape City is a piece of *Burtonesque* grandeur as extraordinary as Gotham. Built across a soundstage at Culver City in Los Angeles, and including 30-foot ape idols, this gothic stronghold cum Aztec city cleverly visualized the stratified ape society.

For scenes beyond the city, the crew would travel to Hawaii to capture the lava flats. Then to Lake Powell, Utah, where the original had been shot (albeit at a different location). And finally they headed to Trona Pinnacles in the Mojave Desert for the climactic battle scene. Each painfully remote but inspiring setting mixed a 1960s sci-fi vibe with Roman epics, Westerns and Burton's familiar otherworldliness.

And each came with its own problems. For a horseback sequence through the shallows of drought-hit Lake Powell, not only was it necessary to pump water *into* a natural location, but this then had to be heated in order to reach the Humane Society of America's required temperature for animal welfare.

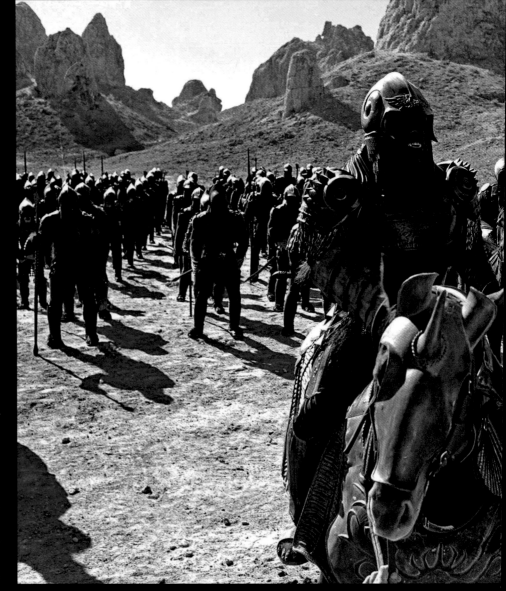

Above: Attar and Thade at the head of the ape army. Writer William Broyles had originally devised three Braveheart-style battles between man and ape, but due to budget constraints this was reduced to one.

22

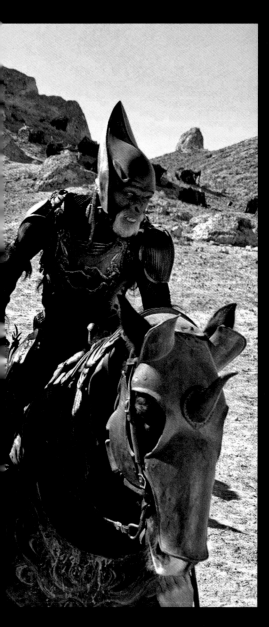

The original film is justly celebrated for how it embraced the political climate of America in 1968, then buckling beneath the strains caused by the Civil Rights movement, student revolts and Vietnam. It is a classic, but a classic of its time. Burton felt his *Planet of the Apes* needed to represent the fragmentation in the society of 2001. 'You've got some apes that are turning more human; then you've got your ape purists. And the self-esteem has not all been beaten out of the humans.'[21]

The reason for the planet's weird population (which also explains why the apes speak English, if not how they have domesticated horses) is ingenious. Everything sucked into the cosmic time warp is spewed out in the opposite order, making Davidson's actions the catalyst creating the planet's inverted natural order.

And then there is the final twist. Over the years, it has become a focal point of fan debate. Davidson returns to Earth to find the Lincoln Memorial now bearing Thade's face. It's the time portal again, apparently, somehow sending Thade back to Earth later than Davidson, therefore returning him to an earlier point to alter human history. Then again, Burton has long felt as if he was a different species from everyone else.

Right: Burton cast Mark Wahlberg as the heroic Captain Leo Davidson (pictured with Estella Warren's Daena) because he thought he had that Heston-like quality of being an anchor for all the far-fetched elements.

Big Fish

Consciously or not, Burton's adaptation of Daniel Wallace's romantic picaresque marked the completion of a trilogy of Edwards. After *Edward Scissorhands* and *Ed Wood*, the story of Edward 'Ed' Bloom follows the pattern of the director taking on a relatively small, personal but still fanciful tale after the abuses of a large-scale blockbuster. It too concerns a dreamer; only this time he is a father not a son. (Edwards Scissorhands and Wood have surrogate pops, in the Inventor and Bela Lugosi.) The resulting film presents a newfound maturity, even a mellowing of Tim Burton's grand style.

Ed Bloom, played in old age by Albert Finney, and as a young man by Ewan McGregor is a perpetual teller of tall tales, embroidering his life with a mythology of giants, witches, werewolves, flummoxed poets, Siamese twins, secret military missions – and wooing your one true love using every daffodil in five states. Crucially, it is also about Edward's frustrated son, Will (Billy Crudup). Returning home to a dying father, he is determined to unravel the fabrications and discover the real man.

John August's script had narrowly missed being made by Steven Spielberg and Stephen Daldry, an indication of its open-hearted sensibility. And when it came Burton's way, it couldn't have struck a deeper chord. His father, Bill, had died in 2000, leaving an ocean of unresolved feelings.

'A few years earlier I wouldn't have been able to make *Big Fish*,' Burton admits with uncommon frankness: 'You're never prepared for your father's death. But at the end of his life, mine was sick, like the father in *Big Fish*.'[22]

The project was an answer to so much in his life. Sapped spiritually by the struggle of *Planet of the Apes*, and dissatisfied by its outcome, he craved something small. He had also left Lisa Marie and entered into a relationship with Helena Bonham Carter, moving permanently to London. Furthermore, he was about to become a father for the first time – just as Will Bloom is about to become a father with his lovely French wife Josephine (Marion Cotillard).

'It's actually the weirdest thing you could ever do. This thing,' marvels Burton, likening fatherhood to something out of *Alien*: the smells, the sounds, the ungovernable growth rate. 'And we're all a result of it, you know? So … It's amazing.'[23]

If *Edward Scissorhands* is the key work of his early career, the amiable, heartfelt *Big Fish* is the Rosetta Stone to Burton's middle ages.

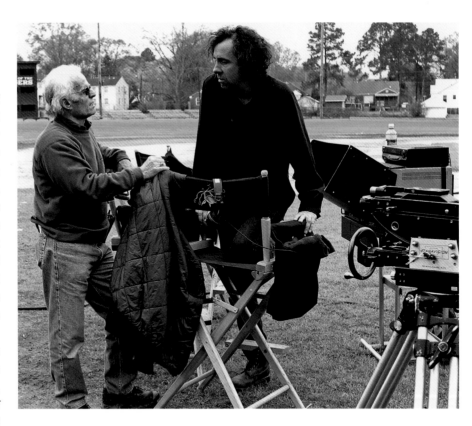

Above: Producer Richard Zanuck (left) confers with Burton. Dissatisfied with the outcome of *Planet of the Apes*, the director had craved something small and personal, which he found with *Big Fish*.

Opposite: Matthew McGrory played misunderstood Karl the Giant (pictured here with Ewan McGregor's Ed Bloom). At 7 feet 6 inches, he was already tall, but Burton used forced perspective to have him appear 12 feet tall.

124

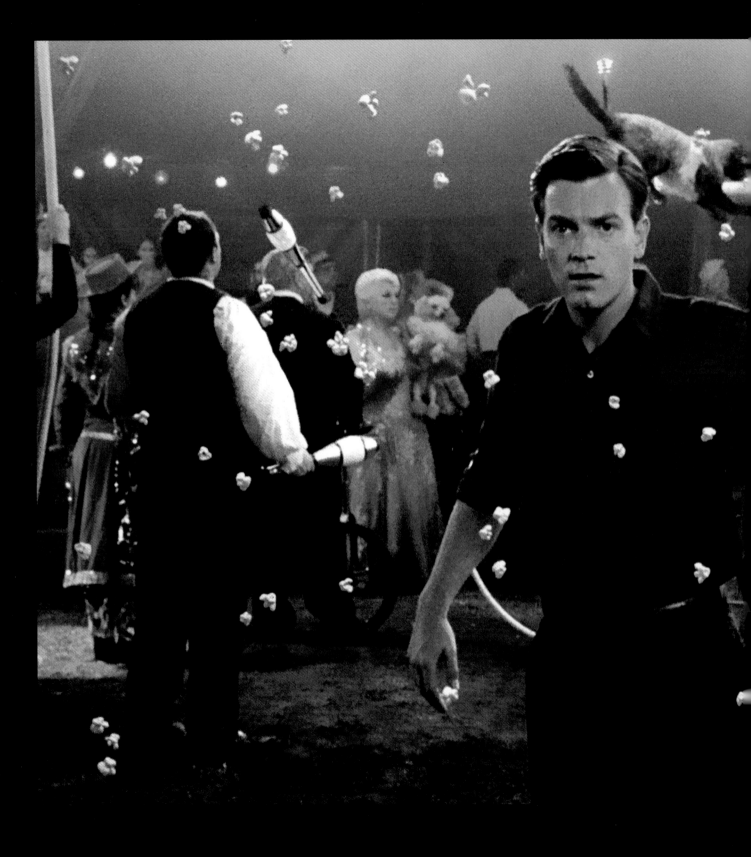

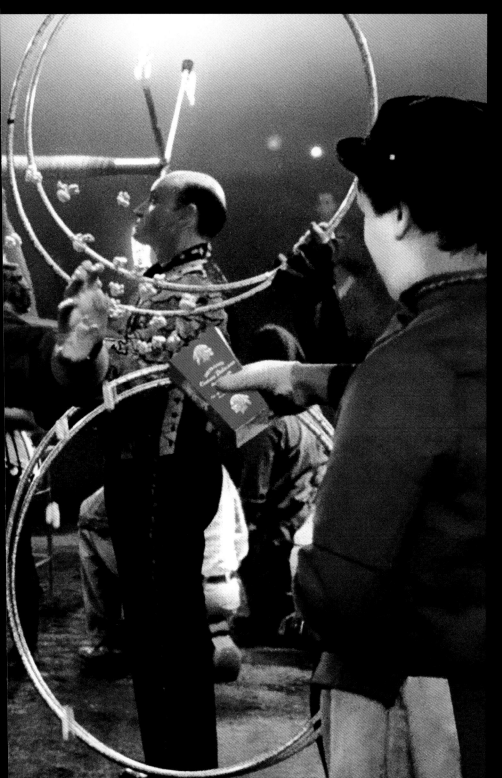

Left: McGregor as the young Ed Bloom in the familiar *Burtonesque* surroundings of a circus. Given that movie productions are described as travelling circuses, you wonder whether there is a metaphor in there.

Essentially, *Big Fish* is set in the here and now. Good old-fashioned reality, or at least Alabama, where Ed takes one last opportunity to regale the world with the peripatetic saga of his life. Through Ed's colourful imagination, the past is transformed into a fable. Into somewhere Burton would be right at home.

Here was the opportunity to deal directly with the realm of folklore that surrounds all his films, but in an American vein.

Wallace thought of his story in even grander terms, giving his book the full title of *Big Fish: A Novel of Mythic Proportions*. 'I've always been partial to *The Odyssey*,' he admits, 'the book and even the cheesy movies that have been made about it.'[24] The surname Bloom is drawn from Leopold Bloom, nucleus of James Joyce's ordinary-man-as-myth masterpiece *Ulysses*. Wallace also schooled himself with the set texts on mythology like James G. Frazer's *The Golden Bough*, and Joseph Campbell's *Hero with a Thousand Faces* – which can be glimpsed on Ed's nightstand.

Though Finney and Ewan McGregor are not exactly alike, Burton felt they had the 'same aura'. He had looked at a picture of Finney in *Tom Jones* (1963) and seen a 'fictional congruity'[25]. (Corroborating his hunch, *People* magazine happened to run an article of potential old/young counterparts and linked Finney to McGregor, who would later come by the set to observe his older counterpart at work.) In the role of Sandra, his great love, Alison Lohman and Jessica Lange offer complementary performances – and complementary hair styling.

The 'real' scenes were shot first, helping to ground Burton's storytelling. There are moments here of shocking normality – sequences requiring not a droplet of dry ice, only a steady hand. Burton had never dealt with emotional reality on this level before,

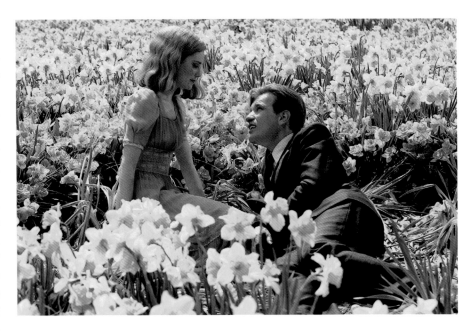

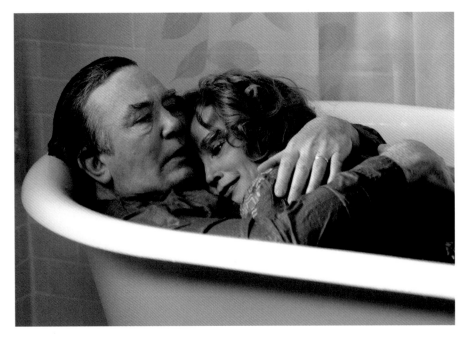

and calmed his natural tendencies to place his camera in an everyday setting such as a hospital ward or a dining table where the characters are plainly human.

The story will gently seesaw back and forth between truth and made-up truth. ✪

Above and top: The two versions of the film's central couple, Ed and Sandra, were cast with actors who possessed the same aura as their counterpart. Firstly, McGregor's young Ed with Alison Lohan's Sandra, top. Secondly, Albert Finney's aged Edward with Jessica Lange's Sandra, above.

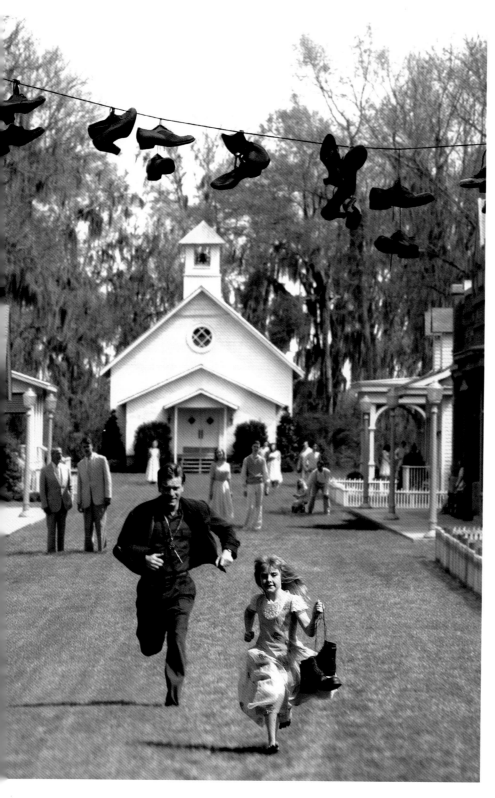

When it came to Ed's untrustworthy past, Burton took his production on the road like a travelling circus, roaming the lush Alabama countryside, dreamy with willows and cypress woods that turn troublesome by night. It was like working on an independent movie, but with a $70 million budget.

'It just needed a handmade quality, because of the nature of it, the stories,'[26] says Burton. They shot at speed, moving onto the next location within days. Not that it was a breeze. This was tornado country, where the *The Wizard of Oz* symbolism got a little too close to home: the circus sequence was beset by an irritable twister, which nearly took their tent. 'The scene where we were shooting Danny naked in the forest,' rues Burton, 'the next day it was under three feet of water.'[27] Fearless to a fault, DeVito willingly braved the woods naked.

All the same, Burton felt as liberated as his Pee-wee Herman days. He enjoyed the fact that they seemed to be making 'a new film every day: circus movie, bad fifties monster movie …' ★

129

Left: At one point Ed finds himself marooned in the beatific town of Spectre. Burton invests this idea of an idyll with some of the spooky monotony he gave the suburbia of *Edward Scissorhands*.

Ed Bloom portrays himself as almost Burton's opposite: a man who goes from sporting hero to travelling salesman with the gift of the gab. He hawks metal hands, each finger a different gadget.

Big Fish amplifies what Burton has long maintained – contrary to appearances, his films are uplifting and he is an optimistic soul. Ed's widescreen American Dreaming might be inflated with nonsense, but it bursts with an unquenchable spirit for life. Burton wanted the fantasy underpinned by reality. There are only five blue screen shots. If they needed a car stuck in a tree, Burton had his crew figure out how to stick it up there. 'People go like, "Oh, we can just CG that in." Well no, it's important to have the car in the tree. Actually, a few inventive people just took out some of the heavier engine stuff and got a crane and they hung it in a tree.'[28]

Spectre, the creepy model town that represents both heaven and hell, was constructed on Jackson Lake Island near Millbrook. It remains there still, dilapidated, a ghost town built by Tim Burton.

The setting might have been deep in the backwaters of Alabama, but suburbia was never far from Burton's mind. Bloom as a gardener on a residential boulevard near enough identical to the one in *Edward Scissorhands*: the lawns are mowed in unison, like a dance number. 'I was glad to get out of those areas,' contends Burton, 'but I still have a soft spot for them.'[29] Maybe he was maturing.

August sums up the film's message as the contrast between an intellectual truth and an emotional truth. 'The flavor of what Edward is saying is more honest than if he had just literally told him, "These are the events of my life."'[30] It's a theme at the heart of Burton's films – the redemptive power of the imagination. Great truths can be

expressed in highly symbolic ways. Burton has told many tall tales, but to dismiss them as pure fantasy is to make a mistake.

There were those who recoiled from what they saw as the film's unabashed sentiment. 'The only danger in *Big Fish* is the constant menace of mush,' lamented Anthony Lane in *The New Yorker*. But largely these were his best notices since *Ed Wood*. 'Burton and company make an unbeatable case for the life-affirming power of make-believe,' said Nathan Rabin at The A.V. Club. A worldwide box office take of $122 million for an adaptation of a little known book gave notice that Burton's personal predilections still connected with people.

More significantly, the film had helped remind Burton that his own father had been more of a fairy-tale character than he let himself believe. 'On moonlit evenings he would take his dentures out – he only had his two canine teeth left – and pretend he was a werewolf. He would start howling, to frighten the neighbours. He was a magical guy, and I had forgotten that for too long.'[31]

131

Left: Following a storm, Ed finds his car up in a tree. Wanting to maintain a handmade quality, and shooting at speed, rather than using CGI Burton gave crew only hours to suspend a real car in a tree.

TIME WARPS

JUST DESSERTS
Chocolate and opera

'Some adults forget what it was like to be a kid. Roald did not,'[1] Burton says, delighted to discover that early drafts of *Charlie and the Chocolate Factory* included a character named Herpes.

Burton understood that the book dealt with 'very sinister things that are part of childhood.'[2] This gleefully politically incorrect tale of nose pickers, chocolate guzzlers and bleating brats getting their comeuppance has sold by the million. Roald Dahl remains the poet laureate of vile children. Naturally, he was one of Burton's favourite children's authors, second only to Dr. Seuss.

Burton wanted to make up for what he saw as the cloying sentiment in Mel Stuart's *Willy Wonka & the Chocolate Factory* (1971). He added elements of fairy tales, science fiction, and even a pinch of Hollywood satire to the mix. The parallel between studio and chocolate factory was there for all to see; a button in the great glass elevator leads to the 'Projection Room'. Burton was dredging up childhood memories of staring through the studio gates in Burbank. The reclusive Wonka is like Howard Hughes or Citizen Kane. Beware, the film hints, Hollywood's sugar. It rots the teeth.

The project, like *Batman* and *Planet of the Apes* before it, had been languishing in studio development, with directors as diverse as Gary Ross and Martin Scorsese contemplating taking the helm. Echoing the Catwoman saga with *Batman Returns*, the list of stars keen to play Willy Wonka was as long as your arm: Nicolas Cage, Robin Williams, Dustin Hoffman, Jim Carrey, Michael Keaton, Will Smith, Robert De Niro … and on it goes.

The main stumbling block was that Dahl's estate retained final say over both the director and the casting for Wonka. The author had been aghast at the liberal changes taken by the 1971 film, and had closely guarded the rights. Completing *Batman*, Burton had enquired about the rights – to no avail. Come 2001, he was seen as the perfect choice.

'Sometimes it is just fate,'[3] he shrugs. He had come to know the estate better while producing *James and the Giant Peach* (1996), encouraging Dahl's guardians by throwing out all the previous scripts, and

commissioning John August to start afresh, but stick close to the book. As for Wonka, Burton had only one in mind – Johnny Depp.

'It was the first time I didn't have to talk anyone into it,'[4] laughs Burton. Depp's eccentricity had recently propelled *Pirates of the Caribbean* into the box-office stratosphere, and Warner were going, 'How about Johnny?' He turns on the sarcasm, 'Okay, if you're going to *force* him on me.'[5]

Opposite: Johnny Depp as unconventional chocolatier Willy Wonka. Burton very much saw the story as Wonka's journey with Charlie as the catalyst for his redemption.

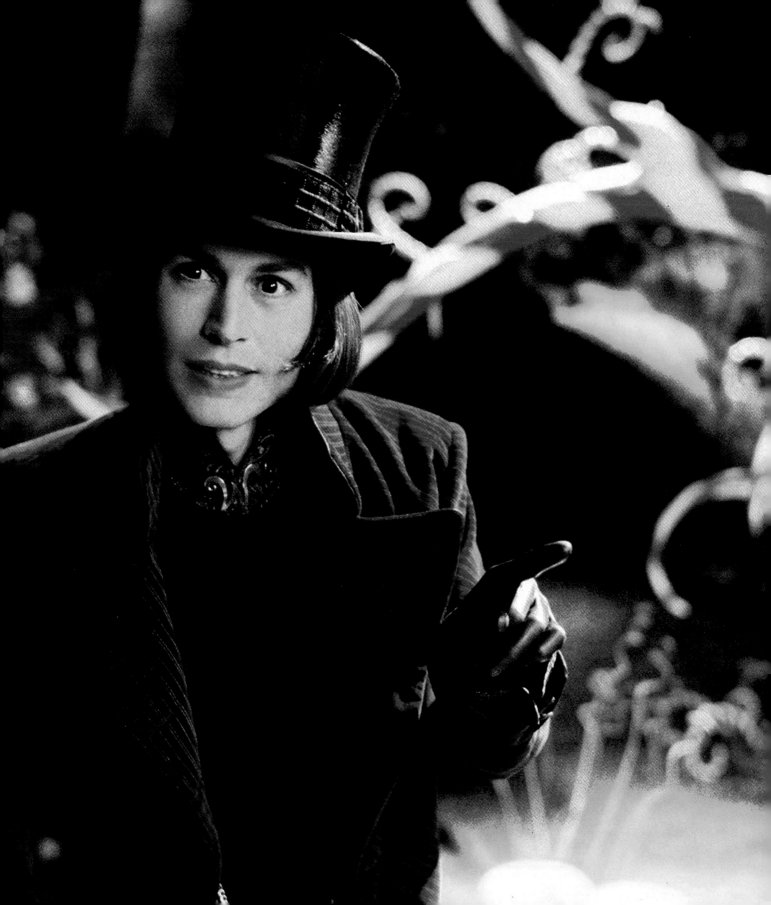

Charlie and the Chocolate Factory

The confectionery meadow was the biggest set ever built on the voluminous 007-stage at Pinewood. Through it flowed a river of chocolate, churned by a chocolate waterfall, and, as per Tim Burton's taste for real fantasy, the liquid was actually made of chocolate. To be accurate, it was 120,000 litres (26,400 imperial gallons) of a glucose mixture supplied by Nestlé. The smell became a little funky as the weeks went on.

"Each room has its own flavour,"[6] reports Burton. His instruction to art director Alex McDowell was 'to make it look as yummy as possible'[7]. The 360° sets for Willy Wonka's wonderland consumed eight sound stages across the studio, dwarfing even the set for Gotham. Although some were less edible: the TV room, as sterile as an operating theatre, was pure Kubrick; the Inventing Room had the 1960s comic-book licentiousness of Mario Bava's *Danger: Diabolik* (1968); while the urban world outside the plant's gates was prefab modern by way of Dickensian gothic. For all the candyfloss colouring, there remains something forbidding about this psychedelic Disneyland.

Take the squirrels. If Wonka's rodents' methods for dispensing with bad nut Veruca Salt (Julia Winter) are not disturbing enough, Burton wondered, why not double the effect with real squirrels? 'The squirrel trainers, man – they went nuts!' he giggles. 'It was like a special James Bond training camp.'[8] Over 19 weeks, 40 squirrels were trained to pick up and shake walnuts, or to paw at Veruca. As with the penguin army from *Batman Returns*, the desired choreography would also necessitate the addition of animatronic co-stars. And it was mostly CGI critters for the close-ups.

The Ooompa Loompas also benefited from a particularly *Burtonesque* touch. He cast Deep Roy, only 1.32 metres (4 feet 4 inches) tall, as all 165 of the diminutive factory workers, using digital trickery to duplicate him within scenes. Roy and his fellow Roys perform a series of edifying Danny Elfman compositions like a geek chorus, offering a musical element to the film's elaborate pick'n'mix.

Shot over the summer of 2004 in high secrecy, Burton was determined he wasn't making a hi-tech movie in the high fantasy mode of *The Lord of the Rings* (2001–2003). This $150 million blockbuster was firmly moulded to its maker's practical whims – and critics swooned. 'Did I really see an Oompa Loompa dressed in a witch-doctor outfit, doing a ceremonial jig with a cacao bean on his head?' wondered Stephanie Zacharek afterwards on Salon.com. The director hadn't been this liberated, on this scale, since *Batman Returns*. ✪

Below: The various sets inside the chocolate factory almost add up to a confectionery version of Halloweentown from *The Nightmare Before Christmas* – another world within a world.

Left: For all its scale and eventual success, Burton saw his Dahl adaptation as a personal story not so different from *Big Fish*, where Wonka struggles to reconnect with his father.

Below: Wonka issues instructions to one of his identikit Oompa-Loompas, each played by Deep Roy. Roy auditioned by lip-synching to Tom Jones' *It's Not Unusual* and would perform all the songs in the film.

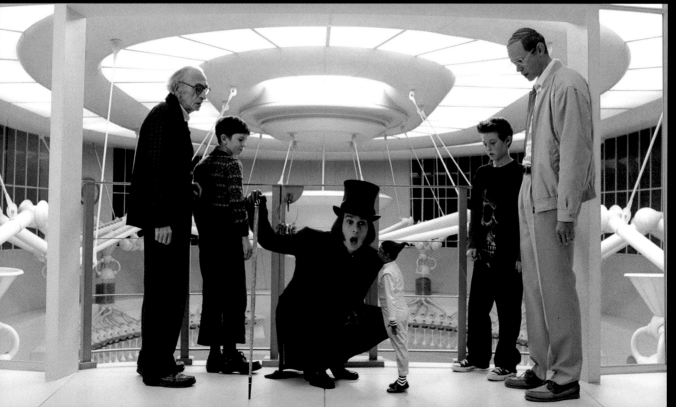

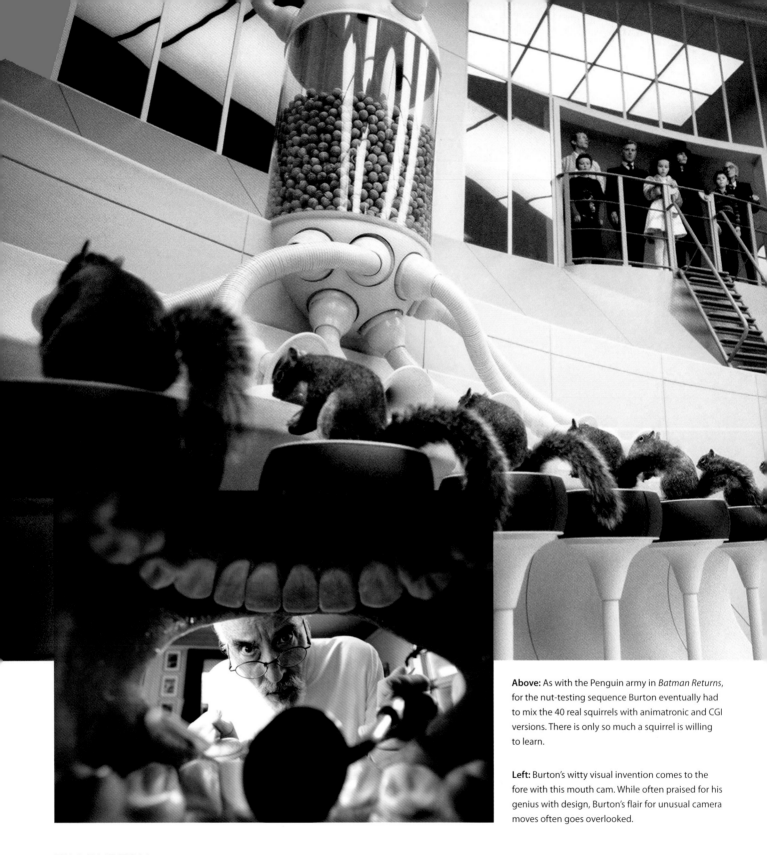

Above: As with the Penguin army in *Batman Returns*, for the nut-testing sequence Burton eventually had to mix the 40 real squirrels with animatronic and CGI versions. There is only so much a squirrel is willing to learn.

Left: Burton's witty visual invention comes to the fore with this mouth cam. While often praised for his genius with design, Burton's flair for unusual camera moves often goes overlooked.

TIM BURTON

During the film's marmalade-paced development, Warner had endeavoured to warm up the relationship between Wonka and Charlie, to make it more paternal and emotionally rounded, but that wasn't going to wash with Burton. 'Well, Wonka is no father of mine, I'll tell you right now,' he sniffs. 'He's a weirdo.'[9]

With Dahl having left plenty of room for interpretation in Wonka, straightaway, director and star were both flashbacking to their American childhoods, when every local TV station came with its own 'weird children's show host'[10] – barely sane clowns dubbed Captain Kangaroo or Mr. Pancake.

'Most people are nuts and that is really fascinating to me,'[11] says Depp by way of qualification. But most people aren't *this* nuts. His mouth crammed with new enamels, Depp's Wonka trills like a Valley Girl. The lavender contact lenses and crushed velvet get-up gives him the air of a 1960s libertine complete with top hat and cane. The hair is most alarming. That was Depp's concoction: he had sketched some ideas and jumped at one that resembled Brian Jones from the Rolling Stones with a Prince Valiant bob. This is a man-child cut off from time.

Indeed, during the press tour, director and star grew weary of dismissing the (not far-fetched) idea that he might be a take on Michael Jackson. They pointed out Wonka's affinity with Ichabod Crane from *Sleepy Hollow* and *Ed Wood*. 'He has faith in himself and his inventions and in that way he is like Ed Wood,'[12] explained Burton.

Depp thinks that Wonka's contradictions make him human. His cheerful face is a 'fixed grimace'[13]. He is childlike, but depressed. He is a showman averse to contact. 'He looks and acts like a 19th-century vampire who is halfway through a sex change,' giggled *Entertainment Weekly's* Owen Gleiberman.

One might describe him as a serial killer for children. Four golden-ticketed horrors will fall victim, one by one, to their own self-centred natures and Wonka's cool indifference. Dewy-eyed and pale as a milk dud, soft-centred hero Charlie Bucket is played in a relatively minor key by Freddie Highmore. He fulfilled Burton's requirement that social outcast Charlie look malnourished enough to be blown over in a strong wind. But in hindsight, the character feels underdeveloped and soppy.

Unmistakably, Burton's interest lay in the antisocial chocolatier. Departing from the book in an attempt to apply psychological motivation to Wonka, we discover his father (Christopher Lee) was a glowering dentist who despised sugar in every form, imprisoning his young son in braces that look like elaborate Martian contraptions.

'I have to admit, young Wonka is me,' Burton claims the character is the embodiment of him as a small boy. 'I had huge teeth and I wore a brace that I hated, a real piece of machinery I had to wear in my mouth.'[14]

Charlie and the Chocolate Factory would prove that Burton was once again as popular as chocolate, making $474 million. Yet the scale is deceptive. For all its success, the film is another personal delectation disguised as a blockbuster.

With his sell-by-date getting closer, Wonka reconnects with his past, sheds his Disney-on-acid eccentricity and enters adulthood with a new (surrogate) family in the Buckets. In 2002 Burton went with Bonham Carter to visit his mother in Lake Tahoe, shortly before she died. To his surprise, he found she had posters of all his films on the walls. Nothing was said, and Burton describes the revelation as 'horrifically touching'[15].

137

Sweeney Todd: The Demon Barber of Fleet Street

After the sweet came the sour. As hard and cold as a cobblestone, *Sweeney Todd* (to shrink its full appellation) is Tim Burton's first true horror film. A point rather offset by it also being a musical — a daring adaptation of Stephen Sondheim's gothic opera about the vengeful barber who slits his customers' throats, depositing their bodies into a meat grinder to be stuffed into pies by his equally unconscionable landlady Mrs Lovett (Helena Bonham Carter).

While still a 21-year-old student at CalArts, Burton made his first visit to London. Listlessly wandering the streets in drainpipe jeans and overcoat, he came to the Theatre Royal, Drury Lane where a production of *Sweeney Todd* was midway through its run. He didn't know much theatre, hadn't a clue who Steven Sondheim was – but it blew him away. He returned to see it again on the following two nights, mesmerized by its mix of song and slaughter. Thus the seed was sown on Burton's long-held desire to adapt it for the big screen.

Flush with confidence in the mid-1980s, he had gone to the legendary composer and proposed adapting Sweeney Todd. 'I said fine,' recalls Sondheim, only to be nonplussed when the young director 'went

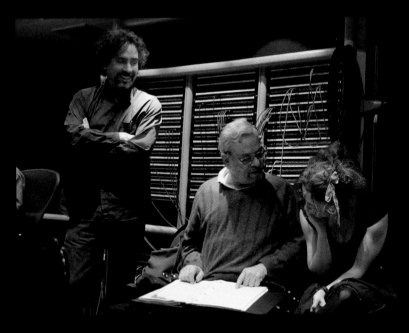

Above: An amused Burton looks on as *Sweeney Todd*'s composer Stephen Sondheim talks Helena Bonham Carter through a particular number. Sondheim would remain close to the production.

TIM BURTON

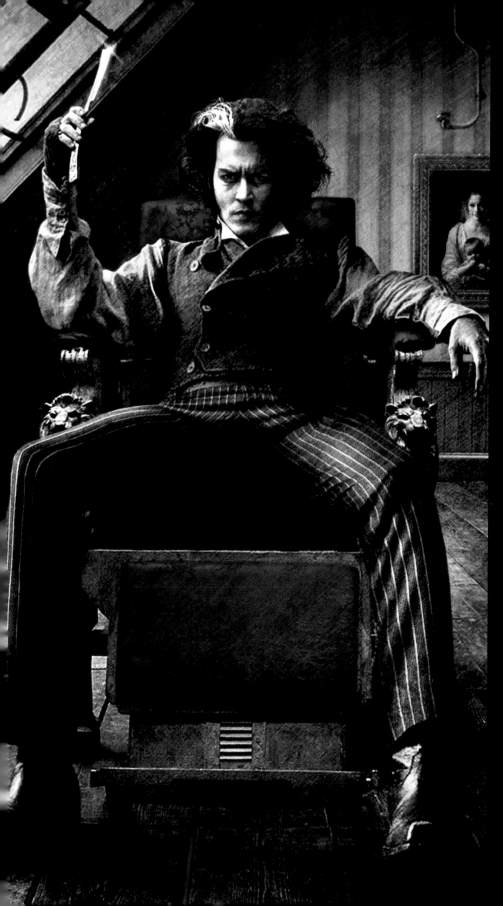

off and did other things.'[16] Burton admits he got sort of 'sidetracked'[17].

When special effects heavy Jim Carrey adventure Ripley's Believe It or Not! fell apart, Burton had rediscovered a sketch he had made after seeing the stage show. Impossibly, his Todd and Mrs Lovett resembled Johnny Depp and Helena Bonham Carter. (Or could it be that they had come to resemble his sketches?) His dance card open, he decided this was the opportune moment to bring Sondheim's *danse macabre* to life in the company of his favourite actors. What they lacked in Broadway training, they would make up for with their gothic bones and pale skin.

'Johnny had gotten to the point where he was the right age,' insists Burton. 'There was something about it that felt really right, even though I didn't know if he could sing.'[18]

The project had been underway at DreamWorks with Sam Mendes directing. Writer John Logan had spent four years at Sondheim's side trying to harness the three-hour musical. Worn down, Mendes departed to make *Jarhead* (2005). Enter Tim Burton stage left.

By his own admission, Sondheim doesn't adapt well. *A Funny Thing Happened on the Way to the Forum* (1966) and *A Little Night Music* (1977) were flops. In theatre, characters can stop and showboat; it's expected. However, Burton was insistent he was making a film, not a musical on film. He wanted to escape the fakery of characters bursting into song. The music needed to feel as if it were ever present in this world.

Left: Johnny Depp strikes the Sweeney Todd pose in a piece of promotional art. Despite it being a musical, this tale of vengeance was foremost a horror film, and remains arguably the darkest film Burton has ever made.

139

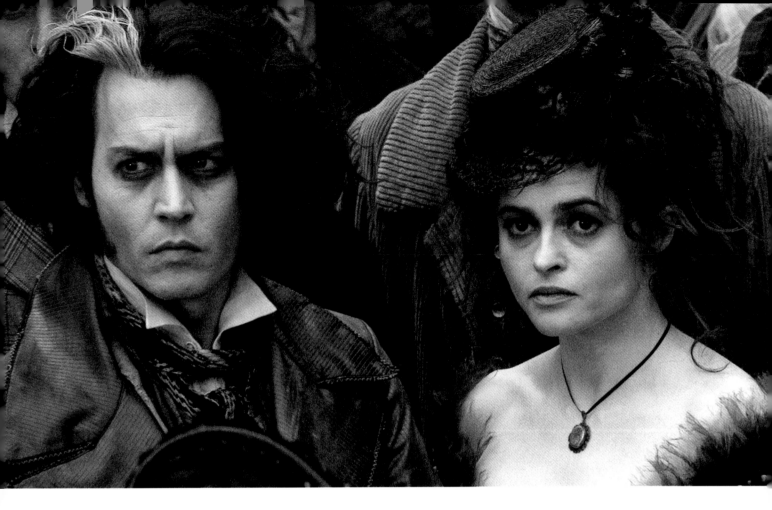

Above: The very odd couple, Sweeney Todd and Mrs Lovett. Burton felt the fact that neither Depp nor Bonham Carter was a trained opera singer would help the film feel less Broadway.

'Sondheim basically wrote this as a Bernard Herrmann-type score,' says Burton, who knew a film was there, buried beneath the theatrical impulses. 'This really edgy music gives the story its pulse, and takes you out of that old chestnut of "talk-SING, talk-SING."'[19]

So songs were excised, while the Greek chorus setting up the story felt improbable in the context of the twisted psychology Burton was chasing. There would be no prologue, no 'The Ballad of Sweeney Todd' – possibly the most famous song in the show. At times, the lyrics would need to be whispered.

Given the music pre-existed the film, it would be the second Burton work that Danny Elfman didn't score. Michael Higham, the supervising musical editor for Sondheim's score found Burton to be a man of few words but a precise vision. When it came to *Sweeney Todd*, he simply said, 'I want the music almost not to stop.'[20] Just like the blood.

Burton had paid a visit to Depp in France, presenting him with a copy of the original cast recording on CD – and his biggest challenge yet. Sweeney Todd isn't simply about singing; it's a vocal assault course of arpeggios, syncopations and atonal shifts. Depp was taken aback. 'I think I was probably more frightened than anyone,' he admits. 'Tim didn't know if I could sing, and I didn't know if I could sing either.'[21]

He shuttered himself away with a friend who was a music producer – and all went quiet.

TIM BURTON

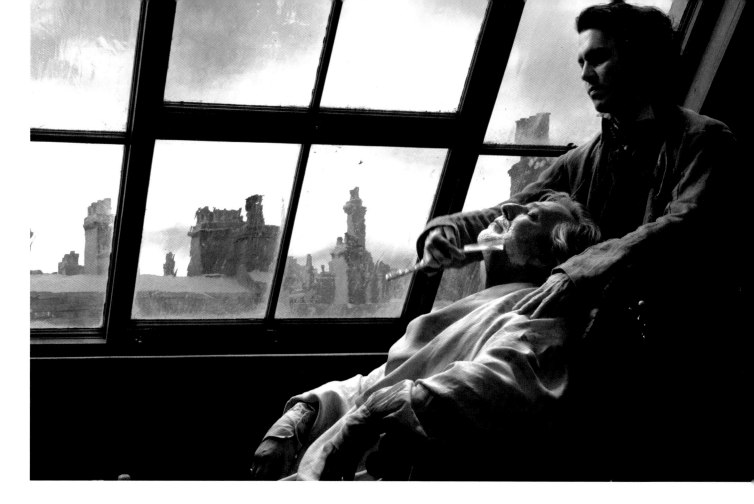

Bonham Carter had been obsessed with *Sweeney Todd* since she saw it as a young girl. Observing the film's development at close hand, she itched to play Mrs Lovett. But not only was she unsure her voice was up to it, she was well aware how it might look. 'It had to be righter than right,' she reflects, before joking, 'I didn't want to get it just because I slept with him.'[22]

She certainly looked the part. Burton adored how her Victorian face was the perfect match for Depp's high cheekbones and dark eyes. The characters were to be ghostly, like those dolls in *Corpse Bride*, only half alive.

In some senses, it was a relief that Sondheim had the final say on casting. It validated Burton's choices. Having taken her own singing classes, Bonham Carter gives a haunting performance. Not the cockney fishwife created by Angela Lansbury in the famous 1979 production, but a stitched-together soul driven to unspeakable actions by economic woe and twisted love. She yearns, heartbreakingly, for better things.

As for Depp, he returned from his self-imposed exile, placed a tape player down on producer Richard Zanuck's desk and, without a word, pressed play. Out came this rough-edged voice brimming with drama and suppressed rage.

The fact that none of the cast are trained opera singers, Burton feels, adds to the film's dance with reality. It literally blurred the lines between what was spoken and what sung. He likens the effect to a silent movie: high melodrama glistening like high art. Emotions were to be as unfettered as the blood. At 48, he was confident, even strident in his dealings with the studio. He knew what he wanted and he argued for it. From the first meeting he had with them he told them, 'There'd be a lot of blood, it would be an R-rating, so let's not even discuss it.' Skimp on the gore and you lose the point. 'How can you get politically correct about a guy who slits people's throats and puts them in meat pies?'[23] ✪

Above: A very close shave as Depp's Todd gets his hands on his foe Judge Turpin (Alan Rickman). Rather than use a green screen, Burton created an ashen 'horror movie London' built on soundstages at Pinewood.

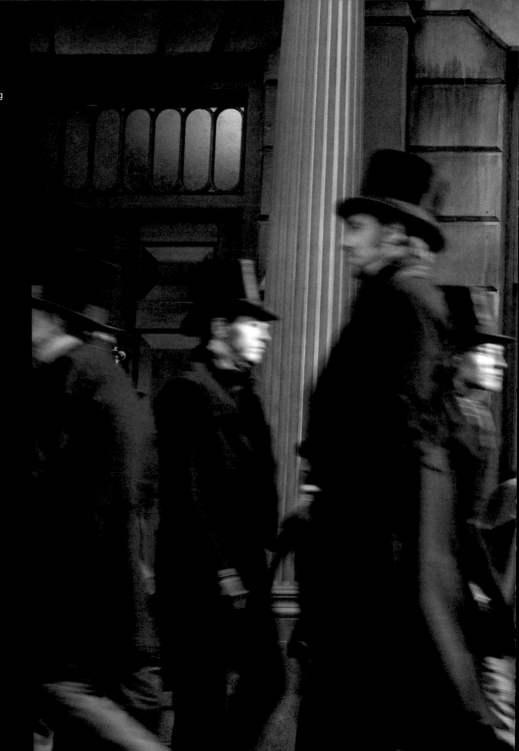

Right: Sweeney Todd (Johnny Depp) brandishes the tools of his trade. The prop department made the razors to Depp's exact specifications, including secret spring-loaded blades because he had experienced difficulty opening the razor quickly.

142

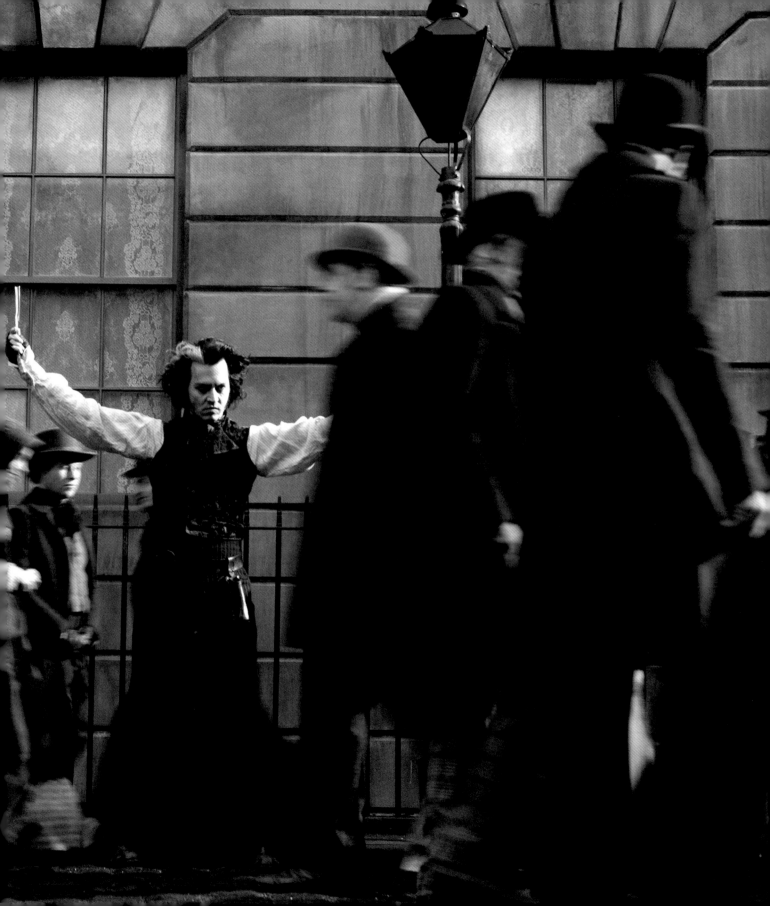

For all intents, Burton was making a $55 million slasher movie put to song. Definably *Burtonesque*, but in its emotional seriousness not something his younger self would or could have made. Filmed over the first half of 2007, Burton was thrilled to be able to mix its Grand Guignol theatrical heritage with a stunning horror movie aesthetic.

The rampant blood had the tomato-hue and runny consistency of the Hammer horrors he tapped for *Sleepy Hollow*. 'It always took you a couple of weeks to get it out of your underwear,'[24] he laughs. With every slit throat, the blood fountains in such profusion (the pumps would be attached to 45-litre/10-gallon tanks), it is not so different from the river of chocolate in Willy Wonka's factory. The point, however, is that the bloodletting is more an emotional release than a physical one.

Still leery of shooting against green screen and creating his backdrop on computers (as he would eventually do with *Alice in Wonderland*), the sets had the heightened look of a thirties horror movie. 'So it's just like an old backlot picture,'[25] he says, gratified how it gave the actors something to work with. Burton's 'horror movie London' was a marvel of production design set outside of any prescribed time or reality, but loosely mid-Victorian. The stage version takes place in 1846.

Burton tasked Oscar-winning production designer Dante Ferretti, once Fellini's man, with embodying Todd's psychosis in the Edward Gorey-like warren of sets. As ashen as the chocolate factory was bursting with colour, events are cloaked in a silvery monochrome (excepting any blood or 'happy' flashbacks) like a German silent film. Burton could work marvels if he ever chose to adapt Dickens – Sweeney Todd brims with the injustices of the class

system. Here is a society literally eating itself.

The film feels like a Burton film to its bones, but this was a new, uncompromising form of *Burtonesque*. Right through to its corpse-strewn finale the mood never lifts. Here is Burton at the height of his powers, transforming a morbid opera into a worldwide box office take of $152 million.

Moreover, Depp had fretted that Todd lacked sympathy. 'That was always the difficulty,' he says, 'taking a character like that and attempting to make people feel for him, at the same time that he's slashing people up.'[26] With a streak of white highlighting his coal-black pompadour, Todd's grim appearance refers to both Humphrey Bogart in *The Return of Dr. X* (1939) and *Bride of Frankenstein*. He was also based on other 'classic horror stars'[27]: Lon Chaney, Boris Karloff, Bela Lugosi and Peter Lorre (for the distraught eyes). The actor thought of Iggy Pop's Bourbon-soaked crooning, and created a 'punk rock'[28] Sweeney. There is a hint of Betelgeuse too, though he's not quite so outgoing.

'We always saw him as a sad figure, not as a villain or anything,' reflects Burton who cultivated close-ups theatre can never match. 'When you meet him he's a dead person really, the only thing that's keeping him going is one single-minded thing.'[29] His desire for revenge on Judge Turpin (Alan Rickman), who stole his wife and daughter, and had him exiled to a penal colony for 18 years. He is Burton's ultimate outsider, who can never fully return. The result is a film of rare intensity.

'Depp is such a soulful presence he gives you a glimpse of this maniac's pain and pathos,' noted David Ansen in *Newsweek*. Todd was Burton's most sympathetic monster; Jack Skellington's tortured artist taken to extremes. 'This guy is just angry

the whole time,' jokes the director. 'It's like if Edward Scissorhands went into a major depression for several years.'[30]

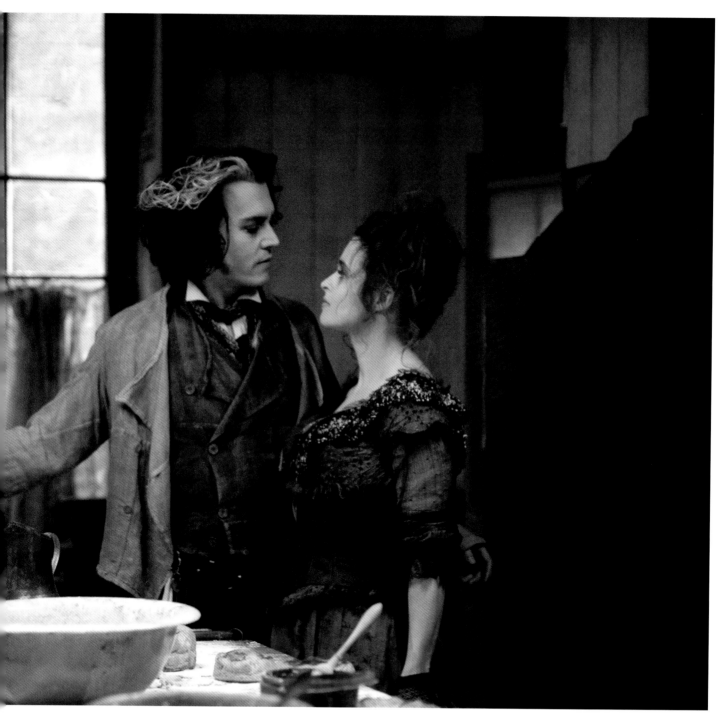

Above: Although Todd was a serial killer (seen here with Bonham Carter's equally uncivilized Mrs Lovett) both Depp and Burton wanted to paint his story as absurdly tragic.

JUST DESSERTS

FAMILY PLOTS
CGI and soap

When Tim Burton settled down in London with Helena Bonham Carter, they moved into a gothic pile in Hampstead, which had once belonged to the Victorian book illustrator Arthur Rackham. Truth be told, Bonham Carter moved next door, but there was an interconnecting tunnel.

The house could easily be one of Burton's sets: sooty brickwork, low-hanging beams, and a large tree dominating the front lawn. Burton made his workshop in the very same room that Rackham used as a studio. You wonder whether the two converse.

Anyway, among his depictions of fairy tale and myth, Rackham illustrated a 1907 edition of *Alice in Wonderland*, Lewis Carroll's masterpiece of literary nonsense – to which Burton's films have often been compared.

Nevertheless, it felt like a sideways step when Disney announced that Burton was to direct a new live-action version of *Alice in Wonderland*. It seemed too obviously *Burtonesque*. What's more, this was part of a two-picture deal with Disney to make 3D films (the second would be *Frankenweenie*). 'This one was presented to me as "*Alice in Wonderland* in 3D!" That just felt really exciting,' he says, 'the trippiness of

Wonderland in 3D just felt really exciting to me.'[1]

This was also to be a more tangential version. Screenwriter Linda Wolverton's script incorporated a potpourri of Alice mythology, drawing upon both of Carroll's novels – *Alice's Adventures in Wonderland* and *Through the Looking-Glass, and What Alice Found There* – as well as the numerous Alice adaptations through the years (of which there have been 17, including a porn version). The idea was that an older Alice (Mia Wasikowska), on the cusp of womanhood and fleeing an unwanted proposal, falls back down the rabbit hole to Wonderland. Only, she has no memories of having been there before. She is, of course, plunging into her own psyche in order to come to her senses.

You would have thought the book's rambling, lackadaisical structure would have suited Burton's general lack of deference to the nuts and bolts of storytelling. However,

whether it was studio pestering (*The Lord of the Rings* had recently made billions), or the notion that the only way to subvert Carroll is to add plot, the film would adopt

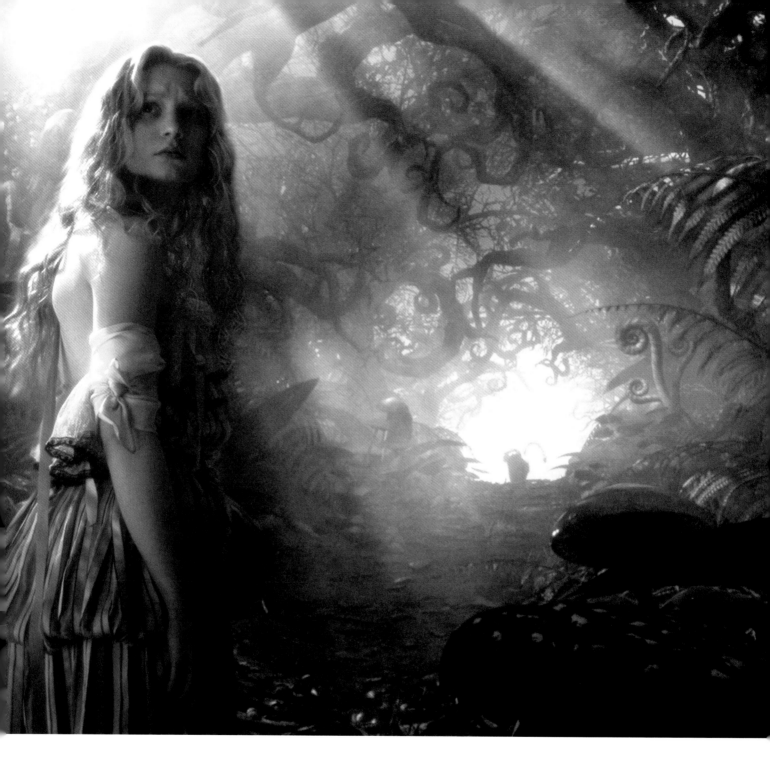

an ill-fitting epic fantasy mode. It would also be made almost entirely out of CGI, Burton's magnificent sets reduced to great slabs of green.

Above: Mia Wasikowska as a more grown-up self-determining Alice than we've seen ever before. Tim Burton had viewed the 1951 Disney animated version of the character as an annoying little girl.

Alice In Wonderland

'One of the reasons why *Alice In Wonderland* and Tim are such a great match is because nothing is exactly as it seems in Wonderland,' figures Anne Hathaway, who plays the White Queen. 'And if you look throughout his filmography, nothing is ever what it appears to be or should be.'[2]

Indeed, Wonderland is not even Wonderland. According to Wolverton, Alice had misheard the name of this strange queendom on her first visit. It is, in truth Underland, underscoring its place as a simulacrum of Alice's subconscious. As with *The Wizard of Oz* (a celebrated variation on Alice's dream logic), there are visual rhymes between the obnoxious humans in the real world and the exotic denizens of Underland.

The director was fascinated by the chance to 'explore the nature of dreams'[3]. Then, you could argue, he has spent most of his career curating a tradition of dream spaces. They flit between guises – afterlifes, planets, suburbias, and chocolate factories – but they are all places where reality submits to Burton's imagination. He has often spoken of filmmaking as a way of working through the murky depths of his subconscious. And *Alice in Wonderland* almost feels like a tribute, or satire, of his own filmography; in Underland, there is just so much of *The*

Nightmare Before Christmas (that larder of so many *Burtonesque* confections).

So it might have been a mighty Disney production, budgeted at $160 million and made with all the latest gizmos, but the result is certainly *Burtonesque*. Nonetheless, eyebrows were raised at the idea of Burton, evangelist for practical effects, not just adopting CGI but letting them swallow him whole. Sure, he had used CGI for *Mars Attacks!*, but that was more necessity than design. This appeared to be an unwelcome shift toward the mainstream. Had he lost his head?

Initially, at least, it was business as usual. Burton's design team gathered together all

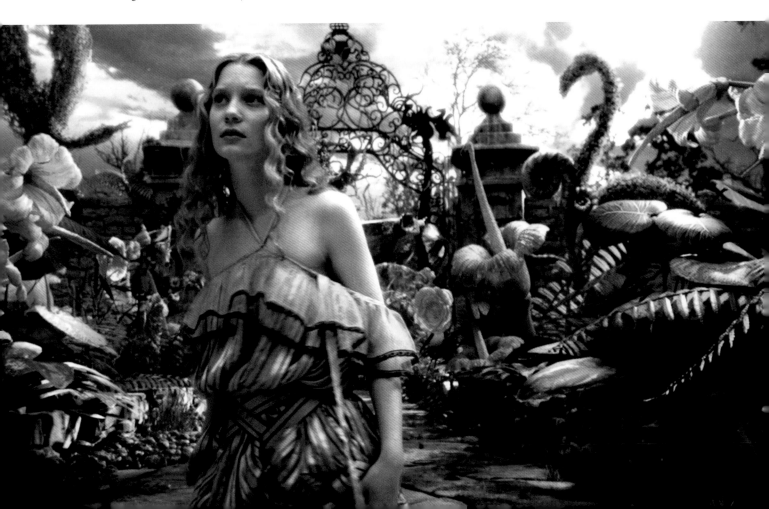

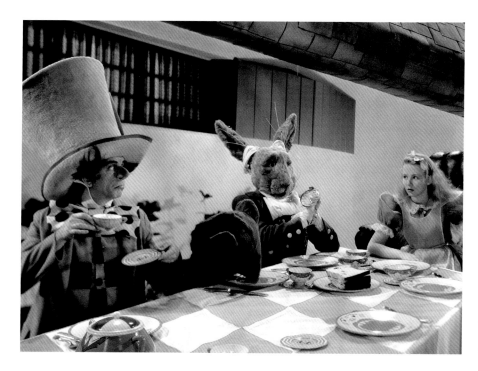

Left: Norman Z. McLeod's star-laden 1933 adaptation was a costly flop, but remains fascinating for featuring Gary Cooper as the White Knight, W.C. Fields as Humpty Dumpty, and Cary Grant as the Mock Turtle.

Below: Similar to Burton's approach, the 1972 William Sterling version, *Alice's Adventures in Wonderland*, featured a cast of big British stars (Michael Crawford, Michael Horden and Spike Milligan) who were often recognizable by their voices.

the illustrations done for the books down the years – including those by Rackham and, of course, the original iconic woodcuts by John Tenniel – to which he added his own. Underland is in decline: colours have faded, and the entire gardenlike world has become hideously overgrown, due to a combination of the Red Queen's tyranny and Burton's house style.

'Alice was an experiment,'[4] the director admits, soon lost in his own creative forest. He found the CGI process every bit as complex and draining as stop motion. The film wasn't even completed until two weeks before release. 'We didn't know what the movie was till the very end. It was exciting and scary. Working on the CG just got more and more and more intense.'[5]

Opposite: While it came as a shock to see stop motion king Burton embrace the possibilities of CGI, he saw it as the ideal tool with which to present Lewis Carroll's absurd story.

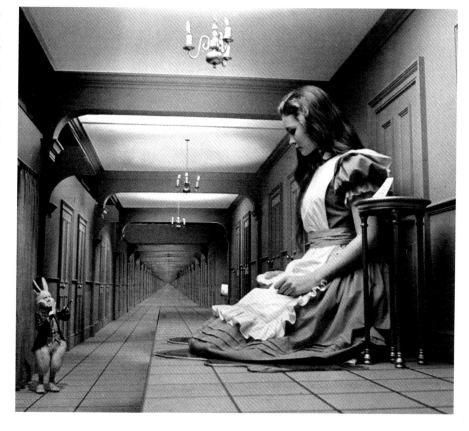

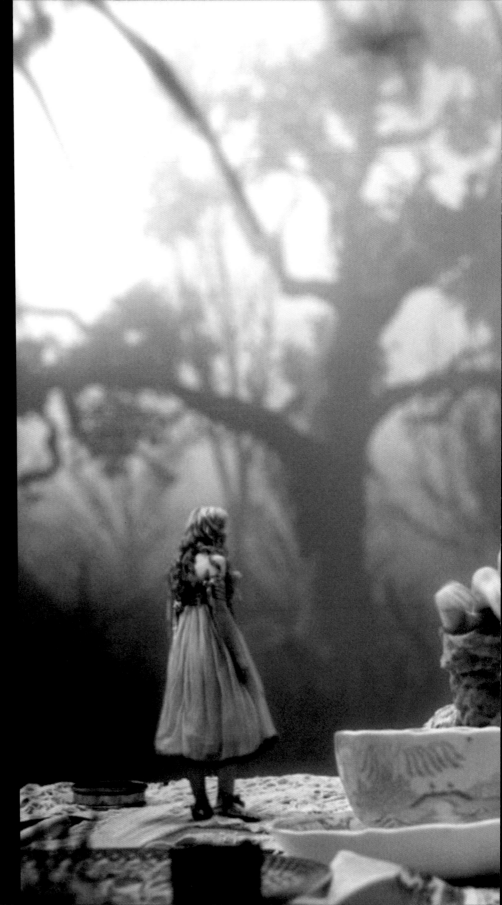

Actors and crew became nauseous staring at nothing but neon green (the country-house exteriors were shot first at Antony House in Torpoint in Devon). And for critics, this was a film gasping for air. The 3D conversion, designed to accentuate the oddness of the world, becomes overbearing. At times, it is all too much. The CGI landscape is as glutinous as a chocolate river. It was like a 'Disney film illustrated by Burton', scolded Todd McCarthy in *Variety*.

Perhaps, in the wake of *Avatar* (2007) audiences simply couldn't get enough of 3D and CGI exotica, because *Alice in Wonderland* became a monster hit. One so successful, crossing the billion-dollar mark worldwide ($1.02 billion), that, for the first time outside of the *Batman* franchise, a sequel was announced. Directed by James Bobbin, with Burton producing, *Alice Through The Looking Glass* (2016) finds Wasikowska's heroine returning to the Underland, via a mirror, to find things in disarray once more.

Indeed, Burton in Wonderland wasn't entirely a lost cause. *Alice in Wonderland* is arguably as grotesque and disturbing a box office sensation as ever there's been. ✪

150

Right: Alice (Wasikowska) startles an excitable Mad Hatter (Johnny Depp). Depp had done his research, the term 'mad hatter' related to 19th century milliners who often went insane because of the mercury in the glue they used for their trade.

TIM BURTON

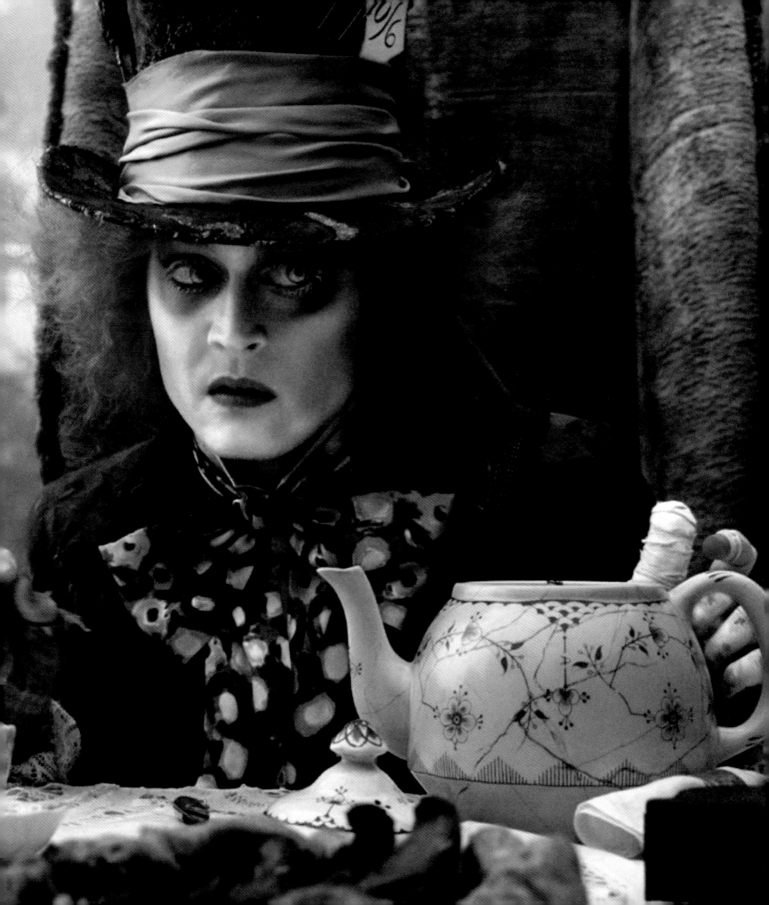

Right: A promotional picture featuring Alice (Wasikowska) and the White Rabbit (Michael Sheen). Released in the wake of *Avatar*, audiences proved receptive to another CGI-smothered 3D world.

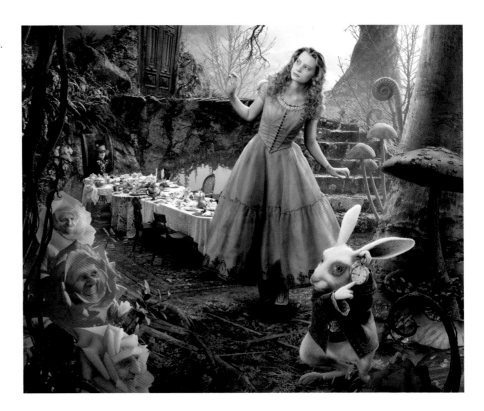

Below: The Mad Hatter (Depp), White Queen (Anne Hathaway) and an armour-clad Alice (Wasikowska) confront the Jabberwocky as the film makes a strange, unsuccessful switch into a more epic fantasy mode.

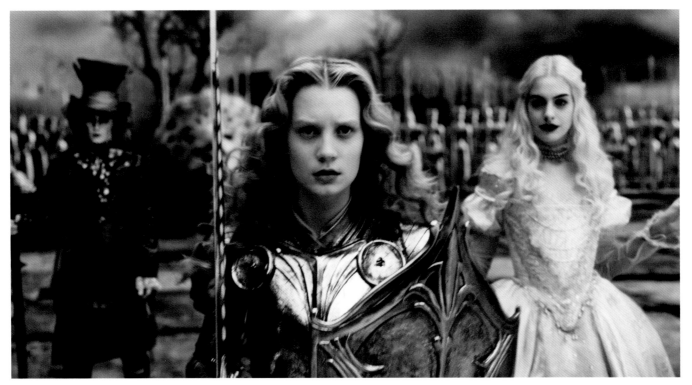

TIM BURTON

It is in the citizens of Underland, new twists on Carroll favourites, that Burton's genius finds leverage. He worked out a cunning classification – three levels of weirdness. There are real actors in Oscar-winning costumes, from Wasikowska's Alice to Johnny Depp as the Mad Hatter (although his eyes are artificially enlarged). There are the creatures created entirely from CGI, and only voiced by actors, such as the Dormouse (Barbara Windsor) or the White Rabbit (Michael Sheen). And between them is an intermediary stage: the 'hybrids'[6], real actors grossly altered by CGI ('mutated' was Burton's term) and partly performed with motion capture by the likes of Crispin Glover as the elongated Knave of Hearts; an engorged Matt Lucas as both Tweedledum and Tweedledee; and Helena Bonham Carter as the Red Queen, given a bulbous head to go with her tantrums.

Inspiration for whom was found in that Hampstead household where Bonham Carter and Burton's toddler Nell ruled the roost. 'Toddlers are tyrants,'[7] explains the actress. Her jolts of petulance, beneath that swollen cranium, are the highlight of the film. Can we also read mischief at the expense of Hollywood toddlers in the Red Queen's sycophantic court?

Hathaway, supposedly the good option (Burton never likes easy distinctions), saw the White Queen as a 'punk rock vegan pacifist'[8] inspired by Blondie and Greta Garbo. The increasingly anglicised Burton swore she was based upon curvaceous television cook Nigella Lawson.

Curiously, Alice is his first female protagonist. He has enjoyed working with strong actresses on strong characters – Michelle Pfeiffer's wild Catwoman and Bonham Carter's forlorn Mrs Lovett – but until now he had never found a female to wholly channel the Burton dream.

The director tends to shrug when Alice is described as a feminist flying the social strictures of an enforced engagement. He saw her simply as someone discovering who she is. 'I've always hated Alice on screen,' he clarifies. 'She's a very annoying, odd little girl. I wanted to make her into a character I could identify with: quiet, internal, not comfortable in her own skin, not quite knowing how to deal with things, being both young and having an old soul.'[9]

By contrast, Depp's Mad Hatter, kindly though he is disposed to be, is the highly strung chatterbox, another Vaudevillian show-off from the school of *Beetlejuice*. His explosion of electric orange hair, mismatched green eyes (created with contact lenses, with one slightly askew), china doll skin, and deranged stage magician tailoring is surely what Depp's Joker might have resembled. Alice herself is more like Batman, or Edward Scissorhands.

'She's experiencing something that I've felt, or my friends have felt,' says Wasikowska, 'this discomfort in your skin, this awkwardness in society, or the pressures and expectations that are upon you. Ultimately, it's a really brave thing to do what makes you happy as opposed to what is the norm.'[10]

Like so many characters before her, Alice, it seems, *is* Tim Burton.

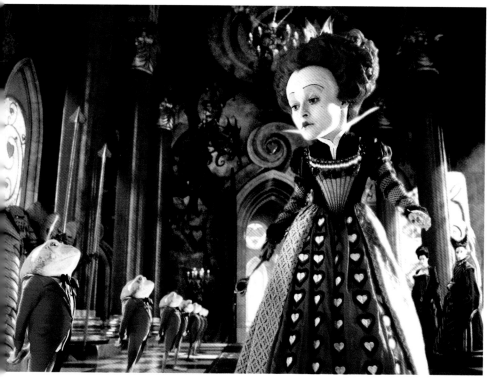

Left: Helena Bonham Carter suffers the indignity of a bulbous cranium as the Red Queen. Burton used CGI in clever ways, including the exaggeration of character traits – the Red Queen is literally big-headed.

FAMILY PLOTS

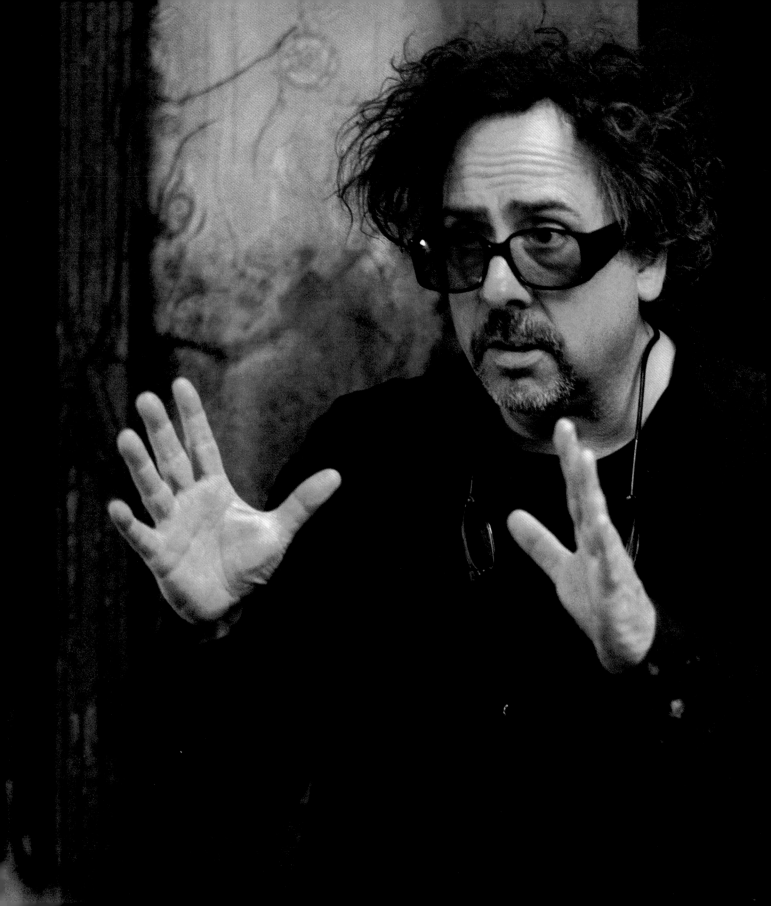

Left: Tim Burton frames a shot with Mia Wasikowska who plays Alice. Remarkably, given his affinity with actresses, *Alice in Wonderland* marked the first time that Burton had made a film with a female lead.

FAMILY PLOTS

Dark Shadows

'I can remember being totally fascinated with Bela Lugosi and the *Dracula* films when I was five years old. I can remember sitting in class in first grade getting in trouble for drawing pictures of Dracula and Frankenstein. I remember it like yesterday. When I was five or six years old, I was totally, utterly obsessed with a television show called *Dark Shadows*. I wanted to be Barnabas Collins. I wanted the cane with the wolf's head on it. I'm sure that, for my parents, that must have been a really scary thing.'[11]

These are not, as you might assume, Tim Burton's recollections but those of Johnny Depp. And, reversing the poles of their relationship, it was Depp who approached his friend with the idea of a big screen adaptation of the 1960s television series. 'I think it was during *Sweeney Todd* where I just blurted out in mid-conversation, "God, maybe we should do a vampire movie together where you actually have a vampire that looks like a vampire." *Dark Shadows* was kind of looming on the periphery, and then Tim and I started talking about it.'[12]

Created by producer Dan Curtis, and running from 1966 to 1971 (totaling 1,245 episodes), the show rearranged the kooks of 'The Munsters' and 'The Addams Family' to create the Collins clan of Collinsport, Maine, who variously featured ghosts, werewolves, zombies and other horror staples. At first rather haphazard, with actors rotating between roles and the supernatural elements subdued by the lack of budget, the series gained its melodramatic wings with the arrival of Jonathan Frid as the resourceful vampire Barnabas Collins.

As ever, the immediate attraction for Burton was one of familiarity. Here was a chance to re-engage with America, in particular the cult branch of pop culture that inspired *Beetlejuice*, *Mars Attacks!* and *Ed Wood*. This was the stuff he had grown up with – not just the source material, but also the 1970s' setting of the two Curtis-directed feature film expansions *House of Dark Shadows* (1970) and *Night of Dark Shadows* (1971). The film's great gothic pile, in dire need of repair thanks to the Collins' impecunious circumstances, offers a crazy *Burtonesque* juxtaposition with the tacky 1970s' trappings that adorn his memories of the era.

'It was not so much making fun of the time, just seeing things from a different perspective,' says Burton. 'When you think of mood rings and Pet Rocks ... I suppose you could find peculiar things in any era but, looking back on that stuff, as eras go, that one does seem stranger than most.'[13]

Depp makes no bones about it; this was the most surreal era in recent memory. 'Not just through the technology and automobiles and such, but actual items of enjoyment for people like Pet Rocks and fake flowers and plastic fruit and troll dolls and lava lamps.'[14]

The $125 million production also offered Burton – now the proud father of two – another opportunity to probe the theme of family. It's always been there: *Edward Scissorhands*, *Big Fish*, *Sweeney Todd* … The Collins clan even reminded Burton of the endearing coterie of misfits in *Ed Wood*: this was an entire family of outcasts. ✪

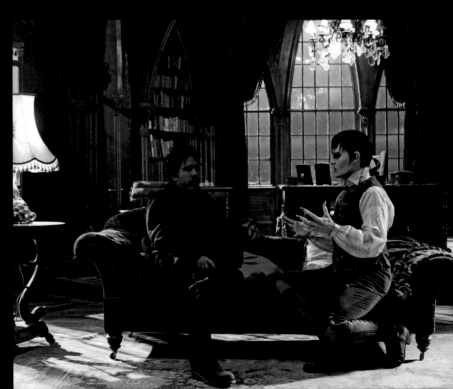

Opposite: Depp in full vampire regalia talks over the scene with his director. The actor would channel most of his performance as the stiff-limbed patriarch through his wildly expressive fingernails.

Above: A resurrected Barnabas Collins (Depp) confronts the breakfast waffle. Trapped outside of his time, the pragmatic vampire acts as a cypher for the audience, for whom the 1970s are equally alien.

FAMILY PLOTS

Burton had met writer Seth Grahame Smith producing his screenplay for *Abraham Lincoln: Vampire Hunter* (2012), noisily directed by Timur Bekmambetov. Sensing another simpatico spirit, he offered him the chance to make sense of this schizophrenic TV series, handing over a compendium of box sets, books, CDs, novelizations, character breakdowns, an early draft by John August, and access to the collective brain bank of aficionados Depp and Burton.

Smith was the ultimate Burton fan boy made good. He had grown up on *Beetlejuice* and *Batman*, and could recall his mother dropping him off to see *Edward Scissorhands* on a 'cold winter's night in Connecticut'[15]. Channelling his idol's topsy-turvy logic, Smith realized he was not adapting the series, but Burton and Depp's twinned memories of the series. As memories can be inconsistent, he reasoned, so the tone could vary, fluctuating between satire, fish-out-of-water comedy, stabs of horror, gothic romance, and soapy family dynamics.

'One of the things that unites Tim and Johnny is their macabre senses of humour,' notes Smith. 'So to me, the idea that [Barnabas] kills something like eleven construction workers and quite a few hippies is balanced by him being remorseful and apologetic. That was a challenge. To get the audience to stay on his side.'[16]

Smith could see how the show could be tuned to Burton's prevailing mood: it is the tale of a likeable outsider, stuck in a screwy cul-de-sac of American values. 'That's what I love about Tim's movies,' he says, who admits *Edward Scissorhands* was in the front of his mind throughout. 'It's the normal people who are the most frightening.'[17]

As well as the tacky 1970s, Barnabas' chalky-faced, *Nosferatu*-fingered, eighteenth-century vampire, must deal with errant

descendants, a failing canned fish business (chiming with the Van Dorts of *Corpse Bride*), and a magically sustained spurned lover, Angelique Bouchard (Eva Green), far more the vamp than the vampire. Despite his urges, Barnabas remains the model of antique civility, exasperated by the venal world in which he has emerged. He may be undead, but he is very human.

The plot ends up as scatterbrained as Barnabas, as if it were a series of episodes

thrown together in a single movie. We begin, as the series did when it first aired, with governess Victoria Winters (Bella Heathcote). A reincarnation of Barnabas' great love Josette du Pres, she arrives at the Collins' ancestral seat, in a spin on Henry James' *The Turn of the Screw*. Here the film gets distracted by the infighting of the cranky family, barely kept in check by haughty matriarch Elizabeth (a splendid reunion with Michelle Pfeiffer). Helena Bonham

Carter is granted the relative glamour of orange hair and Thelma-specs (maintaining a running joke of *Scooby-Doo* references) as the in-house shrink, Dr Hoffman, with a thing for vampire blood. She is supposed to be tending to the growing pains of the literally haunted David (Gulliver McGrath), son of Elizabeth's unscrupulous brother Roger (Jonny Lee Miller), while Elizabeth's teenage daughter Carolyn (Chloe Grace Moretz) is mixing puberty with lycanthropic

leanings. Then the question arises of how the recently reawakened Barnabas will pull his family together, while fending off the suspiciously well-maintained Angelique.

'The theme of the movie to me is, *"blood is thicker than water"*,' Smith explains. 'It's right there in the first and last lines of the movie and we hit that over and over again.'[18] ✪

Above: A banner poster featuring the extended Collins clan, inclusive of nanny, shrink and nemesis. Burton has often been drawn to the unpredictable dynamics of family life in his films.

FAMILY PLOTS

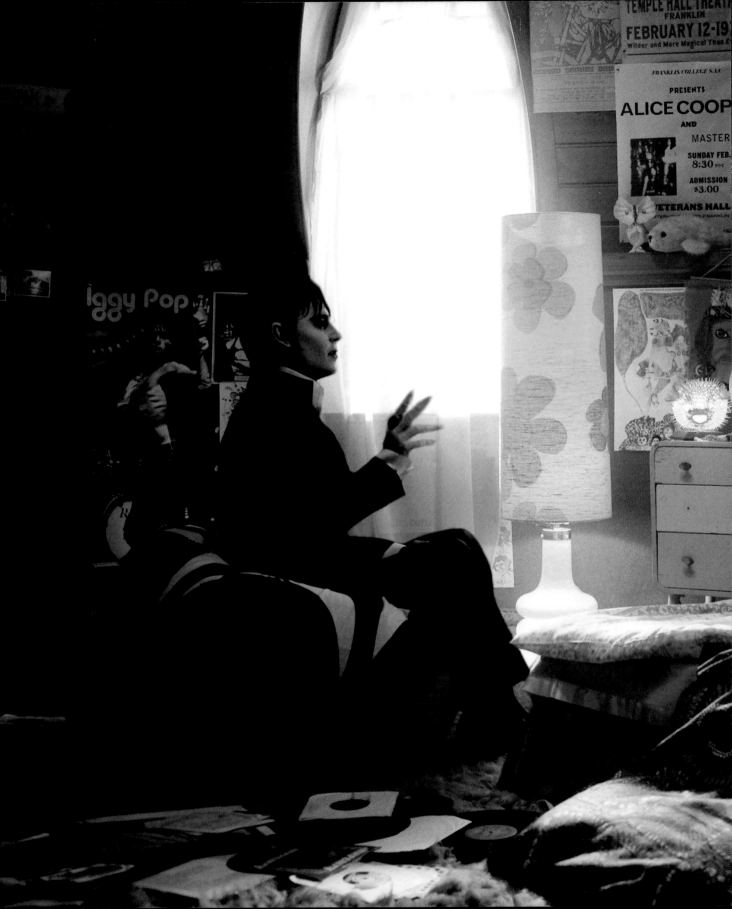

There was a lot to take in. Despite a hardly bloodless take of $245 million worldwide, it was marked a disappointment, the elastic tone confounding both critics and audiences, who felt they should be laughing but didn't quite know where. 'Dark Shadows doesn't know where it wants to dwell,' complained Ann Hornaday in the *Washington Post*, catching the general discontent, 'in the eerie, subversive penumbra suggested by its title or in playful, go-for-broke camp?' Whereas *Mars Attacks!* went full steam ahead into choppy waters of spoof, *Dark Shadows* is restrained. It keeps glancing over its shoulder at *Edward Scissorhands* and *Sleepy Hollow* and wondering if that might have been a better approach.

And yet, half the pleasure lies in that uneasy tenor. We shouldn't know whether to laugh or scream. This was a screenwriter's love song to his director's category-resistant oeuvre – in its own languid way, a Tim Burton *Greatest Hits* album.

Left: Barnabas (Depp) attempts to bond with Carolyn (Chloe Grace Moretz). The hipster accessories of Carolyn's bedroom make the case that the 1970s did have its sanctuaries of cool.

PECULIAR CHILDREN
Art and magic

They were like an alien invasion. In every front hall, every dentist's waiting room, being sold at every drug store, these creepy children with big, big eyes stared out from their paintings.

To Tim Burton's eyes they were like 'Children of the Damned meets Rod Serling's "Night Gallery"'[1], but Margaret Keane's pictures of saucer-eyed waifs translated as art to the American middle class.

Again and again, Burton is drawn back to suburbia. Back to those identikit houses of Burbank, where Margaret Keane's art had spread like an epidemic. And, for his next trick, he chose to reveal the story behind those paintings, once thought to be the work of her delusional husband Walter.

'I was familiar with Walter Keane before I was aware of names like Matisse, Picasso or Warhol,'[2] admits Burton. As with *Ed Wood*, the big-eyed paintings showed the elastic nature of American culture. Some loved them; others viewed them as mass-marketed junk. All these identical eyes staring out of different faces, including Joan Crawford and Natalie Wood, appeal to Burton's alternative tastes. 'There's sort of an uncanny quality and sadness,' he says, 'as well as a darkness and humour and colour.'[3] Which could almost be a description of the Burton school of the peculiar.

Burton actually commissioned Margaret to paint Lisa Marie in 1996. He has since asked her for a portrait of Helena Bonham Carter with their son Bill.

The resonances with Burton's own career are manifest. She created a body of work that is both eccentric *and* populist. Edward Scissorhands and Charlie Bucket have the doleful mien of Keane paintings – emoting almost entirely with their eyes, their faces placid.

Margaret was an isolated child, finding it hard to make friends. She found liberation in her distinctive brand of art. But in the 1950s she would fall prey to Walter Keane, less artist than con artist. Becoming her second husband, and stepfather to her daughter Jane (the model for much of the art), he transformed these big-eyed pictures into a phenomenon.

Walter was no fool; he knew how to market a concept, pioneering the mass reproduction of paintings as prints. Indeed, he is responsible, in many respects, for Margaret's later fame. But this charismatic court jester convinced her that it was vital *he* took the credit, while she was holed up in the studio churning out painting after painting.

'It is kind of symbolic of where the American Dream was really at,' says Burton[4].

Opposite: Amy Adams poses as Margaret Keane at work on one of her strange paintings of 'big-eyed' children. Not since *Ed Wood* had the subject matter of a Tim Burton film thrown a light on his own artistic process.

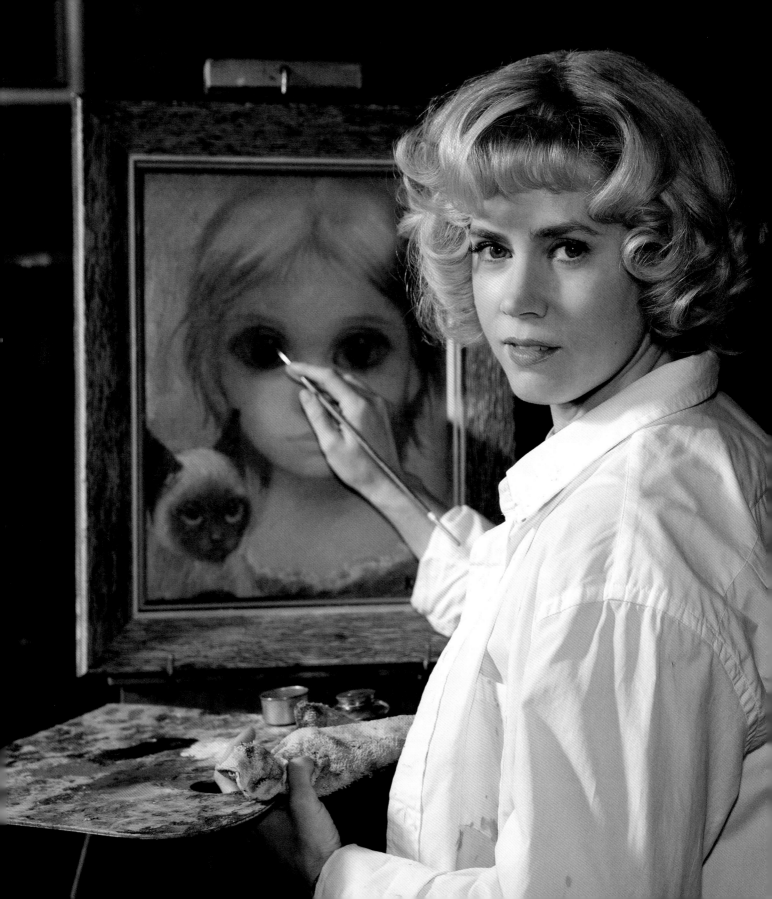

Big Eyes

Big Eyes is a sister film to *Ed Wood*. It shares a similar structure and themes: this warped biopic of a highly unusual artist and her times. Margaret might be a shrinking violet compared to the ebullient Ed, but they share a compulsion to create, and a stormy relationship with the critics. The tastemakers of high art deride the paintings as tasteless hackwork. Burton too has been labelled an artist, and lambasted as a phoney too.

He came to the project off the commercially successful Museum of Modern Art exhibition of his personal art, which had been trashed by art critics. And he relished the opportunity to cast Terence Stamp as the hilariously supercilious John Canady, "General Zod of art critics"[5].

The films also shared a similar trajectory from concept to screen, originating with the same writers. Larry Karaszewski and Scott Alexander had been chiselling away at the project for over a decade, once again drawn to that seam of kitsch unique to America.

'Everyone sort of knows those big-eyed crying children,' says Karaszewski, 'but nobody knew the story behind them.'[6]

Having earned Keane's trust, the two were eager to direct the film as a small indie with a budget that would barely cover wig grooming on a Burton extravaganza. After a soul-destroying procession of false dawns (Kate Hudson and Thomas Haden Church were cast at one point), they turned to their old friend in the hope he might produce the film – just as they had done on *Ed Wood*.

In Karaszewski's considered opinion, 'Tim could just wave his Willy Wonka magic wand and the movie would finally get made.'[7] But as with Ed Wood, having agreed

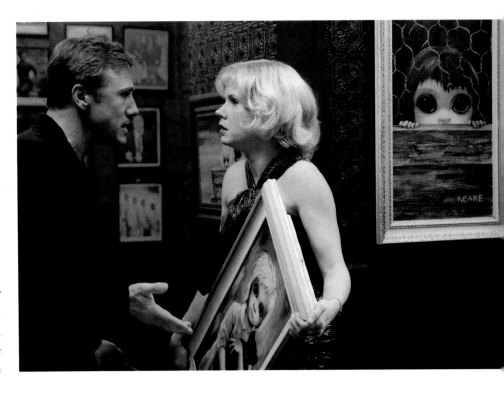

Above: Walter Keane (Christoph Waltz) remonstrates with Margaret at the hip Hungry i nightclub, which due to its declining fortunes had doubled up as an art gallery. For all his deception, Walter did get the paintings noticed.

to produce the film, Burton found himself drawn deeper into Keane's story, and decided to direct. Following the making of several blockbuster-scale films, which had not been necessarily greeted with open arms by the critics, he was keen to make something more nimble. 'I just felt it was the right time and place,' he explains. 'Plus, it was a story that I really had a personal connection to.'[8]

This was more than a case of finding himself in the shy, unappreciated Margaret; the film said things about his artistic process. Art was a way of connecting with the world. And he saw the same thing in Margaret.

Backed by the Weinstein Company to the tune of $10 million (Burton's lowest budget since *Beetlejuice*), the film was shot over 41 days, with the more affordable Vancouver standing in for San Francisco. With six days to capture landmarks in the real city. Remarkably, after 29 years in the business, he was making his first independent film.

'With this kind of budget you just do it,'[9] laughs Burton, who found the financial restrictions liberating. For once, he didn't need to be Tim Burton the blockbuster maker.

Not that the film was untouched by *Burtonesque*. He and long-time production designer Rich Heinrichs created a hyper-realistic West Coast art scene of the 1950s, absorbing some of the painting's alien kitsch and Walter's crackpot personality. It's a sun-bright aesthetic that finds its focal point in the Keanes' modernist mansion – a dream house locked in a dream.

For the art within the art, they used more than 150 variations of Margaret's paintings.

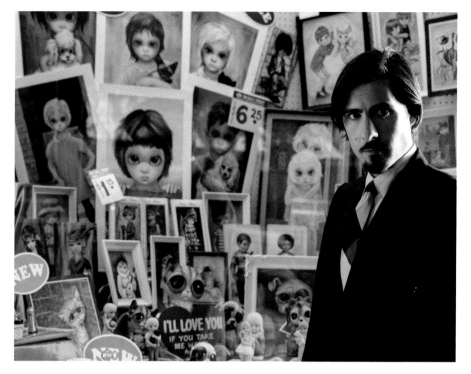

Above: Adams pictured with the real Margaret Keane, who frequently visited the set, and even took a cameo. The artist proved an invaluable source of advice for Adams.

Left: Jason Schwartzman as snooty San Francisco art dealer Ruben. Part of what the elite were so appalled by was the commodification of art into pop culture and commerce.

Spontaneity being the order of the day, Burton wouldn't pick which paintings to use until the day of a scene. Set decorator Shane Vieau had to bring every piece of artwork to set each day in a van. In an amusing marriage of both the film's on-the-fly approach and 'What is art?' theme, when it came to an art fair teeming with paintings for sale, all the set decorators were put to work creating instant modern art, usually with a few swift brushstrokes to the canvas. Most of it was still dripping wet.

Burton was also thrilled to be working with new actors, or as he puts it different jars from the 'chemistry set'[10] of filmmaking. 'Because I'm not a social person, it's a great way to meet people.'[11]

Blending vulnerability, strength, and very big eyes, Amy Adams was ideal for Margaret. Something Karaszewski and Alexander had been well aware of in 2011, when she turned them down. She had felt too

young for the role, unsure how to find 'her way into Margaret'[12].

Then, in 2013, she and Burton got talking at an Academy luncheon. 'Which is like a horrible high school dinner where you're not the popular ones,'[13] groans Burton, who possesses an unsurprising aversion to Hollywood's annual beauty contest. He tries, if at all possible, to be washing his hair on Oscar night.

Before making it as an actor, Adams had drawn up a list of directors she wanted to work with – Burton was on that list. She had been obsessed with *Beetlejuice*. And when Burton offered her the role, she decided Margaret might be right for her, after all.

One of the most interesting questions the film ponders, without lowering itself to pat conclusions, is why Margaret acquiesced to Walter's schemes. 'She was definitely in love with Walter and trusted him,' says Adams. 'And she was devastated by his deceit, but she

became complicit in it, and was overcome by her guilt.'[14] Margaret was trapped in the underworld of Walter's lie.

Rather than feminist, Burton sees her struggle in epochal terms: 'Their story represents, symbolically, something to me about the time and how it was changing from one era to another, from the '50s into the '60s. They captured the spirit of the changing times, but in a weird way.'[15]

Quite a few actors had turned down the role of Walter, nervous about playing such a creep. But Christoph Waltz lit up at the possibilities of this psychological dervish. Walter was the consummate showman – a blowhard like Ed Bloom and a perfect fit for Waltz's prolix talents – and the irony was fascinating: 'Walter is a man with no talent who can't stop talking about how he "came up" with the work he's appropriated and taken credit for.'[16] His talent was pretending to have talent. ✪

Thanks to the performances and the director's restraint, reviews were guardedly positive. If the film never quite achieves the psychological intensity it pursues, A.O. Scott in the *New York Times* appreciated its almost Hitchcockian luridness; that it was 'a horror movie tucked inside a domestic drama wrapped up in a biopic.'

But in common with *Ed Wood* it struggled at the box office, making only $29 million worldwide. The tone was hard to gauge. Was this a comedy or a tragedy? Burton would argue that it was both.

It was the strangeness of the final act that left audiences scratching their heads about this slighter entry into the Burton canon. Of all things, Burton chose to attempt a courtroom thriller, in which Margaret will have her showdown with her conniving and by now borderline lunatic ex-husband. Turning the courtroom into a farce, the film becomes the Waltz/Walter show, and at one point he ends up cross-examining himself. They are eventually forced into a "paint-off" to prove who had the knack for big eyes.

'Some people may think it's over the top, but we actually toned it down because the story itself is so out there,' contends Burton. 'The judge wanted to tape his mouth shut.'[17] The truth can sometimes be stranger than even Burton's fiction.

Right: Burton frames a shot, with Amy Adams' Margaret at work. Canadian artist Lisa Godwin was commissioned to create various 'in-progress' paintings for Adams to add a brush stroke or two in front of the camera.

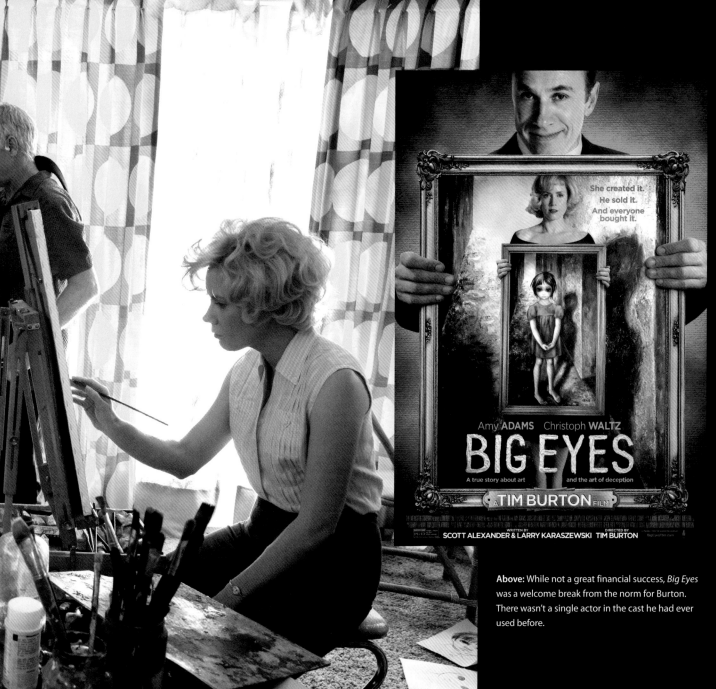

Above: While not a great financial success, *Big Eyes* was a welcome break from the norm for Burton. There wasn't a single actor in the cast he had ever used before.

Miss Peregrine's Home for Peculiar Children

After venturing some way from his chosen path, Burton returned to more familiar ground. From February to July of 2015, he shot an adaptation of Ransom Riggs' young adult novel *Miss Peregrine's Home for Peculiar Children*, with a script by British screenwriter Jane Goldman, who had previously brought *Stardust* and *The Woman in Black* to the screen.

Burton had been mulling over the 20th Century Fox project before *Big Eyes* – news the book's author claimed made his 'closet-goth-boy heart palpitate with joy'.[18] The story might as well have been written with Burton in mind. Circling the realm of horror like *Sleepy Hollow*, it is set on a fog-cloaked Welsh island, where a school for outsiders has been magically preserved in a time loop, endlessly repeating the same sunlit day in 1940.

The pupils – 'peculiars' – each possess a unique supernatural talent such as levitation or invisibility. One can manipulate a swarm of bees, and one can create extraordinary local topiary (sound familiar?). The student body is quietly presided over by the headmistress Miss Peregrine (Eva Green from *Dark Shadows*), who can transform into a bird. 'She's like a scary Mary Poppins,'[19] says Burton.

Stealing into their midst comes Jacob (Asa Butterfield), a 16-year-old peculiar from contemporary Florida, with a talent for spotting Hallowgasts – the monstrous enemies of peculiars. He is investigating his grandfather's elaborate claims of having been a "peculiar", rather like William Bloom in *Big Fish*.

In studio terminology, this was *Harry Potter* meets *The X-Men*. Exactly the kind of formulaic thinking that makes Burton's skin crawl, so you fancy his interest was piqued less by its kinship to his own work, or Hollywood trends, than by the unusual inspiration behind Riggs' novel. The author is a collector of vintage snapshots, 'the kind you find in loose piles at flea markets for fifty cents or a buck apiece.'[20] The strangest-looking ones were always children, and he began to wonder what their stories might be. 'I thought, "If I can't know their real stories, I'll make them up."'[21] Riggs took images that appealed to him (twins in strange masks, a boy in a top hat) and sewed them together into a story.

The film was shot in Cornwall and Lancashire in the UK, and Tampa Bay in Florida, and the cast also included Terence Stamp, Judi Dench and Samuel L. Jackson as the sinister Mr Barron. And after the hermetic green screen world of *Alice in Wonderland*, Burton was thrilled to be shooting a big fantasia out in the open air, 'to be connected to a place and geography while having people actually floating, as opposed to doing it all digitally.'[22] The film is almost naturalistic.

For Riggs, being invited on set was magical. He found Miss Peregrine's old house, more Victorian and sun-dappled than the shadowy, gothic piles of Collinswood or Wayne Manor, to be exactly what he had imagined when creating the story. 'I had a genuine out-of-body moment when I came onto the sound stage. I thought I'd walked into the pages of my book.'[23] ✪

Opposite above: Eva Green's Miss Peregrine demonstrates the unusual curriculum at her peculiar school. According to the film's complicated lore, she is an Ymbryne able to manipulate time and turn into a bird.

Above: While the subject matter may seem familiar to Burton's followers, in contrast with the likes of *Batman* or *Alice in Wonderland*, it was a fantasy set in naturalistic locations.

The flaming torch of Burton's imagination still burns bright. He has signed on with Disney again to develop a live action version of Dumbo. The mind somewhat boggles at the notion – CGI will surely be essential; elephants are reluctant to get airborne. There are also plans, finally, to resurrect the *Beetlejuice* sequel. Both Michael Keaton and Winona Ryder have mentioned secret discussions they have had with Burton.

Making films is so personal to Burton that to simply stop doing so would be like cutting off his air supply. And even then, he would probably rise from the dead, and get on with directing his next.

Wondering if he ever could run dry, he just shrugs. 'Maybe that will happen and I'll revert to some kind of amoeba state,'[24] he jokes. There are always more wonderful nightmares to come, stores of childhood experience yet to be tapped.

As Burton says, 'It's good as an artist to always remember to see things in a new, weird way.'[25]

170

Right: The peculiar children of the title, whose talents include floating, invisibility, strength, summoning fire and dreaming the future. Asa Butterfield (third from the left), as hero Jacob, can detect evil Hallowgasts disguised as humans.

PECULIAR CHILDREN

Sources

Introduction

1. *Playboy*, Kristine McKenna, August 2001
2. *Rolling Stone*, David Edelstein, June 1988
3. *Entertainment Weekly*, Anthony Breznican, 11 May 2012

The Boy Who Lived In The Dark

1. *Burton on Burton*, Mark Salisbury, Faber & Faber, 2006
2. *Tim Burton*, Jim Smith and J. Clive Matthews, Virgin Film Series, 2002
3. Cranky Critic.com, 1999
4. *Rolling Stone*, David Edelstein, June 1988
5. *Burton on Burton*, Mark Salisbury, Faber & Faber, 2006
6. *Guardian*, Amy Raphael, 6 March 2000
7. *Independent*, Gill Pringle, 26 February 2010
8. Ibid.
9. *Playboy*, Kristine McKenna, August 2001
10. *San Diego Union Tribune*, David Elliot, 25 June 1989
11. *New York Times*, Joe Morgenstern, 9 April 1989
12. *Playboy*, Kristine McKenna, August 2001
13. *Vincent*, short film, *The Nightmare Before Christmas* DVD Special Edition, Walt Disney, 2008
14. *Tim Burton* (revised edition), Antoine De Baecque, Phaidon, 2011
15. *Rolling Stone*, David Breskin, 23 July 1992
16. *Burton on Burton*, Mark Salisbury, Faber & Faber, 2006
17. *Cinefantastique* vol. 28, Fredrick S. Clarke, 1996
18. *New York Times*, Joe Morgenstern, 9 April 1989
19. *Interview*, Graham Fuller, December 1990
20. Tim Burton: Exhibition Checklist, The Museum of Modern Art, New York, November 2009–April 2010
21. *Burton on Burton*, Mark Salisbury, Faber & Faber, 2006
22. *Vanity Fair*, Sam Kashner, March 2014
23. MousePlanet.com, Jim Korkis, 6 June 2012
24. *Chicago Sun Times*, Roger Ebert, 17 October 1993
25. *Tim Burton*, Jim Smith and J. Clive Matthews, Virgin Film Series, 2002
26. *Rolling Stone*, David Edelstein, June 1988
27. *Tim Burton*, Jim Smith and J. Clive Matthews, Virgin Film Series, 2002
28. *New York Times*, Joe Morgenstern, 9 April 1989
29. *Cinefantastique*, Michael Mayo, May 1985
30. *Independent*, Gill Pringle, 26 February 2010

Happy Horrors

1. *Interview*, Paul Rudd, 27 October 2009
2. *The Tim Burton Encyclopaedia*, Samuel J. Umland, 2015
3. *Interview*, Paul Rudd, 27 October 2009
4. Ibid.
5. *New York Times*, Joe Morgenstern, 9 April 1989
6. *San Diego Tribune*, David Elliot, 8 April 1985
7. Director's commentary, *Pee-wee's Big Adventure* Blu-ray, Tim Burton Collection, 2015
8. *The Tim Burton Encyclopaedia*, Samuel J. Umland, 2015
9. *Burton on Burton*, Mark Salisbury, Faber & Faber, 2006
10. *Inner Views: Filmmakers in Conversation*, David Breskin, Faber & Faber, 1992
11. *Burton on Burton*, Mark Salisbury, Faber & Faber, 2006
12. *Tim Burton* (revised edition), Antoine De Baecque, Phaidon, 2011
13. *Starlog*, Marc Shapiro, 1988
14. *Inner Views: Filmmakers in Conversation*, David Breskin, Faber & Faber, 1992
15. *Films in Review*, Ken Hanke, November/December 1992
16. *Rolling Stone*, David Edelstein, June 1988
17. *Starlog*, Marc Shapiro, 1988
18. Ibid.
19. *Rolling Stone*, David Edelstein, June 1988
20. *Inner Views: Filmmakers in Conversation*, David Breskin, Faber & Faber, 1992
21. *Cinefex*, Jody Duncan Shannon, May 1988
22. *Tim Burton*, Jim Smith and J. Clive Matthews, Virgin Film Series, 2002
23. *Rolling Stone*, David Edelstein, June 1988
24. *Starlog*, Marc Shapiro, 1988
25. *Time Out*, Simon Garfield, 3 August 1988
26. *Rolling Stone*, David Edelstein, June 1988
27. Ibid.
28. *Burton on Burton*, Mark Salisbury, Faber & Faber, 2006

Strange Heroes

1. *Cinefantastique*, Alan Jones, November 1989
2. Ibid.
3. *Starlog*, Adam Pirani, August 1989
4. *New York Times*, Joe Morgenstern, 9 April 1989
5. Ibid.
6. *Boston Globe*, Jay Carr, 18 June 1989
7. *Burton on Burton*, Mark Salisbury, Faber & Faber, 2006

8. Ibid.

9. *New York Times*, Joe Morgenstern, 9 April 1989

10. Ibid.

11. *Los Angeles Times*, 'The Hero Complex', Geoff Boucher, 12 May 2011

12. *Inner Views: Filmmakers in Conversation*, David Breskin, Faber & Faber, 1992

13. *Rolling Stone*, David Breskin, July 1992

14. *Burton on Burton*, Mark Salisbury, Faber & Faber, 2006

15. *Inner Views: Filmmakers in Conversation*, David Breskin, Faber & Faber, 1992

16. *Cinefantastique*, Alan Jones, November 1989

17. *Mirabella*, David Edelstein, December 1990

18. *Playboy*, Kristine McKenna, August 2001

19. *Starburst*, Alan Jones, July 1991

20. *Popsugar*, Shannon Vestal Robson, 26 October 2015

21. *Los Angeles Times*, Nina J. Easton, 12 October 1990

22. *Burton on Burton*, Mark Salisbury, Faber & Faber, 2006

23. *Edward Scissorhands*: 25th Anniversary Edition DVD, 20th Century Fox, 2015

24. *Interview*, Graham Fuller, December 1990

25. *Inner Views: Filmmakers in Conversation*, David Breskin, Faber & Faber, 1992

26. *Variety*, Matthew Chernov, 7 December 2015

27. MTV News, 24 November 2015

28. *Popsugar*, Shannon Vestal Robson, 26 October 2015

29. *New York Times*, Laurie Halpern Smith, 28 August 1990

30. *Sight & Sound*, Mark Burman, October 1993

31. *Telegraph Magazine*, November 1999

32. *Premiere*, Frank Rose, January 1991

33. *Popsugar*, Shannon Vestal Robson, 26 October 2015

34. *Premiere*, Frank Rose, January 1991

35. Ibid.

36. *Burton on Burton*, Mark Salisbury, Faber & Faber, 2006

37. *Inner Views: Filmmakers in Conversation*, David Breskin, Faber & Faber, 1992

38. *Burton on Burton*, Mark Salisbury, Faber & Faber, 2006

39. Ibid.

40. *Guardian*, Tim Adams, 7 October 2012

41. *Los Angeles Times*, Bob Thomas, 15 January 1991

42. *Chicago Tribune*, Clifford Terry, 4 June 1992

43. *Entertainment Weekly*, Anthony Breznican, 16 October 2015

Poetry Into Plot

1. *Starlog*, Marc Shapiro, July 1992

2. *Inner Views: Filmmakers in Conversation*, David Breskin, Faber & Faber, 1992

3. *Cahiers du Cinéma*, December 1992

4. *Burton on Burton*, Mark Salisbury, Faber & Faber, 2006

5. *Premiere*, Fred Schruers, July 1995

6. *Burton on Burton*, Mark Salisbury, Faber & Faber, 2006

7. *Empire*, Jeffery Resner, August 1992 (quoting 'The Joan Rivers Show', 1991)

8. *Premiere*, Fred Schruers, July 1995

9. *CinePlex Magazine*, Mark Pilkington, 9 May 2012

10. *Rolling Stone*, Gerri Hirshey, 3 September 1992

11. Ibid.

12. Ibid.

13. *Batman Returns* production notes, Warner Brothers 1992

14. Ibid.

15. *Empire*, Philip Thomas, August 1991

16. *Empire*, Jeffery Resner, August 1992 (quoting 'The Joan Rivers Show', 1991)

17. *Batman Returns* DVD, Tim Burton Collection, Warner Brothers, 2015

18. *Starlog*, Bill Warren, January 1997

19. *Starlog*, Marc Shapiro, July 1992

20. Money Into Light, Paul Rowlands, 30 June 2012

21. *Burton on Burton*, Mark Salisbury, Faber & Faber, 2006

22. Le Cinéphage, May–June 1995

23. The Director's Chair Interviews, industrycentral.net, 1994

24. Money Into Light, Paul Rowlands, 30 June 2012

25. The Director's Chair Interviews, industrycentral.net, 1994

26. Ibid.

27. *Cinefantastique*, Lawrence French, 1994

28. Biographical Films, Gavin Smith, April 2013

29. *Cinefantastique*, Lawrence French, 1994

30. *Burton on Burton*, Mark Salisbury, Faber & Faber, 2006

Drop-dead Gorgeous

1. *Hollywood Reporter*, Scott Feinberg, 17 February 2013

2. *Burton on Burton*, Mark Salisbury, Faber & Faber, 2006

3. *Hollywood Reporter*, Scott Feinberg, 17 February 2013

4. *Boston Globe*, Jay Carr, 17 October 1993

5. *Premiere*, Mimi Avins, November 1993

6. Ibid.

7. Ibid.

8. EdWeb, Andy Carvin, October 1993

9. *Premiere*, Mimi Avins, November 1993

10. EdWeb, Andy Carvin, October 1993

11. *Sight & Sound*, Leslie Felperin, December 1994

12. PopEntertainment, Brad Balfour, 25 September 2005

13. *Inner Views: Filmmakers in Conversation*, David Breskin, Faber & Faber, 1992
14. PopEntertainment, Brad Balfour, 25 September 2005
15. Comingsoon.net, Edward Douglas, 13 September 2005
16. Ibid.
17. PopEntertainment, Brad Balfour, 25 September 2005
18. About.com – Tim Burton interview, Rebecca Murray, 14 September 2005
19. About.com – Johnny Depp interview, Rebecca Murray, 14 September 2005
20. Deadline, Anthony D'Alessandro, 17 February 2013
21. *Frankenweenie*, production notes, Walt Disney, 2014
22. HeyUGuys, Jon Lyus, 22 October 2012
23. MoviesOnline, 28 February 2016
24. HeyUGuys, Jon Lyus, 22 October 2012
25. ScreenCrave, Laura Frances, 4 October 2012
26. Deadline, Anthony D'Alessandro, 17 February 2013
27. *Reuters*, Zorianna Kit, 3 October 2012
28. ViewLondon.co.uk, October 2012
29. Ibid.

Head Cases

1. *Starlog*, Bill Warren, January 1997
2. *Premiere*, Christine Spines, January 1997
3. Ibid.
4. *Starlog*, Bill Warren, January 1997
5. *Mars Attacks! The Art of the Movie*, Karen R Jones, Titan, 1996
6. *Tim Burton*, Jim Smith and J Clive Matthews, Virgin Film Series, 2002
7. *Empire*, Steve Goldman, March 1997
8. *Cinefantastique*, Frederick C. Szebin and Steve Biodrowski, January 1997
9. *Fangoria*, Anthony C. Ferrante, March 1997
10. *Tim Burton*, Jim Smith and J Clive Matthews, Virgin Film Series, 2002
11. *Starlog*, Bill Warren, January 1997
12. *Premiere*, Christine Spines, January 1997
13. Ibid.
14. *Burton on Burton*, Mark Salisbury, Faber & Faber, 2006
15. *Empire*, David Mills, February 2000
16. *Burton on Burton*, Mark Salisbury, Faber & Faber, 2006
17. *American Cinematographer*, Steven Pizzello, December 1999
18. *American Cinematographer* interview with Emmanuel Lubezki, Steven Pizzello, December 1999
19. Cranky Critic.com, 1999
20. *American Cinematographer*, Steven Pizzello, December 1999

21. *Fangoria*, Mark Salisbury, February 2000
22. *American Cinematographer*, Steven Pizzello, December 1999
23. Cranky Critic.com, 1999
24. *Entertainment Weekly*, Christopher Nashawaty, November 1999
25. *Burton on Burton*, Mark Salisbury, Faber & Faber, 2006
26. *Telegraph Magazine*, November 1999
27. *The Legend of Sleepy Hollow*, Washington Irving, William Collins, 2012
28. Cranky Critic.com, 1999
29. *Entertainment Weekly*, Christopher Nashawaty, November 1999

Time Warps

1. *Planet of the Apes*, production notes, 20th Century Fox, 2001
2. MTV Movies Blog, Terri Schwartz, 29 December 2011
3. *Playboy*, Kristine McKenna, August 2001
4. *Burton on Burton*, Mark Salisbury, Faber & Faber, 2006
5. *Guardian*, Michael Sragow, 3 August 2001
6. Ibid.
7. *Planet of the Apes*, production notes, 20th Century Fox, 2001
8. *Premiere*, Mark Salisbury, July 2001
9. *Planet of the Apes*, production notes, 20th Century Fox, 2001
10. *Los Angeles Times*, Richard Natale, 6 May 2001
11. *Guardian*, Michael Sragow, 3 August 2001
12. Film4.com, August 2001
13. *Planet of the Apes*, production notes, 20th Century Fox, 2001
14. *Premiere*, Mark Salisbury, July 2001
15. *Planet of the Apes*, production notes, 20th Century Fox, 2001
16. *Premiere*, Mark Salisbury, July 2001
17. Ibid.
18. *Dreamwatch*, Jenny Cooney Carillo, November 2001
19. *Esquire*, Cal Fussman, January 2008
20. Hollywood.com, 22 July 2001
21. *Guardian*, Michael Sragow, 3 August 2001
22. *Premiere*, March 2004
23. American Museum of the Moving Image – *Big Fish* Q&A transcript, moderator David Schwartz, 2003
24. Strange Horizons, Jason Erik Lundberg, 11 October 2004
25. *Le Nouvel Observateur*, 4 March 2004
26. American Museum of the Moving Image – *Big Fish* Q&A transcript, moderator David Schwartz, 2003
27. Ibid.
28. *Big Fish*, production notes, 2003
29. Ibid.
30. Christian Spotlight, Chris Monroe, 30 December 2003
31. *Le Monde*, 28 February 2004

Just Desserts

1. *Daily Telegraph*, S.F. Said, 23 July 2005
2. *Independent*, Louise Jury, 11 July 2005
3. *Charlie and the Chocolate Factory*, production notes, Warner Brothers, 2005
4. *Dark Horizons*, Garth Franklin, 10 July 2005
5. Ibid.
6. *Charlie and the Chocolate Factory*, production notes, Warner Brothers, 2005
7. Ibid.
8. *Total Film*, 1 January 2007
9. The Arts Desk, Sheila Johnston, 9 September 2009
10. IGN, Steve Head, 8 July 2005
11. *Dark Horizons*, Garth Franklin, 10 July 2005
12. *Tim Burton* (revised edition), Antoine De Baecque, Phaidon, 2011
13. Ibid.
14. *Tim Burton* (revised edition), Antoine De Baecque, Phaidon, 2011
15. *Burton on Burton*, Mark Salisbury, Faber & Faber, 2006
16. *New York Times*, Sylviane Gold, 4 November 2007
17. Ibid.
18. Ibid.
19. *Time Out*, Trevor Johnson, January 2008
20. *New York Times*, Sylviane Gold, 4 November 2007
21. NewsBlaze, Prairie Miller, 25 December 2007
22. *Sweeney Todd: The Demon Barber of Fleet Street* Blu-ray extras, Warner Brothers, 2008
23. *Time Out*, Trevor Johnson, January 2008
24. *Sweeney Todd: The Demon Barber of Fleet Street* Blu-ray extras, Warner Brothers, 2008
25. *Time Out*, Trevor Johnson, January 2008
26. *Entertainment Weekly*, Steve Daly, 3 November 2007
27. *New York Times*, Sylviane Gold, 4 November 2007
28. Ibid.
29. The Void Online Magazine, Katie Roberts, 25 January 2008
30. Dark Horizons, Paul Fischer, 18 December 2007

Family Plots

1. Ain't It Cool News, Mr. Beaks, 2 March 2010
2. Collider, Steve 'Frosty' Weintraub, 2 February 2010
3. *Alice in Wonderland* production notes, Walt Disney, 2010
4. *Guardian*, Amy Raphael, 6 March 2010
5. Ibid.
6. *Alice in Wonderland* production notes, Walt Disney, 2010
7. *Daily Telegraph*, 25 February 2010
8. Collider, Steve 'Frosty' Weintraub, 2 February 2010
9. *Guardian*, Amy Raphael, 6 March 2010

10. IndieLondon, March 2010
11. Canoe.com, Randall King, 19 November 1999
12. CraveOnline, Fred Topel, May 2012
13. *Dark Shadows* production notes, Warner Brothers, 2012
14. CraveOnline, Fred Topel, May 2012
15. *Entertainment Weekly*, Anthony Breznican, 11 May 2012
16. Bloody Disgusting, Evan Dickson, 9 May 2012
17. Ibid.
18. Ibid.

Peculiar Children

1. DirectConversations.com, Tim Lammers, December 2014
2. *Big Eyes – The Film, The Art*, Leah Gallo, Titan Books, 2014
3. DirectConversations.com, Tim Lammers, December 2014
4. *Slant Magazine*, Elise Nakhnikian, 19 December 2014
5. *Big Eyes – The Film, The Art*, Leah Gallo, Titan Books, 2014
6. Latin Post, Francisco Salazar and David Salazar, 26 December 2014
7. Ibid.
8. *Big Eyes – The Film, The Art*, Leah Gallo, Titan Books, 2014
9. Ibid.
10. *Slant Magazine*, Elise Nakhnikian, 19 December 2014
11. Ibid.
12. *Big Eyes – The Film, The Art*, Leah Gallo, Titan Books, 2014
13. Ibid.
14. The Wrap, Steve Pond, 7 December 2014
15. DirectConversations.com, Tim Lammers, 24 November 2015
16. *Rolling Stone*, Tim Grierson, 23 December 2014
17. *Slant Magazine*, Elise Nakhnikian, 19 December 2014
18. PageToPremiere, 14 January 2013
19. *Entertainment Weekly*, Gina McIntyre, 4 March 2016
20. 'A Conversation with Ransom Riggs', *Miss Peregrine's Home for Peculiar Children*, Ransom Riggs, Quirk Books, 2011
21. Ibid.
22. *Entertainment Weekly*, Gina McIntyre, 4 March 2016
23. *Entertainment Weekly*, Isabella Biedenharn, 27 May 2015
24. *Playboy*, Kristine McKenna, August 2001
25. *Interview*, Danny Elfman, 22 January 2010

PICTURE CREDITS

The images in this book are from the archives of The Kobal Collection which owes its existence to the vision, talent and energy of the men and women who created the movie industry and whose legacies live on through the films they made, the studios they built, and the publicity photographs they took. Kobal collects, preserves, organizes and makes these images available to enhance our understanding of this cinematic art.

The publisher wishes to thank all of the photographers (known and unknown) and the film production and distribution companies whose publicity images appear in this book. We apologize in advance for any omissions, or neglect, and will be pleased to make any corrections in future editions.

20th Century Fox: 14, 50–51, 54–55, 58, 60, 61, 98, 116–117, 118 right.

20th Century Fox/Greenway: 42 below.

20th Century Fox/Jay Maidment: 168, 169, 170–171.

20th Century Fox/Zade Rosenthal: 22, 53, 54–55, 55 below, 56, 57, 58 below left.

20th Century Fox/Zanuck Co.: 118 left, 119, 122–123, 123 right.

20th Century Fox/Zanuck Co./Sam Emerson: 23 right, 120.

20th Century Fox/Zanuck Co./David James: 121.

20th Century Fox Television: 59.

AIP: 16 left, 16 right, 17.

CBS: 81.

Columbia: 78–79 above, 79 below.

Columbia/Zade Rosenthal: 124, 125, 126–127, 128 above, 128 below, 129, 130–131.

Criswell: 72 below.

Dreamworks/Warner Bros.: 138 below left, 138-139.

Dreamworks/Warner Bros./Leah Gallo: 9, 140, 144–145.

Dreamworks/Warner Bros./Peter Mountain: 141, 142–143.

Fox/ABC: 42 above.

Geffen/Warner Bros.: 15, 18–19, 33, 34–35, 36, 37, 38, 39 above, 39 below.

Joseph Shaftel Productions: 149 below right.

Paramount: 31 left, 149 above.

Paramount/Mandalay/Clive Coote: 106–107, 108–109, 110, 111 above, 111 below, 112, 113, 114 above left, 114–115, 114 below left.

Pee Wee Pictures/Binder/RB Prods.: 26–27.

Produzione De Sica: 29 above.

RKO: 12.

Screen Classics: 72 above.

Specta/Gray/Alter Films/Centaure: 31 right.

Touchstone: 8 below, 13, 73, 74, 75, 76–77, 77 above right, 80, 83, 84, 85.

Touchstone/Elizabeth Aninas: 82.

Universal: 11 above left, 11 below left, 11 right, 52, 92.

Universal/Embassy: 48 above.

Walt Disney Pictures: 23 right, 93, 94–95, 96, 97, 146–147, 148, 150–151, 152 above right, 152 below, 153, 154–155.

Warner Bros.: 7, 24–25, 28, 29 above, 30, 32, 86, 87, 88–89 above, 89 below right, 90–91, 103 above, 103 below, 135 below, 136 below, 156, 157, 158–159, 160–161.

Warner Bros./DC Comics: 4–5, 8 above, 21, 40–41, 43, 44, 45 above, 45 below, 46–47, 47 above right, 48 below, 49, 62–63, 66, 67, 68, 69, 70 above, 70 below, 71.

Warner Bros./DC Comics/Jack Pedota: 65.

Warner Bros./DC Comics/Zade Rosenthal: 64.

Warner Bros./ILM: 104.

Warner Bros./Peter Mountain: 133, 134, 135 above, 136–137.

Warner Bros./Zade Rosenthal: 20.

Warner Bros./Bruce Talamon: 99, 100, 102, 104–105.

Weinstein Company/Tim Burton Productions/ Leah Gallo: 10, 163, 164, 165 left, 165 right, 166–167, 167 right.

GATEFOLD INSERT

Abraham Lincoln: Vampire Hunter: Bazelevs/ 20th Century Fox

Alice In Wonderland: Walt Disney Pictures

Alice Through the Looking Glass: Walt Disney Pictures

Batman: Warner Bros./DC Comics

Batman Forever: Warner Bros.

Batman Returns: Warner Bros./DC Comics/ Zade Rosenthal

Beetlejuice: Geffen/Warner Bros.

Big Eyes: Weinstein Company/Tim Burton Productions/Leah Gallo

Big Fish: Columbia/Zade Rosenthal

Cabin Boy: Touchstone

Catwoman: Warner Bros./DC Comics

Charlie and the Chocolate Factory: Warner Bros./ Peter Mountain

Dark Shadows: Warner Bros.

Edward Scissorhands: 20th Century Fox

Ed Wood: Touchstone

Frankenweenie (short): Walt Disney Pictures

Frankenweenie: Walt Disney Pictures

Hansel and Gretel (short): Gaylord/Lions Gate/ Platypus

Maleficent: Walt Disney Studios

Mars Attacks!: Warner Bros./Bruce Talamon

Men in Black 3: Amblin Entertainment

Miss Peregrin's Home for Peculiar Children: 20th Century Fox/Jay Maidment

Pee-wee's Big Adventure: Warner Bros.

Planet of the Apes: 20th Century Fox/Zanuck Co.

Singles: Warner Bros.

Sleepy Hollow: Paramount/Mandalay/Clive Coote

Sweeney Todd: The Demon Barber of Fleet Street: Dreamworks/Warner Bros./Leah Gallo

The Lord of the Rings: Fantasy Film/Saul Zaentz

Tim Burton's Corpse Bride: Warner Bros.

Tim Burton's The Nightmare Before Christmas: Touchstone

Tron: Walt Disney

176